Made

TEN CENTURIES OF

in

AMERICAN ART

America

ESSAYS BY

Henry Adams

Richard Armstrong

Louise Lincoln

Evan M. Maurer

and Sarah Nichols

EXHIBITION COORDINATOR AND
CONSULTING EDITOR

Kathryn C. Johnson

HUDSON HILLS PRESS

in association with

THE CARNEGIE MUSEUM OF ART

THE MINNEAPOLIS INSTITUTE OF ARTS

THE NELSON-ATKINS MUSEUM OF ART

THE SAINT LOUIS ART MUSEUM

THE TOLEDO MUSEUM OF ART

Made

TEN CENTURIES OF

in

AMERICAN ART

America

Published on the occasion of the exhibition *Made in America: Ten Centuries of American Art*, organized jointly by The Carnegie Museum of Art, Pittsburgh; The Minneapolis Institute of Arts; The Nelson-Atkins Museum of Art, Kansas City; The Saint Louis Art Museum; and The Toledo Museum of Art.

Edited on behalf of the consortium by Mary Ann Steiner and Kathryn C. Johnson

For Hudson Hills Press

Editor and publisher: Paul Anbinder

Copy editor: Fronia W. Simpson

Indexer: Karla J. Knight

Designer: Betty Binns

Composition: Angela Taormina

Manufactured in the United States of America by Stinehour Press

First Edition

Published in the United States by Hudson Hills Press, Inc., Suite 1308, 230 Fifth Avenue, New York, NY 10001-7704.

Distributed in the United States, its territories and possessions, Canada, Mexico, and Central and South America by National Book Network.

Distributed in the United Kingdom and Eire by Art Books International Ltd.

Exclusive representation in Asia, Australia, and New Zealand by EM International.

Library of Congress Cataloguing-in-Publication Data

Made in America : ten centuries of American art. — 1st ed.

 p. cm.

 Exhibition catalogue of items from five American museums. Includes index.

 ISBN 1-55595-111-2

 1. Art, American—Exhibitions.
N6505.M23 1995
709'.73'07473—dc20 94–35429
 CIP

Made in America
TEN CENTURIES OF AMERICAN ART

Authors

HA	HENRY ADAMS	EMM	EVAN M. MAURER
LA	LYNNE AMBROSINI	CM	CARA McCARTY
RA	RICHARD ARMSTRONG	JAN	JUDITH A. NEISWANDER
RB	ROGER BERKOWITZ	SN	SARAH NICHOLS
JDB	JAMES D. BURKE	ZAP	ZOE ANNIS PERKINS
EDG	ELAINE D. GUSTAFSON	DAR	DANIEL A. REICH
KJ	KATHRYN C. JOHNSON	WBR	WILLIAM B. RUSSELL, JR.
DMJ	DENNIS MICHAEL JON	JKS	JOYCE K. SCHILLER
OLG	OLIVIA LAHS-GONZALES	DES	DEBORAH EMONT SCOTT
JLH	JACKIE LEWIS-HARRIS	JS	JEREMY STRICK
ML	MARGARET LICHTER	DST	DAVIRA S. TARAGIN
LL	LOUISE LINCOLN	EJV	ELIZABETH J. VALLANCE
LWL	LOUISE W. LIPPINCOTT	CW	CHARLES WYLIE

What is American art? That question has been posed, debated, and responded to in earnest for a long time, and by everyone from political pundits to academics to car salesmen. What is considered art is sometimes no more certain than what is deemed American. This exhibition of 160 works of art selected from our five museums does not define American art. It does, however, attempt to revise our thinking, for ourselves and for the people in our communities, about how we might approach American art.

The decision to prepare a grand exhibition of American art for the communities of our five museums was a natural one. We learned it was an appealing subject to our audience when our five museums polled visitors about their interests for future exhibitions. Each of us can truly list American art as one of the strengths of our collections. But most importantly, it was an opportunity for us to create an exhibition in which the subject matter and approach could be determined by principles of inclusion and accessibility as well as quality.

We knew that within our collections we had the works of art to compile an exhibition of masterpieces for a standard survey of American art. We also knew that our present states of consciousness about who we are, how we have been shaped, and what the American experience has been would force us to recognize that kind of exhibition as uncomfortably dated and restrictive. How to update and expand our categories was sometimes a challenge. What we present to you here is, by turns, inclusive, intriguing, and still in flux; it moves forward, not always with even paces, among touchstones of nationalistic notions and expanded motives of inclusion and assimilation.

We hoped to follow as many as possible of the strands and strains that have woven themselves into the pattern of American culture. Much of the vitality of America in the past as well as in the 1990s has sprung from the diversity of our citizenry, and we wanted our exhibition to reflect this cultural richness. What emerged from these goals was a more complete picture of the sources and aspects of American art, arching from the pottery of the Anasazi artists in the eleventh century to Andy Warhol's pop icon of Elvis Presley at the end of the 1960s: truly ten centuries of American art. There are obvious gaps in this exhibition and a somewhat abrupt and arbitrary end in 1970, not only because we are drawing only from our own collections, but also American art of the last two decades needs some time for assessment. We have had to acknowledge that there were not many works by African-Americans in our collections and few by Hispanic-Americans and Asian-Americans. That recognition has prompted us jointly and individually to focus our collecting activities on those areas in the future.

The wish to be inclusive and representative directed us to consider the materials of expression as well as the subject matter. There was, of course, a selection of wonderful paintings and sculpture that one would expect of an exhibition of American masterpieces culled from five major museums. And most of us display our finest works of decorative arts in our galleries with paintings and sculptures, so that the concept of combining different media was natural to our selection process.

We also chose to include some very fine photographs. In that medium we had fine works of art depicting subjects not addressed in other media, although we do not consider this exhibition a cultural history show. Insight into our attitudes toward realism as well as the experience of landscape has been greatly affected by the development of photography.

Among our five museums there is also a wealth of Native American art. It is by no means a seamless record from Anasazi pottery through modern works, but the areas of strength—the ancient period and the late nineteenth century—yield examples of the eloquence and importance of art in the lives of the first Americans.

The range of different media and the expanse of ten centuries have been organized into eight sections for both the exhibition and this catalogue: Ancient America; Colonial and Federal America; Democratic Vistas; American Impressions; Native American Art; Artistic Interiors; The Modern Age; and Art After World War II. The brief essays that introduce these sections have been written to provide a succinct view of the social and artistic context for the works of art. The entries are similarly concise in discussing the work of art and its artist.

This exhibition and the catalogue that accompanies it have been planned, mounted, written, and produced by our staffs. In the mid-1980s the directors of our five museums first dreamed of selecting Impressionist and Post-Impressionist paintings from each of our permanent collections for an important exhibition that would be presented to each of our communities. The consortium of the art museums in Kansas City, Minneapolis, Pittsburgh, St. Louis, and Toledo was established, and the exhibition that was circulated in

1989–90 was so enthusiastically received that we all attracted record numbers of visitors. This second collaboration builds on the success of our first effort, refining the strengths and minimizing the problems. We have come to believe not only that working as a consortium is a viable alternative to more expensive routes of preparing major exhibitions, but we propose it as a model alternative. Our staffs have benefited greatly from the dialogue among the five museums; we have felt more grounded in the expectations of our communities; and we have been able to hold costs to affordable levels.

We hope you will find this exhibition of a thousand years of American art as stimulating, thought-provoking, beautiful, and broadening as we who have worked on it. We are fortunate to live in a country with a fascinating visual history from which we can learn much about both our past and—through reflection—our present, maybe even our future.

JAMES D. BURKE, DIRECTOR
The Saint Louis Art Museum

PHILLIP M. JOHNSTON, DIRECTOR
The Carnegie Museum of Art

EVAN M. MAURER, DIRECTOR
The Minneapolis Institute of Arts

DAVID W. STEADMAN, DIRECTOR
The Toledo Museum of Art

MARC F. WILSON, DIRECTOR
The Nelson-Atkins Museum of Art

This exhibition was created by a consortium of five midwestern museums who chose to tap the wealth of our own resources—outstanding works of art, knowledgeable and experienced staff, and creative ideas—to tell an updated version of the story of art in America. In collaborating to make a touring exhibition for the communities of our five cities, we have participated in a very American tradition that seeks a unity in plurality. We gratefully acknowledge the cooperation among our five staffs and thank the many individuals who have contributed their expertise.

The Minneapolis Institute of Arts agreed to assume the lead in coordinating the exhibition, communicating our progress and exhorting us to completion. We thank Kathryn C. Johnson, director of education there, for the administrative leadership this undertaking demanded. She managed the administrative coordination of our effort with skill, diplomacy, patience, and optimism. DeAnn Dankowski, research assistant to the director, was matchless in maintaining the lists, data, and images that we all relied on. Minneapolis also agreed to serve as fiscal agent for the consortium; Timothy Fiske, associate director there, managed the finances and budget.

The Saint Louis Art Museum took responsibility for the exhibition's catalogue, written and produced under the direction of Mary Ann Steiner, that museum's director of publications. Suzanne Tausz functioned as editorial assistant, incorporating the writings of the twenty-seven contributors into the whole and managing the many revisions along the way to a final publication. The authors of the eight essays are to be commended for their thoughtful insights and recognized for their flexibility in rethinking and rewriting to achieve the best relationship of parts to the whole: Henry Adams, Richard Armstrong, Louise Lincoln, Evan M. Maurer, and Sarah Nichols

wrote the essays of cultural history and social context. The contributors of the entries on each work of art were equally committed to succinct and accessible information. We thank Henry Adams, Margaret Conrads, and Deborah Emont Scott from The Nelson-Atkins Museum of Art; Richard Armstrong, Louise W. Lippincott, and Sarah Nichols from The Carnegie Museum of Art; Roger Berkowitz, Elaine D. Gustafson, and Davira S. Taragin from The Toledo Museum of Art; Lynne Ambrosini, Dennis Michael Jon, Louise Lincoln, Evan M. Maurer, Judith A. Neiswander, and William B. Russell, Jr., from The Minneapolis Institute of Arts; and James D. Burke, Olivia Lahs-Gonzales, Jackie Lewis-Harris, Margaret Lichter, Cara McCarty, Zoe Annis Perkins, Daniel A. Reich, Joyce K. Schiller, Jeremy Strick, Elizabeth J. Vallance, and Charles Wylie from The Saint Louis Art Museum. We thank Tim Thayer, whose photography of all the three-dimensional works of art greatly enhances this catalogue.

The Carnegie Museum of Art in Pittsburgh accepted responsibility for preparing an interpretive video to be used at all five venues. Marilyn Russell, curator of education, worked with her colleagues at all five museums to produce the engaging video. Special thanks to the production company Schwartz & Associates in St. Louis, whose in-kind contributions helped to make the video possible. The Carnegie also provided their chief conservator William Real to attend to conservation of works of art in the exhibition.

The complex arrangements of transportation and insurance fell to The Toledo Museum of Art. The final list of works that would travel from five cities and range in scale from a tiny silver caviar server to monumental steel sculpture, from fragile Civil War photographs to huge modern canvases presented more than the usual complexities of packing, shipping, and protecting. Patricia Whitesides, registrar, and Steven J. Nowak, associate registrar, ably coordinated those efforts. They were supported throughout by their colleagues Cindy Cart, associate registrar in Kansas City; Nick Ohlman, registrar, and Jeanette Fausz, assistant registrar, in St. Louis; Cathy Ricciardelli, registrar, and Peggy Tolbert, associate registrar, in Minneapolis; and Cheryl Saunders, registrar, and Monika Tomko, associate registrar, in Pittsburgh. Toledo also took on the task of developing special merchandise related to the works of art in the exhibition. Crist Bursa, Toledo's manager of museum store merchandising, commissioned the appealing selection of posters, notecards, T-shirts, calendars, and puzzles that are available in each of our museum shops.

The Nelson-Atkins Museum in Kansas City volunteered to handle both the national fundraising efforts and the national publicity campaign. Michael Churchman, director of development, and Mary Ellen Young, development assistant, negotiated the approaches for corporate and government support. Gina Kelley, public information officer, Nancy Nowiszewski, project assistant, and Margaret Keough, information assistant, oversaw the promotional materials and supervised the media communications.

We are especially grateful to the consortium coordinators at each of the museums: Sarah Nichols from the Carnegie; Sidney M. Goldstein in St. Louis; Kathryn C. Johnson in Minneapolis; Margaret Conrads in Kansas City; and Lawrence W. Nichols in Toledo. They

successfully maintained a network for the distribution and collection of information that ranged from the uplifting to the banal.

Neither the exhibition nor the book could have come to fruition without the early efforts of Henry Adams, former curator of American Art at The Nelson-Atkins Museum of Art, and Michael E. Shapiro, former curator of 19th and 20th century art at The Saint Louis Art Museum. Together with Kathryn Johnson, they formed the curatorial team that selected the works of art you see here and articulated the vision that frames them. Sarah Nichols, curator of decorative arts at The Carnegie Museum of Art, coordinated the selection of the many pieces of furniture, glass, ceramics, and metalwork. The quality and range of those objects confirm the wisdom of our long-debated decision to include decorative arts in the exhibition. Thanks to James D. Burke and Olivia Lahs-Gonzales of The Saint Louis Art Museum, who selected the photographs for the exhibition, there is an admirable representation of that medium and an interesting approach to some of the important issues of American history and culture.

The exhibition is supported in part by a grant from the National Endowment for the Arts, a federal agency. Additional funding has been provided by a grant from the John S. and James L. Knight Foundation.

Our final and heartfelt thanks are directed to the citizens of our five communities. We recognize that they are the primary underwriters of this project. While we are mindful of the financial and moral support we receive in the daily operations of our museums, we are pleased to be able to acknowledge the people of our communities for enabling us to proceed with so large and important an undertaking.

Ancient America

The American continent was first settled about 50,000 years ago, when people came from the plains of Siberia across the narrow Bering Strait into what is now northern Alaska. By 10,000 to 8000 B.C., descendants of those immigrants had slowly but steadily moved across both North and South America, living as nomadic hunters and travelling in small family-related bands. By about 2000 B.C. people had begun farming; this in turn led to the earliest permanent homes and villages, which developed into many of the complex cultures whose artistic record we enjoy and learn from today. Descendants of these first Americans still live in ancestral areas, where they continue the ancient ways of their people through lifestyle, religion, and art.

The high desert areas of the Southwest and the woodlands of the Southeast have sustained a long cultural history that includes the most complex of the ancient American societies. The cultures of the Southwest developed over thousands of years; their most intense period of cultural growth extended from about A.D. 500 to 1000. Most people lived in small farming villages of five to ten extended families, but some settlements grew into towns of over 1,500 people. These communities were connected by organized systems of trade that moved farm produce, woven cloth, pottery, and other trade goods over hundreds of miles. In some cases their trade systems reached as far west as the Pacific coast, south into Mexico, and northeast to the great cultures of the Great Lakes and Woodlands.

By A.D. 1200 the three great cultural complexes of the Southwest—the Anasazi in northern Arizona and New Mexico, the Mogollon in the central and southeastern sections of that area, and the Hohokam of southern Arizona—consisted of hundreds of distinct groups that can be identified by the materials, shapes, and decoration of their pottery. Ceramics were painted or incised with both abstract and representational designs. The most common were bold geometric patterns whose vocabulary of curved lines, spirals, angled zigzags, and

steps were organized into repeated series and expertly integrated with the shapes of the vessels they decorated. The patterns generally referred to natural phenomena such as clouds, lightning, rain, and sun, which are associated with the water and growth essential to the survival of a society based on agriculture.

Around the same time in the southeastern area of the North American continent, a growing population of hunters, gatherers, and farmers was developing its own sophisticated system of interrelated cities and cultural groups. These large, complex societies were led by priests, warriors, and hereditary rulers who governed urban centers larger than most contemporary European cities. Substantial 13th-century cities in what are now Moundville, Alabama; Etowah, Georgia; Cahokia, Illinois; and Spiro, Oklahoma, were the administrative, social, and ceremonial centers of an extended complex of farming villages that were bound by social ties, religion, military power, trade, and even taxation. Their sophisticated traditions of large-scale earthen architecture, stone and wood sculpture, and ceramics demonstrate a highly developed sense of form, design, and personal expression.

Ancient American people incorporated art into every aspect of their daily lives. They relied on the power of visual communication as a prime element in ceremonial traditions to express their intimate connections with the sacred forces that motivated the world. Art was made in a variety of forms and of many materials, including paintings and engravings on walls, sculpture in wood and stone, ceremonial objects, masks, garments, and ceramic vessels. Because of the organic and fragile nature of the materials used in many of these art forms and the relative permanence of fired clay, pottery has come to serve as the most complete record of the great diversity and strength of ancient American artistic traditions.

One of the most important forms of artistic expression for ancient people was personal adornment. Body painting was considered a primary medium for expression. Clothing made of preserved animal hides or woven from cotton and other fibers was often decorated with painted and woven patterns or symbolic designs created with beadwork and shells. Necklaces, bracelets, and ornaments made of bone, shell, freshwater pearls, seeds, and metals were commonly worn by men and women of all ages.

The arts of the ancient Americans can help us to understand the richness of cultures that flourished long before the European immigration to the Western hemisphere. Recognition of this historical record of the social, spiritual, and artistic traditions of ancient American people allows us to reexamine the long history and complex cultural environment of our nation.

EVAN M. MAURER

Bowl

about 1000–1200

Mogollon, Mimbres, New Mexico
Earthenware, pigments
9 inches diameter
The Saint Louis Art Museum
Purchase, 113:1944

This bowl features the image of a bat whose wings are decorated with geometric designs that are similar to those on the border. The artist's concern for design was allied with a faithful attention to natural details such as the claws, teeth, and tail of the animal.

The Mimbres were part of the Mogollon cultural group in the southern part of present-day New Mexico who, from A.D. 1000 to about 1200, produced the finest works of representational imagery in the ancient Southwest. Their small to medium-sized ceramic bowls usually have an inner surface painted white and then covered with geometric designs and drawings in black or red. In addition to their interest in depicting life from the natural world, such as mammals, birds, fish, insects, and plants, the Mimbres artists often represented humans in activities of war, hunting, and ritual. These vital representations were often included in burial sites. EMM

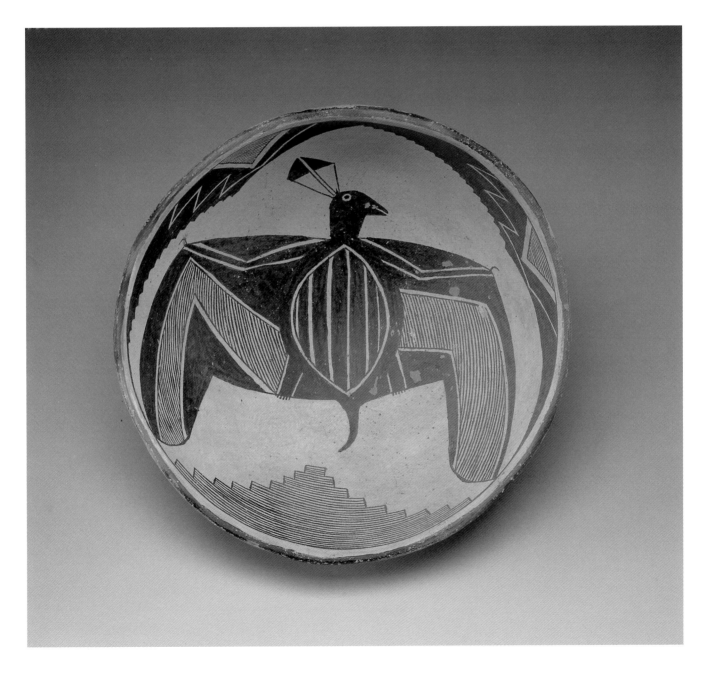

Storage Jar

about 1050–1250

Anasazi, Tularosa, Arizona or New Mexico
Earthenware, pigments
14⅜ inches high
The Saint Louis Art Museum
Purchase: Funds given by the Children's Art Festival, 172:1981

This narrow-necked storage jar was shaped from coils of clay that were worked into a thin-walled, smooth-surfaced vessel. The vessel was then covered with white paint, burnished, and finally painted with black geometric designs. Tularosa artists were known for their mastery of two basic symbolic designs still used by Pueblo artists today: the angled step design that refers to clouds and therefore rain; and the spiral that alludes to natural growth and creative energy.

The Tularosa villages were located in the southern Anasazi area around the Little Colorado River. By A.D. 1100 many of these small southwestern farming communities had grown into large multistoried, enclosed towns, with different buildings for food storage, living space, and ceremonial activities. Ceramic vessels and animal sculptures were the finest of the arts made by the people of these communities. They produced a variety of bowls, jars, and ladles that were used in daily life as well as in important ceremonial occasions, including burials. EMM

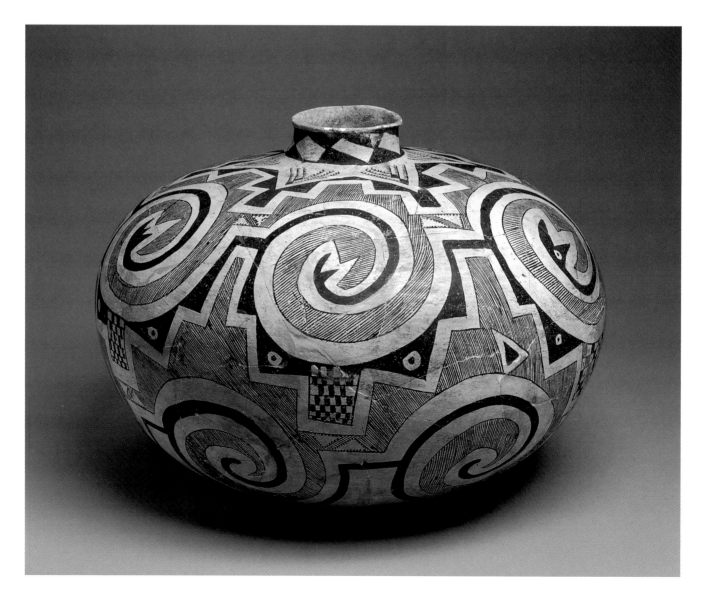

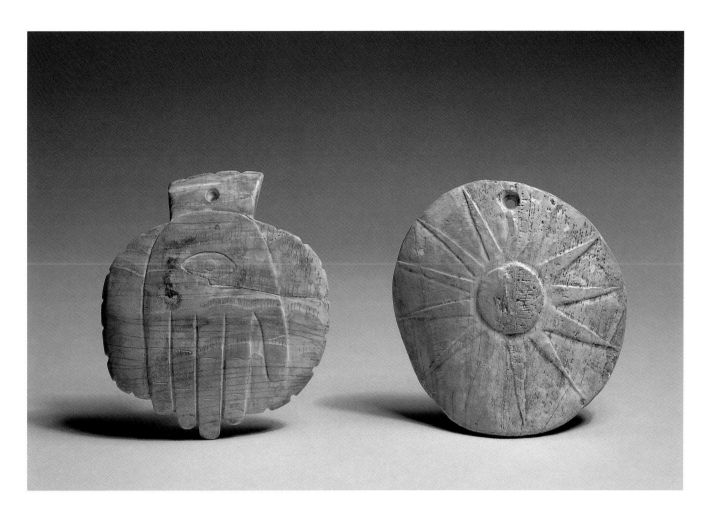

Gorgets

about 1200–1350

Caddoan, Spiro Site, Oklahoma
Shell
Sun: 4 inches diameter
Hand and Eye: 4¼ inches diameter
The Minneapolis Institute of Arts
The William Hood Dunwoody Fund,
91.37.1, 2

These gorgets, pendants worn around the neck, display two of the most important symbols in Native American culture. The human hand, often embellished with the image of an eye, is a motif common to southeastern ritual objects from ceramics to jewelry. In many Native American cultures the hand is the ultimate symbol of a human being and the individual's ability to affect the world. The other gorget is engraved with a multirayed sun, which is universally recognized as a primal creative force. The twelve rays emanating from the disk may refer to the cycle of lunar months and the seasonal position of the sun in the sky.

Such shell pendants were worn by high-ranking warriors, priests, and political leaders in many ancient southeastern cultures. By the 1200s these communities participated in an extensive system of trade and communication and had developed a body of ritual symbols that were used from Georgia in the east to the Spiro Site in Oklahoma in the west. EMM

Vessel

about 1200–1700

Caddoan, Hodges, Arkansas
Ceramic
7 1/16 inches high
The Minneapolis Institute of Arts
The Ethel Morrison Van Derlip Fund,
89.17

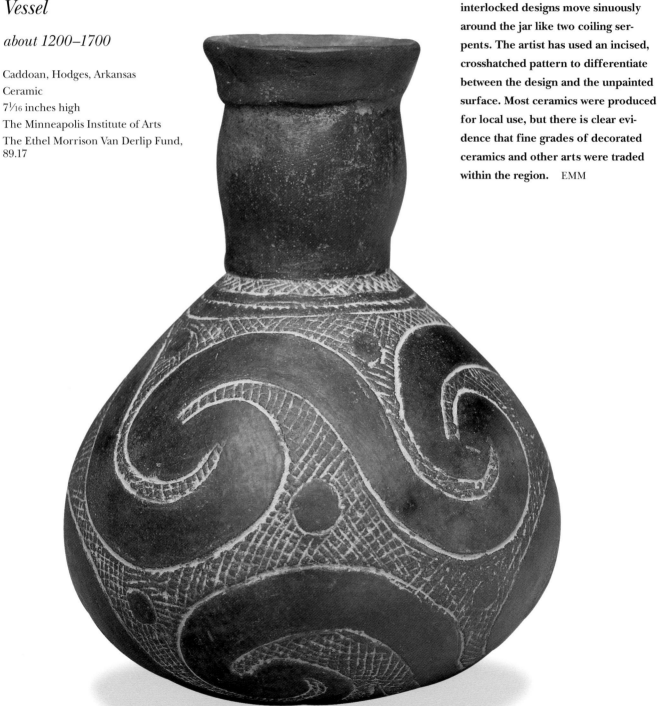

The cultures of the eastern woodlands inhabited a huge area from the Gulf Coast to the Great Lakes, and from the Missouri River to the Atlantic Ocean. Large areas of the southwestern section of the woodlands were occupied by the Caddoan peoples, who produced a sophisticated tradition of ceramic vessels decorated with engraved and painted designs.

This tall-necked jar is a type commonly found in sites located in present-day Arkansas. Its broadly curving, interlocked designs move sinuously around the jar like two coiling serpents. The artist has used an incised, crosshatched pattern to differentiate between the design and the unpainted surface. Most ceramics were produced for local use, but there is clear evidence that fine grades of decorated ceramics and other arts were traded within the region. EMM

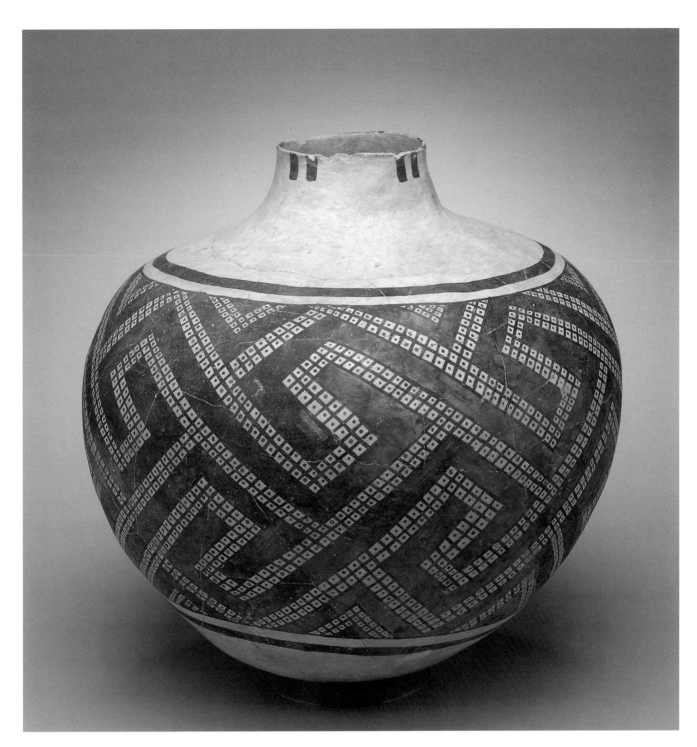

Storage Jar

about 1260–1300

Anasazi, Kayenta, northern Arizona
Ceramic, pigments
18 inches diameter
The Minneapolis Institute of Arts
The Putnam Dana McMillan Fund,
90.106

This Kayenta jar is part of the southwestern ceramic tradition that usually features black designs on white or red backgrounds. The beautifully shaped, full, round form of this example is painted in a unique Kayenta style of decoration that leaves small areas of white to create the design against large areas of black. The interlocked step design is found in many ceramic styles and in woven textiles as well.

The Kayenta were groups of Anasazi people who farmed in the San Juan River area in what is now northern Arizona and southern Utah. They developed a tradition of highly sophisticated ceramic forms and designs that extended the range of aesthetic choices available to the artist. EMM

Bowl

about 1400–1625

Anasazi, Sikyatki, northern Arizona
Ceramic, pigments
10 inches diameter
The Minneapolis Institute of Arts
The Ethel Morrison Van Derlip Fund,
90.50.1

Sikyatki (Yellow House) is the name given to the early Hopi Pueblo that was destroyed during interclan hostilities in 1625. Sikyatki ceramics can be distinguished by their thin-walled, smoothly burnished, yellow-tan surfaces and by their elaborately painted designs in shades of red, brown, and black. The dark, oblong form placed just off-center in this bowl probably represents a prayer stick *(paho)* decorated with two painted and clipped feathers and a bear paw. The dynamically curved shapes that end in a spiral are references to long, curving feathers used in religious ceremonies. Much of the pottery made by contemporary Hopi ceramists is based on designs inspired by the artists of Sikyatki.

In the late Anasazi period, between A.D. 1400 and 1650, the scattered Pueblo farming communities experienced the new pressures of a changing environment, population growth, and territorial challenges from rival groups. The most successful of these groups, such as the Hopi of northern Arizona, still live in their ancient villages, some of which have been continuously occupied since A.D. 1100. They are the oldest surviving communities in North America. EMM

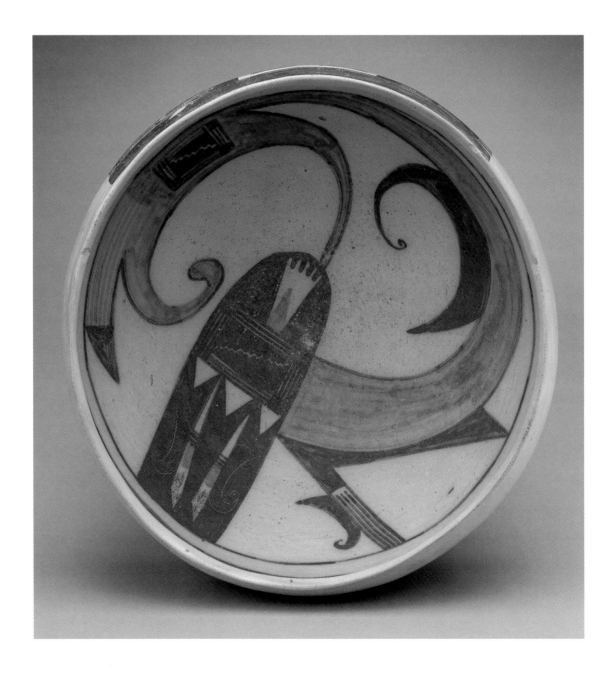

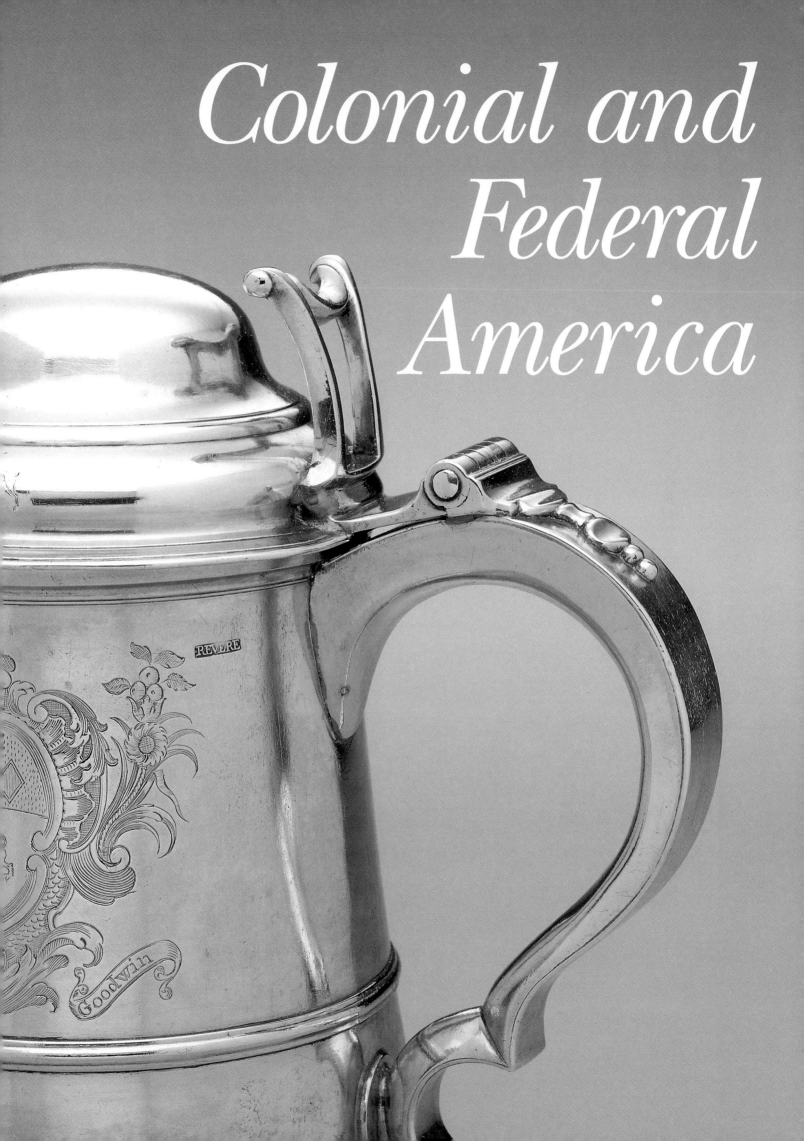

Colonial and Federal America

A small band of men and women established the first English settlement on the North American continent at Jamestown, Virginia, in 1607. Thirteen years later the *Mayflower* set sail from England and deposited its Puritan passengers several hundred miles north of Jamestown to found the Plymouth Colony in Massachusetts. And proceeding as if the land were not inhabited by several million Native Americans and as if cultures of long-standing tradition had not already developed civilizations and territorial rights, a steady stream of reformers, adventurers, explorers, settlers, and opportunists followed to claim the land, colonize the territories, and take possession of the resources of this vast continent.

The English were not the only ones to see the Americas as an answer to problems of overcrowding, religious persecution, disastrous inheritance laws, and economies ruined by prolonged wars. Other 17th-century immigrants came from Holland, Germany, Spain, and France, and they settled in New Amsterdam (later New York), Pennsylvania, New Mexico and Texas, and Canada and, later, the Mississippi River valley, respectively.

Each group sought to transfer its entire culture to the New World, thus beginning a period of Eurocentric domination of American culture—not only along the Eastern Seaboard but also along the frontier that was being pushed ever westward by the press of the white population. Native peoples were considered the *other*, characterized as wild and barbarous, as opposed to civilized and Christian. They were to be exterminated or, at the very least, subjugated, and their cultures were not assimilated by the new settlers. But, unlike the Europeans, native peoples, often with flair and openness, appropriated European techniques and materials for use in their own arts and crafts.

The 17th-century settlers succeeded in establishing a stable and cultivated society in prosperous, fashion-conscious, comfortable urban centers, where skilled craftspeople and willing patrons came

together, and the arts of the architect, painter, engraver, cabinet-maker, carver, and silversmith could flourish. For more than 150 years the thirteen colonies remained totally dependent politically and economically and, as a consequence, artistically, on Britain. Luxury goods such as fine ceramics, glass, and textiles could be imported only from England. Britain viewed the American colonies as an exclusive market for her own exports and therefore discouraged investment in industries that competed with her own. The Revolution, of course, loosened the political chains that had bound the Atlantic community to Britain, although ties of kinship, economics, and a common language made complete disassociation impossible.

Even in the colonial period, when artists and craftspeople still considered themselves part of the British realm, works made in America were often executed with different materials, processes, and stylistic variations. Urban centers such as Philadelphia, Boston, New York, and Charleston were dominant forces in politics and the arts, and each developed its own regional style. These distinctive regional styles evolved according to the tastes of the local affluent patrons, social customs and economic status of the community, the range of raw materials available, the mix of native-born and immigrant crafts-people, and access to the pattern books and works of art imported from England. In this melting pot of different influences, American artists made uniquely American things.

The colonial and federal periods were dominated by two artistic styles that were conveniently and symbolically separated by the Revolution. The Rococo style was characterized by exuberant detail, elegance, and asymmetrical design; its antithesis, Neoclassicism, celebrated the intellect, truth, order, and rationality. Neoclassicism was more than a passing fashion. It had an ideological base. In 1811 the architect Benjamin Henry Latrobe pointed out that in ancient Greece "perfection in the arts, freedom in government, and virtue in private life, were contemporaneous." By emulating classical cultures and proclaiming the importance of the arts to the well-being and integrity of the nation, the new republic could aspire to take its place among the great civilizations of the world.

Identification with the cultures of Greece and Rome not only affirmed the importance of the arts, it inspired stylistic choices as well. As the dominant style of American art after the Revolutionary War, Neoclassical art recalled the themes, forms, and proportions of ancient Greek and Roman art and architecture. Seen in the design of public buildings, furniture, clothing, tableware, metalwork, and much more, Neoclassicism addressed itself to the civic ideals of the ancient world.

The cultures of Greece and Rome also taught that ruin follows close on the heels of decline in patriotism and morals. To prevent such a decline and fall, America needed American heroes. George Washington was the ideal role model, and after his death in 1799 he became the symbol of the new Republic. The painter Gilbert Stuart and his daughter Jane functioned as a virtual factory for the production of George Washington portraits destined for walls in countless statehouses, libraries, and courtrooms. Washington's image proliferated across America in sculpture and engravings that were then reproduced on ceramics and textiles as well as on paper. The emerg-

ing middle class could pay homage to America's founding father in the very furnishings of their homes.

The cult of Washington was part of the quest for a national identity that was growing in the arts as in every other aspect of the new American society. Prior to the Revolution, artists in America had felt isolated from the mainstream and often sought their inspiration from England. John Singleton Copley, for example, believed that proper artistic training was only available in Europe, so in 1774, spurred by the uneasy political situation, he abandoned a successful career in America and left for London. But in the new Republic, it was hoped that artists would no longer need to leave their homeland for training, fame, or fortune. The arts on the North American continent were making a leap toward independence.

SARAH NICHOLS

JOHN GREENWOOD
1727–1792

Sea Captains Carousing in Surinam, 1758

Oil on bed ticking
37⅜ x 75¼ inches
The Saint Louis Art Museum
Purchase, 256:1948

In the mid-18th century, the Boston-born artist John Greenwood lived for a time in the South American colony of Surinam, an important Dutch port on the maritime trade route between the West Indies and the Americas. While in Surinam Greenwood created this picture, which is believed to be the first genre painting (that is, a scene of everyday life) made in the Americas.

Sea Captains Carousing in Surinam is an informal group portrait of the artist's rowdy friends enjoying themselves in a foreign port. Captain Ambrose Page is vomiting into the coat pocket of Mr. Jonas Wanton of Newport, Rhode Island. Seated nearby is Captain Nicholas Cooke, the future governor of Rhode Island, wearing a broad hat and smoking a long pipe. Cooke talks with Captain Esek Hopkins, who sports a cocked hat and holds a wineglass. Captain Hopkins will later be commander in chief of the Continental Navy. His brother Stephen Hopkins, then governor of Rhode Island and a future signer of the Declaration of Independence, is dousing Jonas Wanton with rum. Greenwood painted himself vomiting in the doorway in the background of the painting. JKS

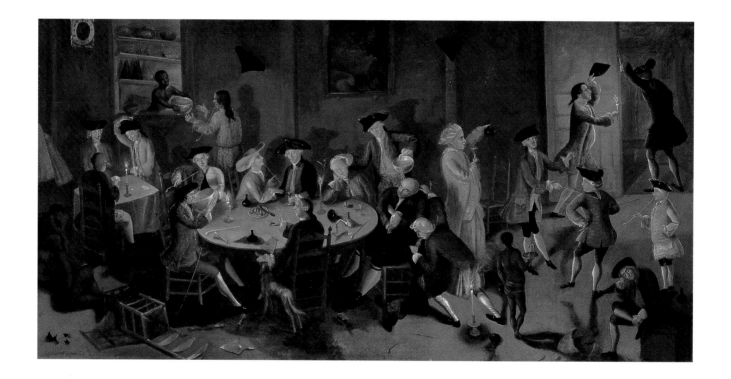

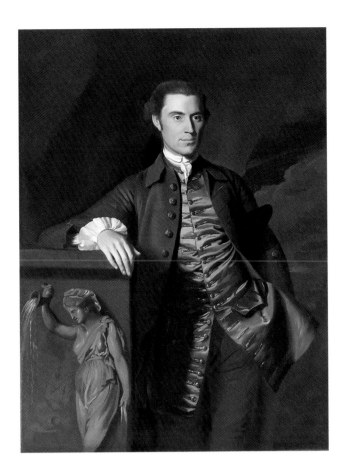 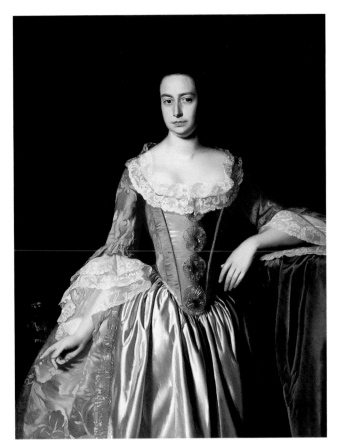

JOHN SINGLETON COPLEY
1738–1815

Thaddeus Burr, 1758–60

Oil on canvas
50⅝ x 39⅞ inches
The Saint Louis Art Museum
Purchase, 174:1951

Eunice Dennie Burr,
1758–60

Oil on canvas
49¾ x 39⅜ inches
The Saint Louis Art Museum
Purchase, 173:1951

In 1759 Thaddeus Burr, second cousin of the notorious Aaron Burr and a future delegate to the Connecticut Convention that would ratify the Constitution, married Eunice Dennie of Fairfield, Connecticut, in the Boston home of their friend John Hancock. These portraits of the Burrs were painted by John Singleton Copley, a neighbor of Hancock's. The couple stayed with the Hancocks while they were sitting for Copley.

The two paintings appear to show the couple leaning on either side of the same block of carved stone: Eunice's arm rests on a drape of cloth that obscures the face of the stone, while Thaddeus's fingers grip the opposite corner above a classical figure, perhaps a reference to his education.

Eunice's right hand is extended toward a small parrot, whose exotic nature alludes to wealth. The greenish tint of Eunice's face is a result of the green underpaint (now showing through) that artists sometimes use to create shadows within the flesh tones. JKS

Dressing Table

about 1760–80

Philadelphia
Mahogany, white pine
31 inches high
The Minneapolis Institute of Arts
Gift of James F. and Louise H. Bell in
memory of James S. and Sallie M. Bell,
31.21

The dressing table and the tall chest of drawers that usually accompanied it were often the most elaborate pieces of furniture in the well-to-do colonial home. The floral carvings on the quarter columns and delicately twisted molding around the top of this table are of exceptional quality. The cross-hatching on the legs, usually left blank, and the carved sides, almost always plain, suggest that the cabinet might have been made by Benjamin Randolph, who had an important workshop in Philadelphia during the 1760s.

The form of the dressing table, as well as its carved decoration, was adapted by American craftsmen from English designs. Benjamin Randolph was known to have employed carvers who had emigrated from England, and he was surely aware of the expanded third edition of Thomas Chippendale's *Gentleman and Cabinetmaker's Directory.* First published in 1754, it was an influential source for designs in the Rococo style, characterized by carved shell shapes, C scrolls, floral motifs, and asymmetrical designs. This style of carving was especially popular in Philadelphia. JAN and WBR

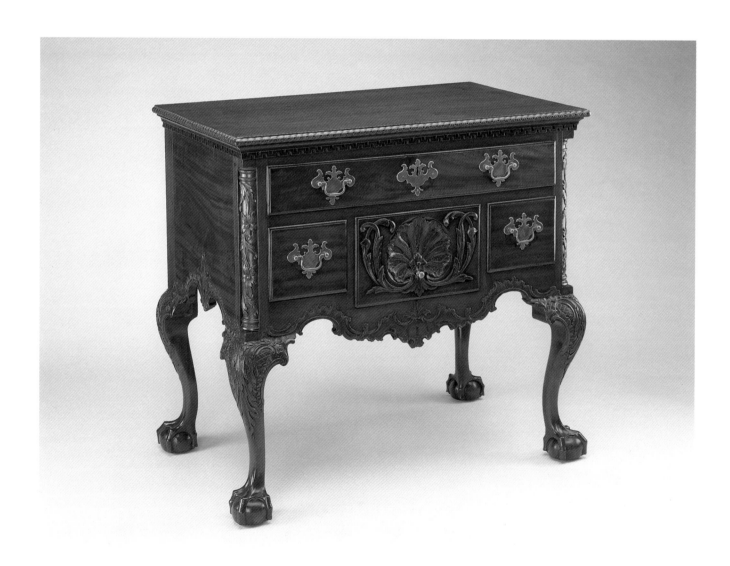

Chest-on-Chest

about 1765–80

Philadelphia
Mahogany, pine, poplar, brass
92½ inches high
The Carnegie Museum of Art
Purchase: Richard King Mellon
Foundation Grant, 74.45

The central basket finial shown here was generously loaned by the Philadelphia Museum of Art from a chest-on-chest in its collection.

Martha Powell, a wealthy Philadelphian who lived in the same house on Third Street for eighty-five years, was the original owner of this magnificent chest-on-chest made of dramatically colored wood; it retains its original hardware. In 1827 Martha Powell bequeathed the

"Mahogany Chest of Drawers in my Front Room" to Jane Bettle, the wife of "her esteemed relation" and executor, Samuel Bettle, with whose family the chest remained until 1974.

There were a number of excellent cabinetmaking shops in Philadelphia, many of which made versions of the chest-on-chest. By Philadelphia standards, where Rococo carving was acknowledged to exhibit "a spirit of dazzling excess," this chest-on-chest appears restrained in both form and decoration. However, the use of Chinese fretwork in the hardware, the flame finials, the central basket finial, and the richly carved rosettes at the end of the broken pediment all point to the Rococo style. The height of these chests made the use of the top drawers difficult but certainly helped create an impression of wealth. SN

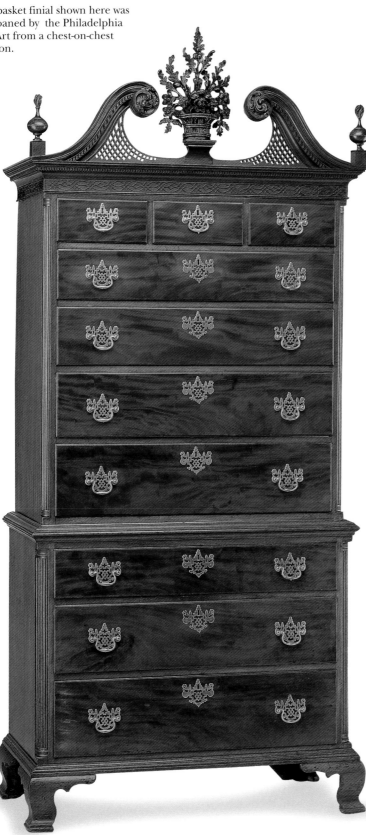

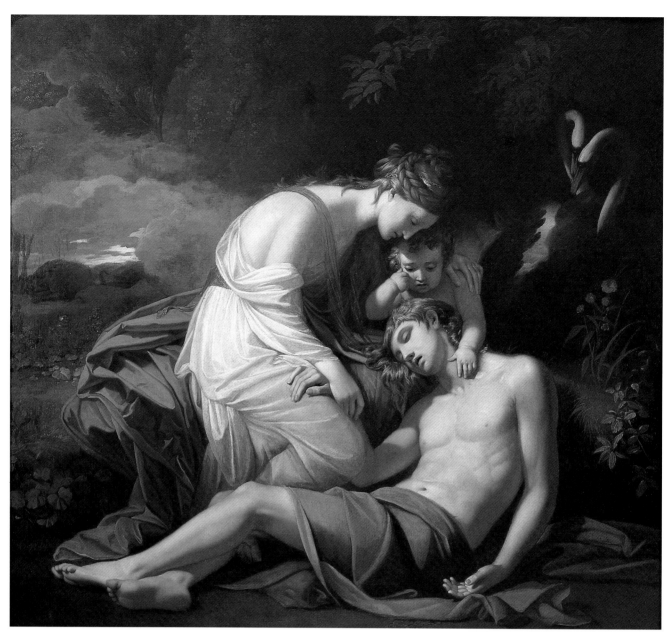

BENJAMIN WEST
1738–1820

*Venus Lamenting the
Death of Adonis,* 1768
(retouched in 1819)

Oil on canvas
64 x 69½ inches
The Carnegie Museum of Art
Purchase, 11.2

This elegant painting presents the myth of Venus and Adonis as recounted in the classical text of Ovid's *Metamorphoses*, a standard Roman source for artists since the Middle Ages. The story tells of the goddess Venus, accidentally scratched by one of Cupid's arrows, who falls in love with a human, Adonis. Heedless of her warnings, Adonis hunts a dangerous wild boar and is mortally wounded. Bereft, Venus then transforms her lover's dripping blood into the brilliant red anemones that can be seen near the right edge of the painting. West's composition deliberately echoes a mourning theme from Christian art: the Virgin grieving over the body of the dead Christ.

Benjamin West was a pioneer of the Neoclassical style, which favored subjects from Greek and Roman myth and history. West was born in the American colonies, but left at the age of twenty-one to study painting in Rome and London. Ten years later, having made his home in England, he exhibited *Venus Lamenting the Death of Adonis* at the newly founded Royal Academy. Throughout the Revolutionary War and the War of 1812, West retained his American citizenship and his role of mentor to American artists; at the same time he rose to the peak of the British art world and was elected president of the Royal Academy in 1792. LWL

PAUL REVERE II
1735–1818

Tankard, 1769

Silver

8⅝ inches high

The Toledo Museum of Art

Purchased with funds from Mr. and Mrs. Robert J. Barber; Dr. and Mrs. Edward A. Kern; Mr. and Mrs. Stanley K. Levison; Mr. and Mrs. George P. MacNichol, Jr.; and the Florence Scott Libbey Bequest in Memory of her Father, Maurice A. Scott, 1988.43

Paul Revere is the most famous name in American silver, renowned for both his legendary patriotism and his outstanding work as a silversmith and an engraver. This tankard is listed on August 25, 1769, in Revere's daybooks as the commission of Captain Joseph Goodwin, whose richly engraved coat of arms and crest it bears. Goodwin, possibly captain of the sloop *Charming Molly*, was apparently an affluent patron, his name appearing frequently in Revere's ledgers. He, like other prosperous colonists, often converted spare capital into such visible symbols of material success.

Revere adhered to the standard form of a tall, one-handled drinking vessel that for centuries was popular for beer and cider. However, in order to accommodate its exceptional weight—at 44 ounces it was almost twice as heavy as most tankards of the time—Revere used a double-scrolled handle to balance the mass, while the open thumbpiece provided a sense of lightness. RB

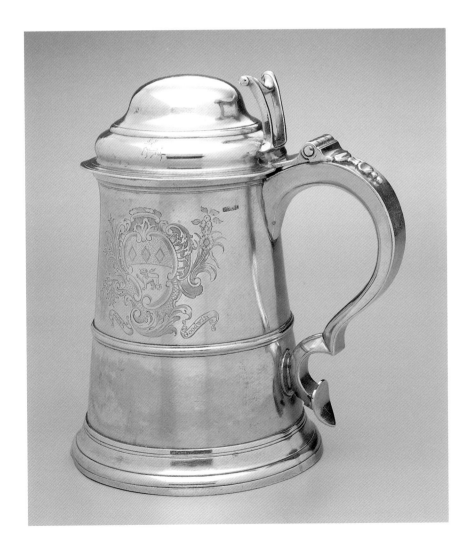

MYER MYERS
1723–1795

Tankard, about 1776–82

Silver
6⁹⁄₁₆ inches high
The Toledo Museum of Art
Gift of Mr. and Mrs. Stanley K. Levison,
1979.122

Myer Myers, a contemporary of Paul Revere, is noted both for his superior skills as a silversmith and for his unique position as early America's best-known Jewish silversmith. Although Myers spent most of his career in New York, he and his family, like many other patriotic Americans, left New York at the onset of the Revolution to escape British rule. From 1776 to 1782 he lived in Connecticut, for part of that time in the town of Stratford, which was also home to Daniel Shelton. Shelton's monogram is elegantly engraved on the cover of this tankard; his daughter Jane's initials were later placed on the handle in commemoration of her marriage in 1781.

Restrained elements of the Rococo style, which had been imported from England, are evident in the tankard's S-scroll handle, the scalloped front edge of the cover, and the delicately engraved monogram. RB

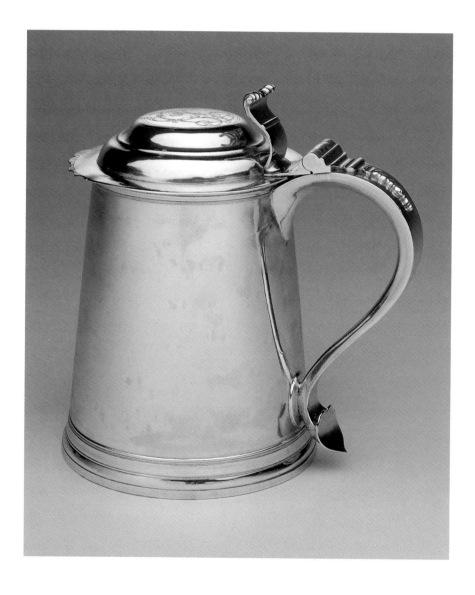

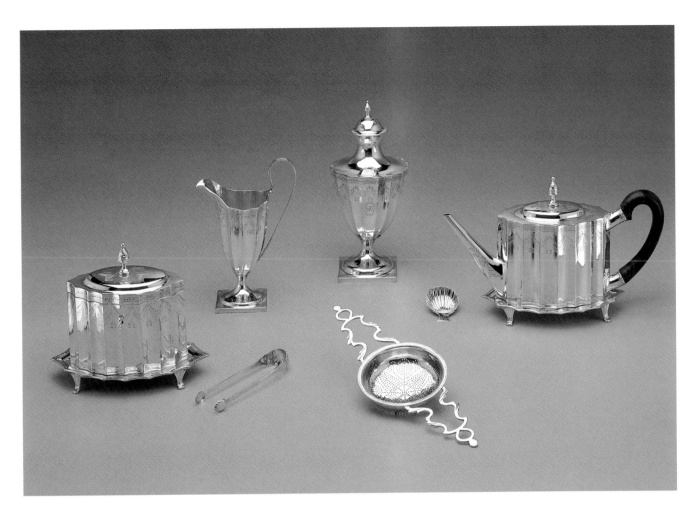

PAUL REVERE II
1735–1818

Tea Service, 1792–93

Silver
Teapot: 6⅛ inches high
The Minneapolis Institute of Arts
Gift of James F. and Louise H. Bell,
60.22.1–7

This set, commissioned in 1792 by John and Mehitabel Templeman of Boston, is the most complete of Paul Revere's tea services to survive. The teapot, sugar urn, and cream jug are typical components of such a service, but some of the other pieces are more unusual. An expensive commodity in early America, tea was often kept under lock and key in a tea caddy. The caddy in this set is one of two known tea caddies made by the Revere shop. The shell-shaped spoon, used to measure dry leaves into the pot, is the only one Revere is known to have made. The strainer was used to strain the wine punch that often accompanied tea at festive gatherings. The sugar tongs, although struck with Revere's mark, are a later addition to the service.

The teapot and tea caddy, with their vertical grooves (called flutes), look like portions of classical columns. Such references to Greek and Roman styles were popular in America after the Revolutionary War, as the citizens of the new nation looked to antiquity for models of democratic government. The cylindrical forms of the teapot and caddy were made from sheets of silver with lapped and riveted seams, a much less arduous process than raising, or hammering, a shape from a flat disk of silver, as was done for the cream jug and sugar urn. JAN and WBR

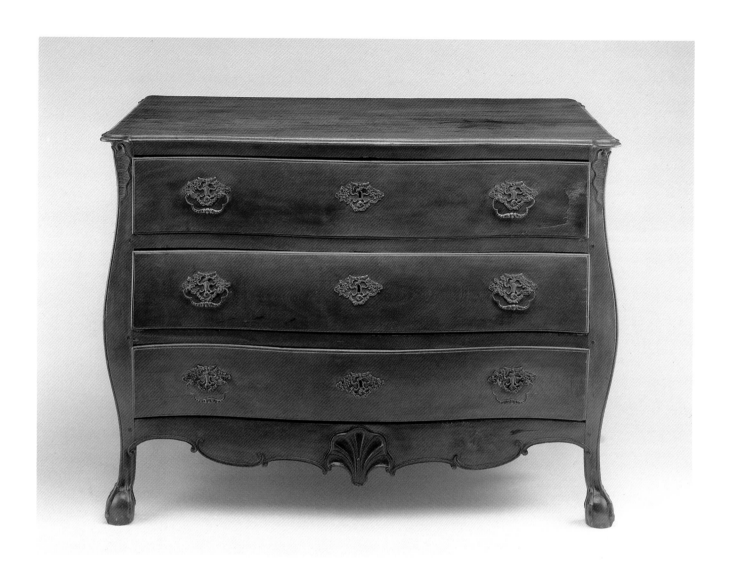

Commode

about 1800

Probably St. Louis, Missouri, or Vincennes, Indiana

Cherry, walnut, Atlantic cedar, white pine

39 inches high

The Minneapolis Institute of Arts

Gift of the Decorative Arts Council, 90.38a–d

This commode is a rare and refined piece of frontier furniture from the upper Mississippi River valley. Life on the frontier was rugged, and few families could afford, or had the interest, to commission fine furniture. Furniture making was often a sideline to the more lucrative and necessary undertaking of building houses. In the upper Mississippi River valley, furniture was strongly influenced by provincial French craft traditions that were brought by French and French-Canadian settlers driven from Canada by English territorial expansion. Far from the metropolitan style centers of both the French colonies in Canada and the English colonies on the East Coast, these settlers perpetuated the furniture styles of the 17th and early 18th centuries, when Canada was originally settled.

This commode is unusual in its combination of French and English elements. Although it was made about 1800, the swelled form of its front and sides is similar to French furniture of the 1730s, as are the C-scrolled carving of the apron and the carving of the upper corners in imitation of gilt-bronze mounts. However, the claw-and-ball feet are distinctly English and appeared frequently in Thomas Chippendale's fashionable furniture designs in the 1750s. The careful internal construction is also atypical of French cabinetmakers, especially the thinly cut and painstakingly dovetailed drawers that uphold English standards of craftsmanship. JAN and WBR

BENJAMIN HENRY LATROBE
1764–1820, designer
Probably Hugh Finlay and
John Finlay, Baltimore, makers

Klismos Chair, 1808

White oak, yellow poplar, white pine, cane, reproduction silk fabric
34½ inches high
The Saint Louis Art Museum
Purchase: Funds given by the Decorative Arts Society in honor of Charles E. Buckley, 217:1975.1

This chair comes from a large set of furniture that was designed by the architect Benjamin Henry Latrobe for William Waln, a wealthy Philadelphia merchant, and probably executed by the brothers Hugh and John Finlay of Baltimore, great proponents of painted, or "fancy," furniture. The chair's klismos form and classical decoration were probably inspired by the published designs of the Englishmen Thomas Hope and Thomas Sheraton, whose ideas reflected the period's preoccupation with ancient Greek, Roman, and Egyptian art. This chair is one of the most dramatic interpretations of a Grecian furniture form made in America, and its graceful, attenuated lines and delicate proportions attest to the high sophistication in furniture of the era. Owning classically inspired objects such as this, as well as ancient artifacts, was considered evidence of artistic cultivation and the virtuous lifestyle to which many Americans aspired. ML

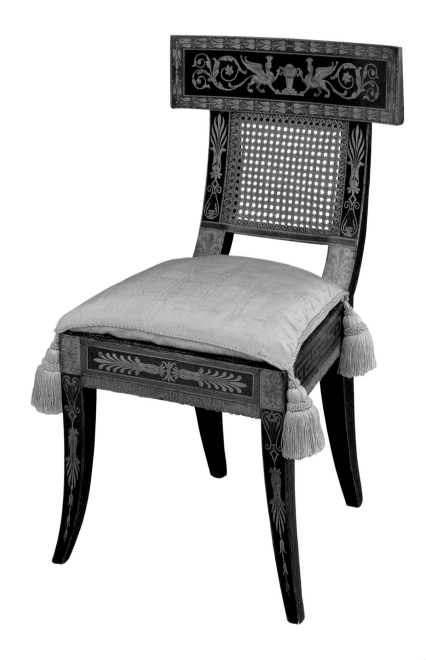

SAMUEL GRAGG
1772–1855

Side Chair, about 1808–15

Oak, maple, paint, gilding
33⅞ inches high
The Saint Louis Art Museum
Purchase: Funds given by the Decorative
Arts Society, 18:1979

One of the most sophisticated examples of American furniture from the early 19th century was an "elastic" chair patented in 1808 by Samuel Gragg. Its shape was derived from an ancient Greek chair form called klismos, and it was partially constructed of solid wooden rods that were bent by hand. Like much stylish and classically inspired furniture at the time, the chair was painted and decorated with such motifs as peacock feathers and acanthus leaves.

When they were first introduced, these chairs were advertised as "Patent CHAIRS and SETTEES, with elastic backs and bottoms made in a new, elegant and superior style of the best materials." The elastic characteristic implied a concern not only with comfort but also with new techniques of construction. By eliminating some traditional joinery and laborious hand carving through wood-bending techniques, this design foreshadowed the mass-produced furniture that would appear fifty years later. CM

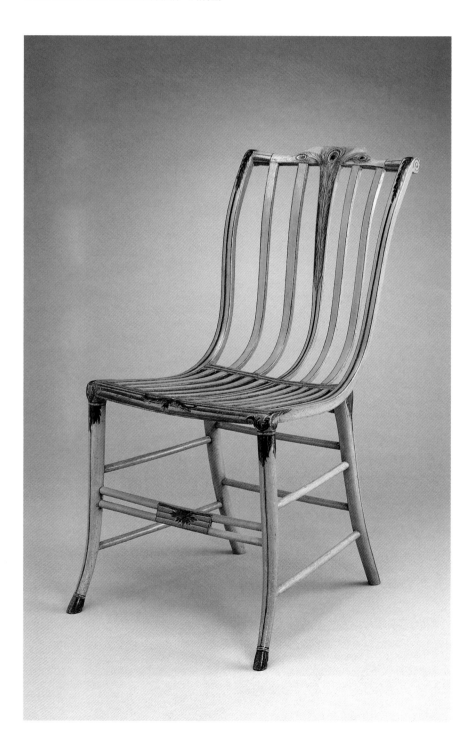

THOMAS SULLY
1783–1872

Portrait of George Washington, about 1820

Oil on canvas
94 x 60 inches
The Minneapolis Institute of Arts
The William Hood Dunwoody Fund,
32.12

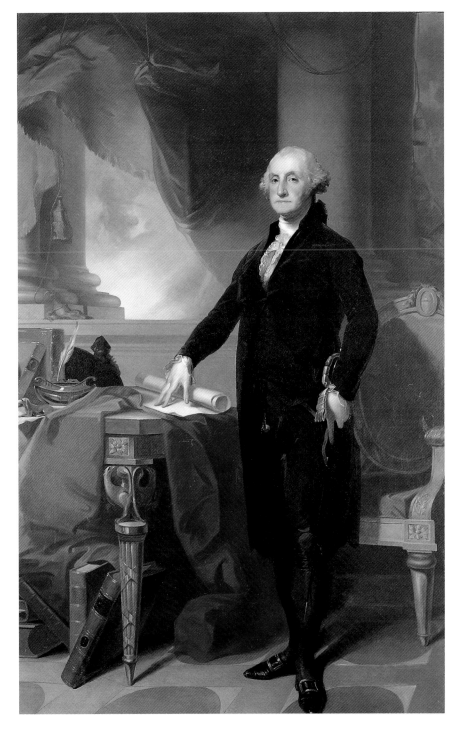

In 1807 the young Thomas Sully met Gilbert Stuart in Boston and received encouragement from the famous older portrait painter. This confirmed the direction that the young artist had sought to take: like Stuart and numerous members of the Peale family, the self-taught Sully in his turn would become a preeminent American portraitist.

Sully is known to have made many copies of Stuart's portraits of George Washington for various states, munici-palities, and historical societies, no doubt with Stuart's blessing, since the latter could not meet the astonishing demand for them. This painting is a copy of one of the most famous por-traits of Washington that Stuart painted between 1797 and 1800. Stuart's paint-ing now belongs to the New York Public Library.

This portrait emphasizes Washington's role as statesman— his right hand rests on a copy of the Constitution—while the sword alludes to his military heroism. The noble pose and low point of view, combined with the classical columns and grand drapery borrowed from 17th-century European portraiture, confer an aura of grandeur on the first president.

Sully closely copied Stuart's original, but his own style is still evident. The color is prettier; surfaces are more opaque and glossy; forms cast sharper shadows; and the head is more iconic, crisply modelled, and heroic. LA

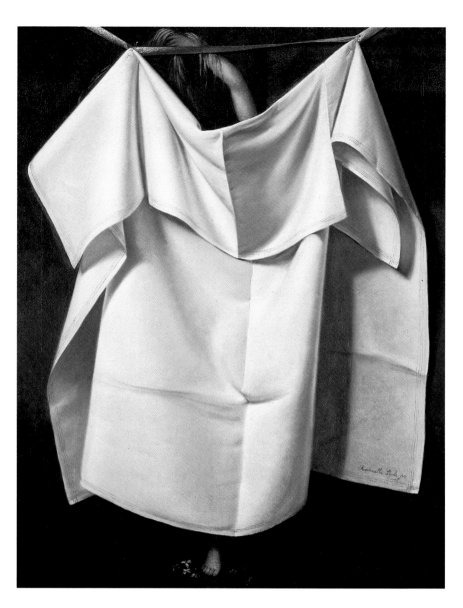

RAPHAELLE PEALE
1774–1825

Venus Rising from the Sea—A Deception,
1822

Oil on canvas
29¼ x 24⅛ inches
The Nelson-Atkins Museum of Art
Purchase: Nelson Trust, 34–147

I am very uneasy about Raphaelle," his father, Charles Willson Peale, once wrote, "blessed with great talents yet lost I fear by evil habits." These forebodings proved well founded, for Raphaelle's final years were filled with drunkenness, marital discord, and financial difficulties. He died at the age of fifty-one; yet before his demise, Raphaelle Peale earned a notable place in the history of American art. He was the first American painter to concentrate on still life.

Most of Peale's paintings are beautifully designed tabletop still lifes, showing fruit and other edibles. His masterpiece is arguably this humorous rendering of *Venus Rising from the Sea— A Deception.* Once mistakenly known as *After the Bath*, the painting does not represent an actual figure. Instead, it presents the illusion of a cloth cover-

ing the painting *Venus Rising from the Sea* by the British academic painter James Barry. Erotic paintings often were covered with curtains; Peale's design alludes to this fact, and also teases the viewer, since his painted curtain can never be lifted and the viewer's naughty urges are condemned to perpetual frustration.

Despite the originality and high quality of Peale's work, he never enjoyed commercial success. Shortly before his death, his chief means of support was writing humorous couplets that were placed in cakes by a Philadelphia baker. HA

Side Chair

about 1835

New York
Maple, brass, rush
32 inches high
The Carnegie Museum of Art
Bequest of Mary E. Schenley, 31.1.1

This chair was part of a suite of rosewood-grained and gilt furniture purchased in New York by the wealthy entrepreneur William Croghan for the magnificent house he built in Pittsburgh in the mid-1830s for his young daughter Mary. Painted furniture was extremely popular and fashionable in the early 19th century, and clearly Croghan wanted this house, which he named Picnic, and its furnishings to announce the family's wealth and position, not only to Pittsburgh but to the world at large.

Although this chair follows the popular Greek klismos form with its curving front and back legs and scroll back, it also incorporates Egyptian motifs with the cast-brass sphinx in the center of the back. The interest in Egypt was inspired by the illustrated publications following Napoleon's 1798 campaigns in the country and quickly spread from France to the rest of Europe and America.

The architectural decoration of Picnic was bold and impressive, combining Greek, Roman, and Egyptian influences. The suite of furniture to which this chair belonged obviously reflected its setting as well as America's fascination with ancient cultures. SN

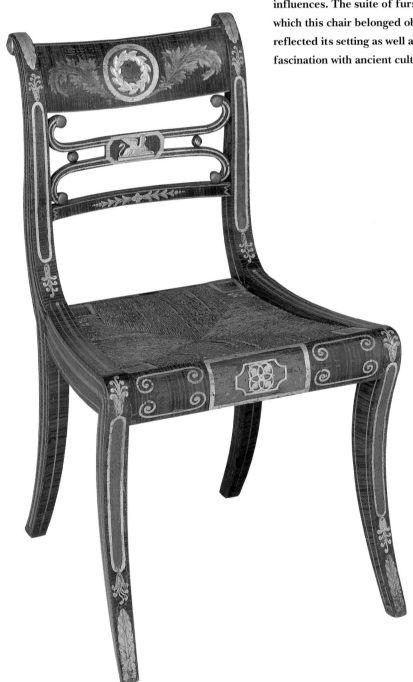

Democratic Vistas

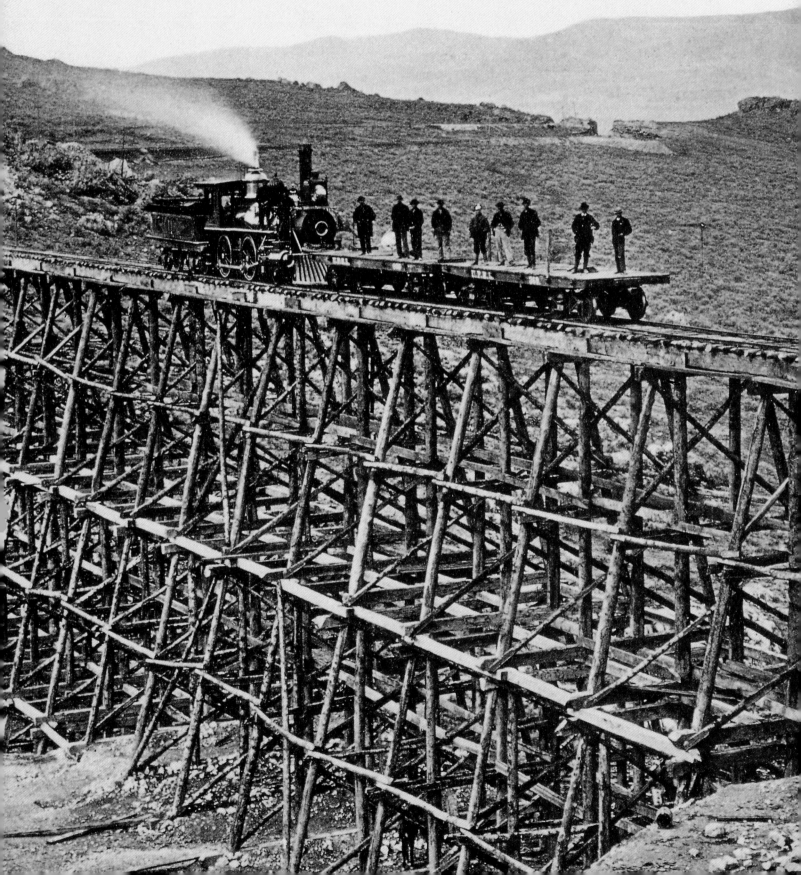

I n the January 1853 issue of *The Knickerbocker* magazine, a reviewer observed that landscape was the kind of painting most Americans preferred. "We find upon our walls a greater preponderance of landscapes," he noted. "They indicate the general taste and preference for this form of art.... There can be no doubt that there is a more genuine and sincere admiration of landscape painting in our country than for any other; and it is because it is more easily understood by even the most common minds."

Landscape painting no longer holds such unquestioned supremacy over other art forms. Why was landscape once so popular to the American audience and so graspable even to "common minds"? Why did it lose its dominance after the Civil War? The reasons for this rise and fall are complex, but surely a major factor was demographics. Through the 1860s America was still predominantly rural, and close to 80 percent of the population supported itself by farming. Thus, open land continued to be the primary source of wealth as well as the primary setting for both work and leisure activity. It is not altogether surprising that pictures of the land seemed more interesting to most people than those of any other subject.

The interest in land, in fact, was not simply an individual concern. For this was a period when the boundaries of the United States were rapidly expanding, as settlers of European descent relentlessly took over the domains of the Native American population and, within a few decades, had transformed their newly founded country from a slender strip of settlements along the Atlantic seacoast to a continental nation. In 1803 Jefferson made the Louisiana Purchase; in 1819 Florida was purchased from Spain; in 1836 Texas became independent from Mexico, and in 1845 it was admitted as a state; in 1848 the United States took from Mexico what are now California, Nevada, Utah, Colorado, Arizona, and New Mexico—a territory greater than the British Isles, France, and Italy combined.

Manufacturing and European luxury goods also moved westward at a rapid rate. In the 1790s, for example, Pittsburgh was still a fron-

tier fort, ringed by trees and hostile Indian tribes. Within twenty or thirty years it had become a center of glassmaking, iron production, and milling.

In short, from about 1800 through about 1850, land and the possession of the land were central issues of the national consciousness. Thomas Cole, whose conception of the wilderness was a metaphor for the limitless possibility of America, later came to be known as the founder of the Hudson River School of painting. Cole's career is neatly bracketed by two great events of western expansion. His work began to receive recognition in 1825, at the very moment when the Erie Canal opened up commerce to the center of the continent; he died in 1848, just as gold was being discovered in California, the event that extended Euro-American settlement to the farthest western edge of the continent.

Who purchased these landscapes of American scenes? While farmers may have appreciated them, it appears that they were mostly purchased by city dwellers—often men who had grown up on small farms, made their way to the city, and prospered. The archetype might be Luman Reed, a small-town boy who became a prosperous grocer in New York and who generously patronized Cole, Asher B. Durand, and other painters of the Hudson River School. Durand's famous "Letters to the Crayon," a central document of American landscape painting, contains a long passage describing the therapeutic effect of a beautiful landscape on the mind and soul, after a long day of urban toil. "To the rich merchant and capitalist," Durand noted, "Landscape Art especially appeals—nor does it appeal in vain.... Suppose such a one, on his return home, after the completion of his daily task of drudgery—his dinner partaken, and himself disposed of in his favorite arm-chair, with one or more faithful landscapes before him, and making no greater effort than to look into the picture instead of on it, so as to perceive what it represents; in proportion as it is true and faithful, many a fair vision of forgotten days will animate the canvas, and lead him through the scene: pleasant reminiscences and grateful emotions will spring up at every step, and care and anxiety will retire far behind him."

During the late 1850s and early 1860s, photography became a democratic alternative to painting. With the development of the glass-plate negative in the 1860s and the medium's ability to render minute detail, landscape photography soon became a popular form of representation. Carleton E. Watkins was one of the first practitioners to produce landscape photographs as art objects, exhibiting them in Salons and international expositions. After the Civil War, many of the renowned landscape and war photographers were commissioned by western survey expeditions, and they produced some of the most memorable images of the newly discovered western landscape. These expeditions employed many of the well-known photographers of the time, including Timothy O'Sullivan, and painters like Albert Bierstadt and Thomas Moran.

Next to landscape painting in artistic popularity came genre subjects. Here we see the national preoccupation with democracy, a new form of government with which to rule a nation. Americans boasted to foreigners and to each other that it was the best form of government ever devised. But privately, they may not have been so sure. For

democracy depends on the decisions not only of high-class, well-educated people but also of simple tradesmen, farmers, former slaves or, in the case of western painters such as George Caleb Bingham, the fur traders, boatmen, squatters, and raftsmen who lived along the river. Usually someone is misbehaving in these pictures—indulging in some activity that was considered a vice at the time, such as excessive drinking or playing cards. Despite their superficial optimism, many of these paintings seem to ask whether democracy could possibly work, given the crude nature of the common man.

This was certainly a question that occurred to foreign visitors, such as the young French aristocrat Alexis de Tocqueville or the English gentlewoman Frances Trollope. As Mrs. Trollope observed: "The theory of equality may be very daintily discussed by English gentlemen in a London dining-room, when the servant, having placed a fresh bottle of cool wine on the table, respectfully shuts the door and leaves them to their walnuts and their wisdom; but it will be found less palatable when it presents itself in the shape of a hard greasy paw, and is claimed in accents that breathe less of freedom than of onions and whiskey."

HENRY ADAMS

Footed Pitcher

1835–50

Probably New York State

Non-lead glass, blown and tooled with applied decoration

7¹¹⁄₁₆ inches high

The Toledo Museum of Art

Purchased with funds from the Libbey Endowment, Gift of Edward Drummond Libbey, 1959.73

This pitcher represents the culmination of the South Jersey style: its heavy walls are adorned with a superimposed layer of glass tooled into swirls and loops resembling lily pads. During the early 19th century, American glasshouses focused on the production of window glass and utilitarian vessels. With abundant raw materials, southern New Jersey became a glassmaking center. A type of functional, blown glassware emerged that is characterized by thick walls; they were often plain but sometimes they were decorated with applied hot glass in the form of trailed threads, blobs with impressed patterns, leaf-shaped swirls, or crimped feet and handles.

The movement of glassworkers from one employer to another took this style to glasshouses in New York State and parts of New England. In the 1920s such glassware was named "South Jersey," although pieces cannot be firmly identified with specific glasshouses from that locale. The high quality of the workmanship and design suggests that this pitcher probably came from a New York State glasshouse. DST

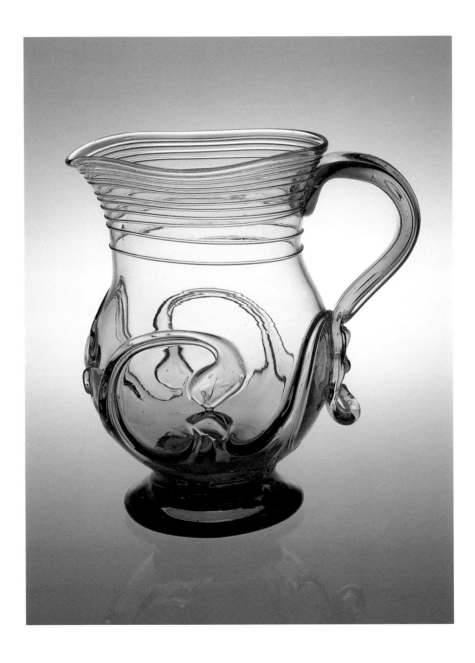

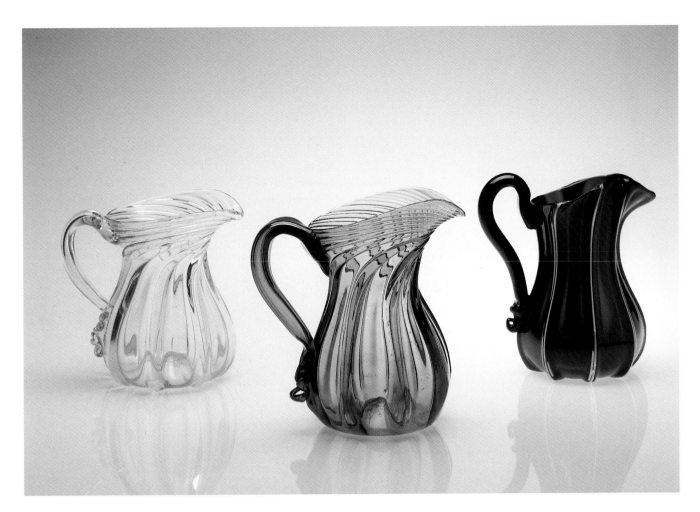

Three Pitchers

about 1840–70

Pittsburgh
Glass
Heights range from 7½ to 8½ inches
The Saint Louis Art Museum
Bequest of Christine Graham Long,
416:1961
The Carnegie Museum of Art
Gift of the Pittsburgh Early American
Glass Club, 50.4.3
The Toledo Museum of Art
Purchased with funds from the Libbey
Endowment, Gift of Edward Drummond
Libbey, 1984.27

In 1825 Pittsburgh was lauded as "the unrivalled domicile of manufacturing skill and ingenuity, and a grand emporium of internal commerce." Glassmaking was one of the earliest and most ingenious of the industries established in Pittsburgh, which was perfectly located, owing to river and canal transportation, to service glass markets from Maine to New Orleans.

Glass tablewares for the commercial market were made by blowing glass into full-size molds patterned with sweeping ribs typical of the Rococo Revival style popular in the mid-19th century. Such pillar-molded wares were known as "riverboat glass" because their sturdiness and low production costs made them ideal pieces to outfit early paddle wheelers servicing the Ohio and Mississippi Rivers and the bars and hotels along them.

Although similar in shape, these pitchers clearly did not come from the same mold. The differences in form and color not only suggest the popularity of pillar-molded pitchers but also reveal the diversity still available in an industry that was moving rapidly toward standardization and mass production, a necessary consequence of supplying the ever-growing market. SN

THOMAS COLE
1801–1848

The Architect's Dream,
1840

Oil on canvas
53 x 84¹⁄₁₆ inches
The Toledo Museum of Art
Purchased with funds from the Florence
Scott Libbey Bequest in Memory of her
Father, Maurice A. Scott, 1949.162

This painting portrays an ideal realm imagined by the architect, who reclines in the foreground with his eyes closed. The odd combination of buildings, stage-like setting, exaggerated contrasts of scale, and numerous vanishing points indicate that the scene is a fantasy. The buildings also represent the history of Western civilization and exemplify particular cultures, specifically Egyptian, Greek, Roman, and Gothic.

The painting was commissioned in 1839 by the architect Ithiel Towne, who owned the largest architectural library in America; in fact, he made part of his payment to Cole in books. Cole, whose own architectural accomplishments included the design for the Ohio State Capitol, was allowed to choose the specific subject of the painting within the broad guidelines of a view of Athens. The varied buildings may reflect the mid-19th century's taste for combining elements from different styles of architecture; it may also refer to Towne's designs in Greek and Gothic Revival styles. The dreamer who rests atop a pile of books and portfolios may be an allegorical portrait of either Towne or Cole. And the books and architectural styles, as backdrop for the dreaming architect, may signify the power of the human mind to envision and the human hand to construct creations of amazing variety, splendor, and enduring appeal. EDG

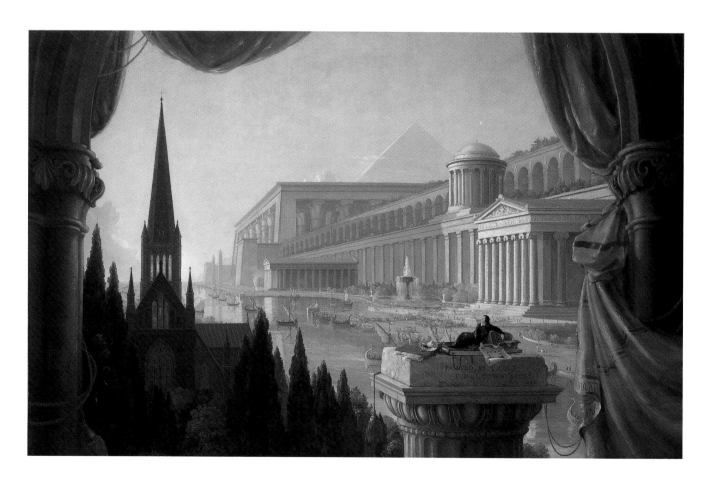

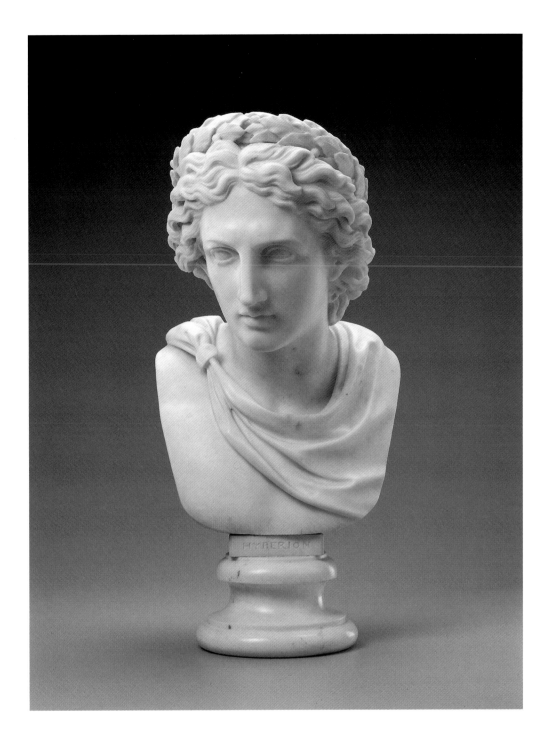

THOMAS CRAWFORD
1813–1857

Hyperion, 1841

Marble
23¾ inches high
The Carnegie Museum of Art
Purchase: Gift of Mrs. George L. Craig, Jr.,
and Patrons Art Fund, 86.36

In Greek mythology Hyperion is one of the Titans, the race of doomed giants that preceded the more familiar pantheon of gods headed by Zeus. Because his domain was the sun, Hyperion appears to have been a forebear of the Greek sun god, Apollo. Thomas Crawford suggests the identity of the two deities by crowning Hyperion's idealized head with a laurel wreath, the standard attribute of Apollo. In addition to his choice of a Greek subject, Crawford sought to emulate the soft modelling of late classical Greek sculpture.

Crawford moved to Italy in 1835 in order to study with Berthel Thorvaldsen, the great Danish sculptor then residing in Rome, where access to quarries and skilled carvers made marble sculpture both possible and popular in the 19th century. Still struggling for patronage in the early 1840s and unable to afford the services of a professional carver, Crawford seems to have executed much of this marble bust himself. LWL

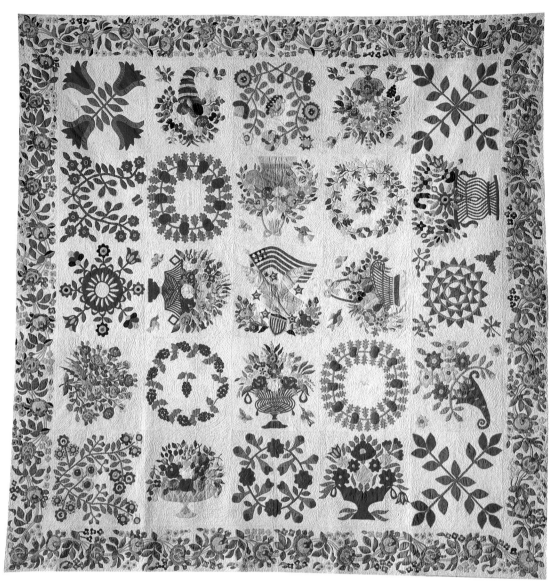

Album Quilt

1848

Baltimore
Cotton, quilted and appliquéd
100 x 100 inches
The Saint Louis Art Museum
Gift of Mrs. Stratford Lee Morton, 1:1973

Quilts were an important part of American households in the 18th and 19th centuries. They were made not only to keep people warm, but also as valued decorative items. Women made quilts for their own families and also worked in groups to create gifts for special friends or honored individuals within the community. This quilt is a particularly striking example of the very elaborate "show quilts" made in Baltimore in the middle of the 19th century.

This quilt was in keeping with the 19th-century fashion of incorporating memories of special occasions, events, or personal attributes in autograph books, samplers, and album quilts. It was made as a tribute to Elizabeth Morrison by a group of women friends from a Methodist Church in Baltimore who called themselves "The Ladies of Baltimore."

Baltimore album quilts all share a characteristic design format. They are made of a collection of squares laid out in a horizontal and vertical grid, and the blocks are composed of colorful fabrics and intricately designed, appliquéd motifs. Names, Bible verses, affectionate messages, or patriotic references were embroidered or sometimes inked.

The inscriptions on this album quilt not only identify the makers and the recipient, but they also offer insight into the political events of the time and the makers' sense of humor. One inscription reads "From One of the Rough & Ready/to the/Worthy President/Mary Ann Hudgins/1848," making a parallel between the quilter and General Zachary Taylor, who was known to his troops as "Old Rough and Ready." LS and ZAP

POTTIER AND STYMUS
New York, about 1859–88

Cabinet, about 1867

Rosewood, bronze, porcelain
57 inches high
The Minneapolis Institute of Arts
The John R. Van Derlip Fund,
89.2a–c

This cabinet was originally from the Nathaniel Wheeler House in Bridgeport, Connecticut. As one of the more expensive and elaborate pieces to furnish a main drawing room, the cabinet would have been used for the display of sculpture or other decorative objects. This cabinet combines motifs from several historical periods and is typical of the stylistic revivalism so popular during the 19th century. The heavy proportions, dark wood, and use of such architectural details as the central cartouche are characteristic of the Renaissance Revival style. The bronze mounts, porcelain plaques, and floral inlays of exotic woods, however, recall French Neoclassical furniture of the late 18th century. Such agricultural implements as a hoe, scythe, shovel, farmer's hat, and seed bag interspersed with blossoms and stalks of wheat displayed in the central medallion are all emblems of rural life.

Pottier and Stymus was one of the most fashionable New York cabinet-making and interior-decorating firms of the 1870s and 1880s and enjoyed an international reputation. JAN and WBR

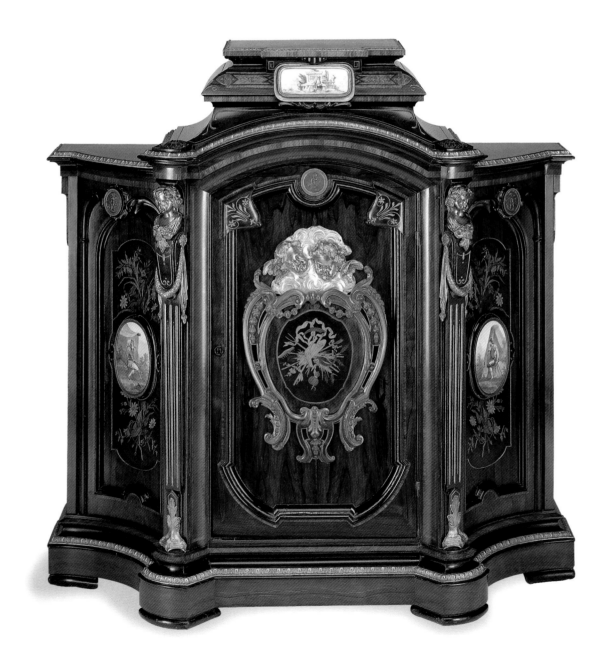

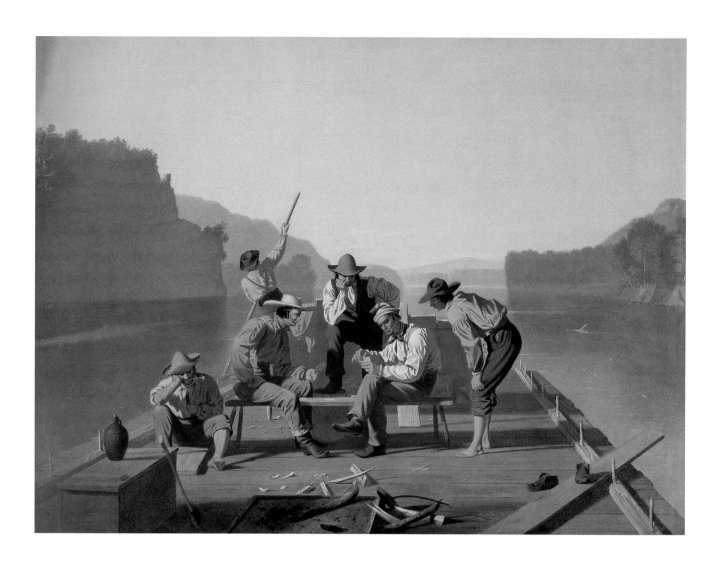

GEORGE CALEB BINGHAM
1811–1879

Raftsmen Playing Cards, *1847*

Oil on canvas
28 x 30 inches
The Saint Louis Art Museum
Purchase: Ezra H. Linley Fund, 50:1934

The six raftsmen in this painting are either preoccupied with their card game or absorbed in their own thoughts. Like many other of Bingham's genre paintings, the time of day is either dawn or dusk; the sunlight is casting long shadows across the boat and landscape. In the foreground are charred pieces of wood from an earlier fire. The man sitting at the left seems not to be totally awake. All eyes focus on the man in the knit cap, whose posture and expression suggest that he is in no hurry to play his hand.

Though there had been earlier paintings of river life, Bingham was the first and most masterful artist to use the river to symbolize the passage of time and the pleasure to be found in nature and companionship. This romantic view was not a realistic record of life on the river at mid-century. Rather, it

hearkened back about 50 years to a simpler time of undashed expectations and colorful characters. The river, that fluid and reflective substance illuminated by the sky above it, is the fundamental element both structurally and metaphorically of Bingham's river paintings.

Bingham was first known as a portrait painter, but he aspired to attract a more national market by making paintings about everyday life in America. Bingham submitted *Raftsmen Playing Cards* for consideration to the American Art Union of New York, an association that distributed fine art through a lottery system. The Art Union paid Bingham the lofty sum of $300 and promptly awarded the painting to the lottery winner, Mr. Edwin Croswel of Albany, New York. JKS

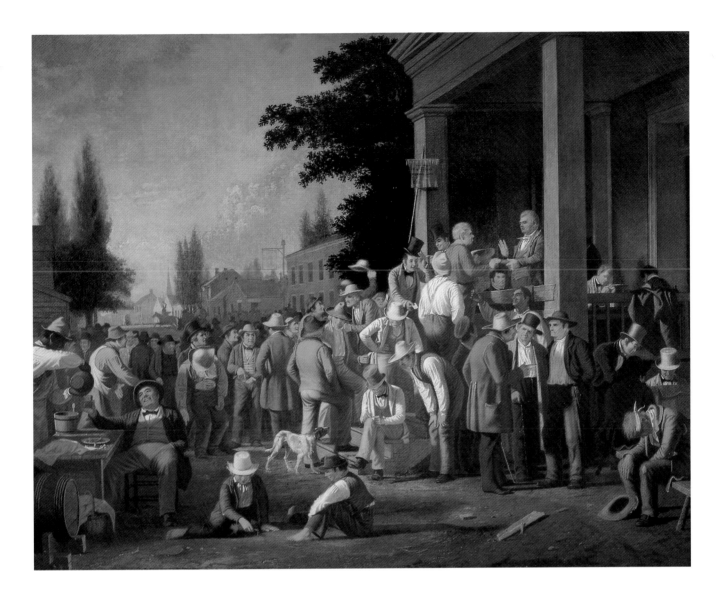

GEORGE CALEB BINGHAM
1811–1879

The County Election,
1851–52

Oil on canvas
35⁷/₁₆ x 48¾ inches
The Saint Louis Art Museum
Purchase, 124:1944

This painting explores a subject dear to the heart of America as well as to that of the artist. Throughout his life, Bingham was involved in politics, mostly as a member of the conservative Whig party. He ran for election to the Missouri legislature twice and was elected in 1848; later he ran unsuccessfully for the U.S. Congress. His experience caused him to view the "mire of politics" with a mixture of idealism and cynicism, both of which are seen in *The County Election.*

The men (at that time in our history only property-owning men could vote) in the dynamically composed triangle approach a courthouse, where they will declare their votes out loud. Some continue to debate, even argue, and one

man, directly below the official administering oaths of eligibility, seems to be ready to flip a coin. On the far right is a man with a bandaged head, and on the left we see a liquor concession as well as a man so drunk that he must be carried to the polling station. It was a common practice to buy votes with alcohol.

Bingham believed that art was history's "most efficient hand maid," and he consciously set out to chronicle the story of Missouri on its way from frontier territory to progressive civilization. The courthouse shown in this painting is modelled after the one in Bingham's hometown of Arrow Rock, Missouri.

JKS

SANFORD ROBINSON GIFFORD
1823–1880

The Wilderness, 1860

Oil on canvas
30 x 54⁵⁄₁₆ inches
The Toledo Museum of Art
Purchased with funds from the Florence
Scott Libbey Bequest in Memory of her
Father, Maurice A. Scott, 1951.403

Gifford's *The Wilderness* is a striking account of the transitory visual effects of light, distance, and atmosphere on the perception of nature. Working from studies made at various mountainous areas in New England, he created an idealized rather than an actual, topographically correct landscape.

The motif of a monumental, solitary peak rising above the forests—perhaps Mt. Katahdin in Maine—dominates the composition. Except for the trees and rocks in the foreground, the scenic details are veiled by the soft glow of light-filled, humid air. The muted tones, hazy atmosphere, and still water impart a feeling of serenity, of time suspended; nature is frozen in her most idyllic state. Based on studies Gifford made of the Mic Mac Indians of Halifax Basin, Nova Scotia, the family in the foreground and the canoeist may symbolize human beings living in harmony with nature—a theme the artist returned to in several of his paintings. EDG

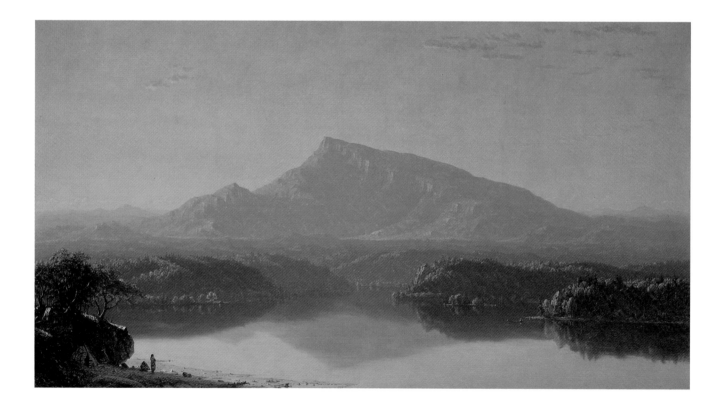

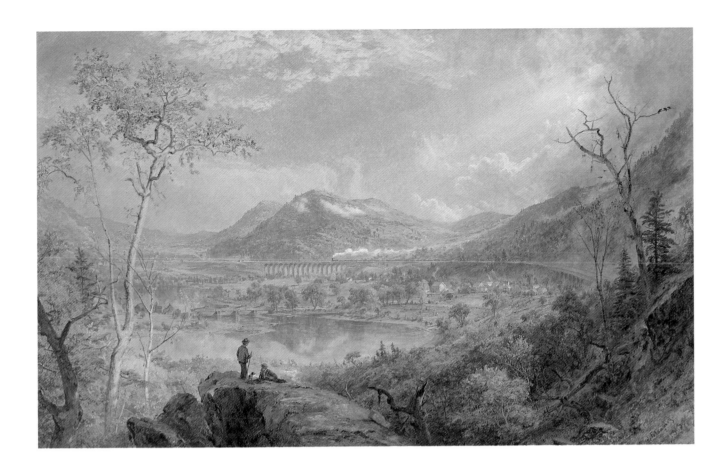

JASPER FRANCIS CROPSEY
1823–1900

Starrucca Viaduct, Pennsylvania, 1865

Oil on canvas

22⅜ x 36⅜ inches

The Toledo Museum of Art

Purchased with funds from the Florence Scott Libbey Bequest in Memory of her Father, Maurice A. Scott, 1947.58

This painting is a celebration of both nature and industry. Built in 1847–48 by the New York and Erie Railroad, the viaduct was among the great engineering feats of its time. Its scale dwarfs the old-fashioned wooden bridge in the middle distance that leads to the village of Lanesboro in northeastern Pennsylvania.

Nineteenth-century landscape painting usually presented the railroad as a symbol either of industrial progress and change or of man's destruction and exploitation of nature. In the reflective attitude of the figures gazing over the valley toward the train, by the nestling of technology within the landscape, and by the dominance of the undisturbed foreground wilderness, Cropsey seems to be suggesting that nature can absorb the effects of technology without adverse consequences. The composition's overall emphasis, however, is on the beauty and serenity of the Susquehanna River Valley. Industry remains a small, romanticized counterpoint to the brilliant fall foliage. EDG

DAVID GILMOUR BLYTHE
1815–1865

The Higher Law, 1861

Oil on canvas
20¼ x 24½ inches
The Carnegie Museum of Art
Purchase: Gift of Mr. and Mrs. John F.
Walton, Jr., 58.56.3

Although he was an unknown and largely self-taught portrait painter when he arrived in Pittsburgh in 1856, David Gilmour Blythe responded to the city's urban horrors and the later devastation of the Civil War with unprecedented satires and allegories. Blythe's bitter tone and unsparing cynicism distinguish his work from that of any other painter of the period.

In this painting, Blythe presents his view of the causes of the American Civil War. Flag-bedecked Liberty collapses to the ground between a ranting northern abolitionist on the left and a demonic southern slaveholder on the right. Two African-Americans, a freed man and a slave, appear to observe the crisis with passive indifference. Blythe seems to blame extremists on both sides of the slavery issue for the start of the war—an attitude that was shared by many northerners as well as the administration of President Abraham Lincoln, whom Blythe admired greatly. The painting's many inscriptions enhance its resemblance to political cartoons published in the northern press. LWL

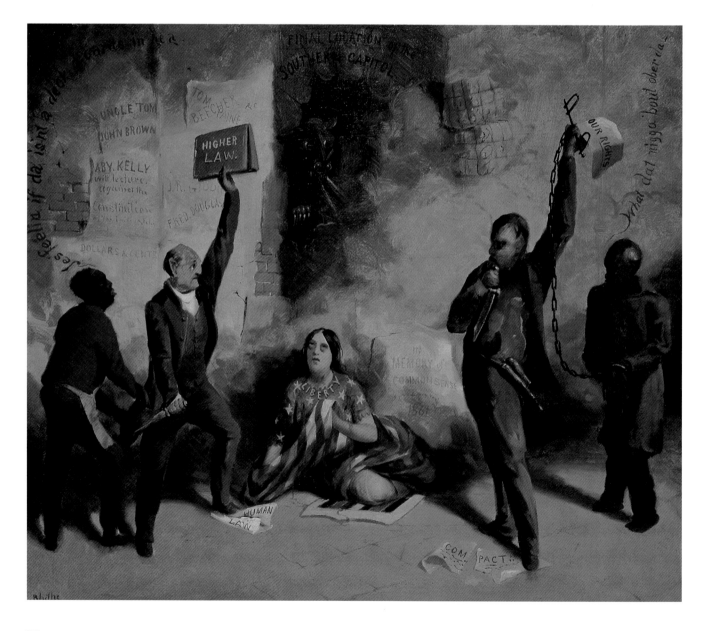

GEORGE N. BARNARD
1819–1902

Rebel Works in Front of Atlanta, Ga., No. 3, 1864

From *Photographic Views of Sherman's Campaign*
Albumen print
10 x 14 inches
The Toledo Museum of Art
Purchased with funds from the Libbey Endowment, Gift of Edward Drummond Libbey, 1988.86

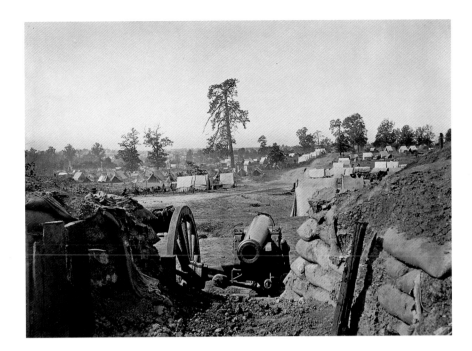

ALEXANDER GARDNER
1821–1882

The Sharpshooter's Last Sleep, 1863

Albumen print
8¹⁵⁄₁₆ x 6¾ inches
The Saint Louis Art Museum
Purchase: Friends Fund, 16:1993

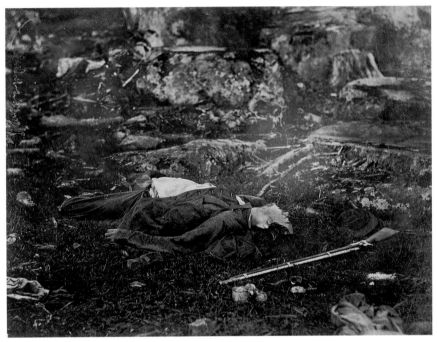

One of the first significant historical events recorded by photographs, the Civil War established the reputations of a number of important photographers whose images are engraved in our cultural memory. Mathew Brady's studio in Washington, D.C., sent numerous photographers into the field to document the war. Photographs of actual battle scenes do not exist because in the early 1860s the photographic process could not yet capture events in motion. However, Alexander Gardner and A. J. Russell each produced a series of powerful photographs that documented the horrible aftermath of some of the battles. After the war, Gardner and George N. Barnard, also a former Brady photographer, produced special-edition albums that chronicled the battlefields, towns, and people involved in the Civil War. These images can be seen as an early form of photojournalism and often were translated into wood engravings for the popular press such as *Harper's Weekly* and *Frank Leslie's Illustrated Newspaper.* OLG

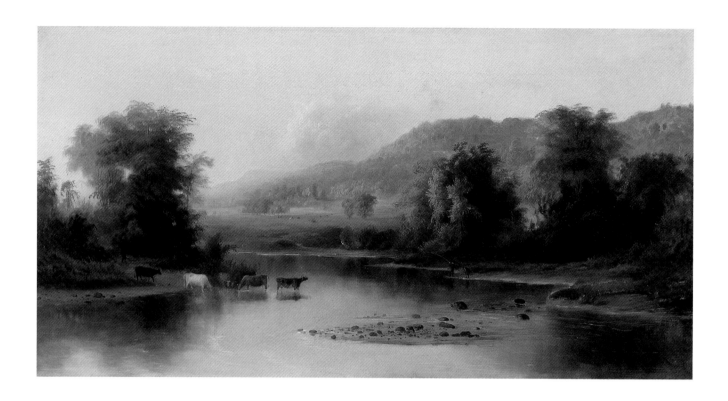

ROBERT S. DUNCANSON
about 1817–1872

View of the St. Anne's River, Quebec, 1870

Oil on canvas
21 x 40 inches
The Saint Louis Art Museum
Purchase, 163:1966

Robert Duncanson was an African-American artist considered by many North Americans and Europeans at the time to be the best landscape painter of the period. A freeborn person of color, Duncanson began as a housepainter and, in spite of social and racial discrimination, advanced his artistic career to a place in the arts parallel to Phyllis Wheatley in literature and Frederick Douglass in politics. Duncanson left his native Ohio in the early 1860s to escape the trauma and racial tensions of the Civil War. He lived in Canada for several years and was instrumental in generating a "nationalist" art movement there. He did not return to the United States until shortly before his early death in 1872, which may have been an outcome of lead poisoning from his years as a housepainter.

View of the St. Anne's River, Quebec was painted during the peak of Duncanson's career. The painting was created from field sketches collected during his travels in Canada and combines a penchant for detail (the influence of the Hudson River School's romantic realism) and a compositional structure popular among American landscape artists at that time. The golden pastoral setting of cattle wading in shimmering water and the glowing sunset reflected on foliage illustrate Duncanson's skillful use of light and color to establish a mood of tranquil repose. JLH

FREDERIC EDWIN CHURCH
1826–1900

Jerusalem from the Mount of Olives, 1870

Oil on canvas
53½ x 83½ inches
The Nelson-Atkins Museum of Art
Gift of the Enid and Crosby Kemper
Foundation, F77–40

Frederic Church studied with Thomas Cole, the leader of a group of painters that has been called the Hudson River School, and he carried the ideals of that group to their dramatic peak with vast paintings of natural wonders. Many of his early works embodied a patriotic message, celebrating the American scenery; but as his career progressed, Church journeyed to increasingly distant places in search of dramatic subjects.

Jerusalem from the Mount of Olives, one of Church's last major canvases, was inspired by a trip the artist made to the Middle East in 1869. During a brief visit to Jerusalem, Church made sketches and purchased photographs showing the city from the Mount of Olives. The sketches and photographs served as the basis for this painting, which he completed shortly after his return to the United States. As was his

practice, Church exhibited the finished painting in New York in a one-picture show, charging admission to see it. Visitors who paid the entrance fee also received a little diagram of the picture, identifying the principal monuments it depicts.

At the time Church painted this picture, firmly held religious ideas were being challenged by the evolutionary theories of Charles Darwin. By showing Jerusalem from the Mount of Olives, a spot that had changed little since biblical times, Church may have hoped to endow religious belief with a measure of demonstrable historical verity. HA

TIMOTHY O'SULLIVAN
1840–1882

Black Cañon, Colorado
River, from Camp 8,
Looking Above, 1871

Albumen print
8 x 10¾ inches
The Saint Louis Art Museum
Purchase: Funds given by the Martin
Schweig Memorial Fund for Photography
and Museum Funds, 127:1976

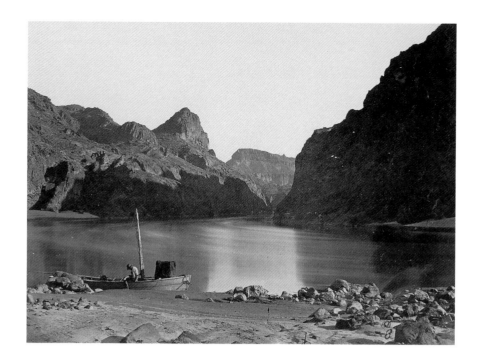

TIMOTHY O'SULLIVAN
1840–1882

Cañon de Chelle/
Wheeler Survey, 1873

Albumen print
8¹⁄₁₆ x 10⅞ inches
The Toledo Museum of Art
Harold Boeschenstein, Jr. Fund, 1983.63

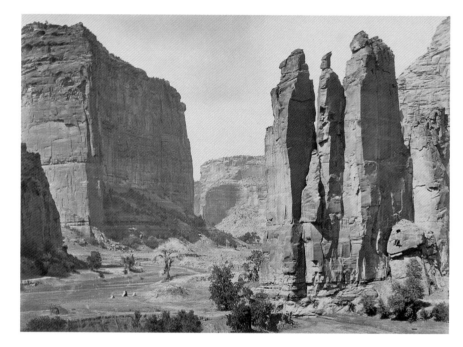

Painting and photography in the mid to late 19th century share a complex and layered history. Although originally described as the "handmaid of the fine arts," photography was rapidly acclaimed as an art form itself. There was a great deal of cross-fertilization: painters influencing

CARLETON E. WATKINS
1829–1916

Distant View of the Domes, Yosemite Valley, California, about 1866

Albumen print
15¾ x 20⁷⁄₁₆ inches
The Minneapolis Institute of Arts
Gift of Walter R. McCarthy, 91.125

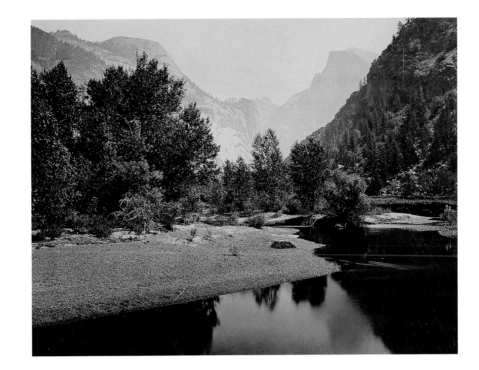

ANDREW JOSEPH RUSSELL
1830–1902

Trestle Work, Promontory Point, Salt Lake Valley, about 1870

From *Sun Pictures of Rocky Mountain Scenery*
Albumen print
6 x 8¹⁄₁₆ inches
The Minneapolis Institute of Arts
The John R. Van Derlip Fund, 78.90.28

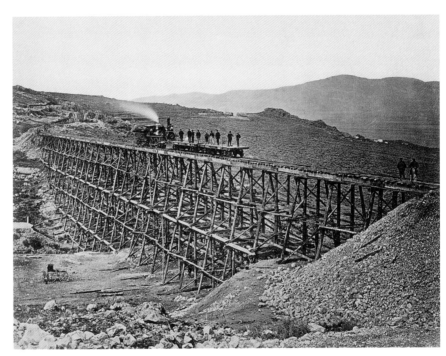

photographers and photographers influencing painters. The speed with which a photograph could be made and the objective information it could provide made it especially suitable for recording the landscape.

Just after the Civil War, photography became a major component of expeditions to survey the land west of the Mississippi. One of the first expeditions, led by Josiah D. Whitney in 1866, commissioned Carleton E. Watkins as photographer. Watkins was already recognized as one of the first photographers to make images of the landscape for purely artistic reasons, and his presence added status to the enterprise. The government commissioned many photographers like Watkins and Timothy O'Sullivan to "document" these expeditions. In addition to government surveys, the railway companies hired photographers to record the progress of their railway lines and to extol the virtues of the scenery that could be enjoyed by rail. Andrew Joseph Russell was among those who carried out these commissions. OLG

American
Impressions

The phase of history that the French remember as the Beautiful Epoch (La Belle Epoque) has always been known in America by less flattering terms—"The Brown Decades," "The Gilded Age," or "The Robber Baron Period." For Americans the Civil War cast a dark shadow over the last third of the 19th century: those who had lived through the war could not help remembering their dead friends, sons, and brothers who continued to march beside them, as invisible companions, toward the grave. Moreover, this tragic carnage came at a time when religious faith was being challenged by the theories of evolution that put forth a definition of man having nothing to do with the image and likeness of God; rather, he was a descendant of the apes, the product of a brutal process of natural selection. Man might be the highest form of animal, but he was essentially still an animal, like the rest.

If the period before the Civil War was one of geographical expansion from one shining sea to the other, in the period after the war this process was in a sense reversed, as the population began to clot and concentrate in great urban, industrial centers. Cities began to suck up people like gigantic vacuum cleaners, pulling farmers off their land, absorbing immigrants from Europe, breeding their teeming populations like insects. Indeed, the cities expanded like cancerous tumors, to a size that had not existed anywhere on the face of the globe since the fall of Rome. In the mid-1870s, New York became the first American city to have a population of over a million, and it was soon followed by Boston, Philadelphia, Chicago, Cleveland, and a dozen others. Manufacturing gradually replaced farming as the work activity of most Americans.

Cities breed concentrations of both wealth and filth. Thanks to new machinery and economies of scale, manufacturing grew more and more efficient: the average output of American workers quadrupled in the span of a generation. With no income tax to cut into their gains, the rich could hardly find enough ways to consume their

WINSLOW HOMER
1836–1910

The Country School,
1871

Oil on canvas
21⅜ x 38⅜ inches
The Saint Louis Art Museum
Purchase, 123:1946

Winslow Homer's view into a one-room school illustrates a slice of New England country life from the 1870s. Through the use of perspective, Homer allows the viewer to become part of the painting's action. So it is as a reluctant pupil that we take note of the details in the classroom: lunch pails, flowers, slate boards, ink bottles, window shades, the teacher's hat hanging from a nail above the chalkboard, the school bell on the teacher's desk, and one shiny black marble at the edge of one of the windowpanes. Spots of sunlight highlight the desks and floorboards and reveal the children's faces in several degrees of attention. A small boy sits crying on a bench, perhaps a victim of the class bully or a harsh reprimand from his teacher.

Homer's interest in scenes of everyday life grew out of his experience as a magazine illustrator in the 1850s in Boston. Many of his images relate to the interest in childhood evident in American literature after the Civil War. Stories like Mark Twain's *Tom Sawyer* spoke to the country's lost innocence and melancholy. This was also a period of reform in public education, when in many communities the one-room country schoolhouse was already a nostalgic memory. JKS

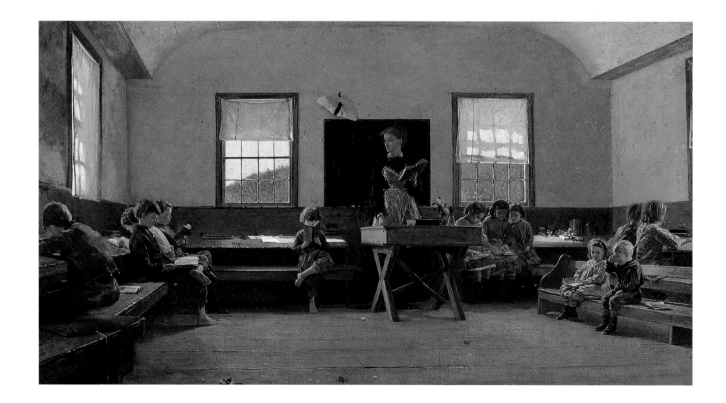

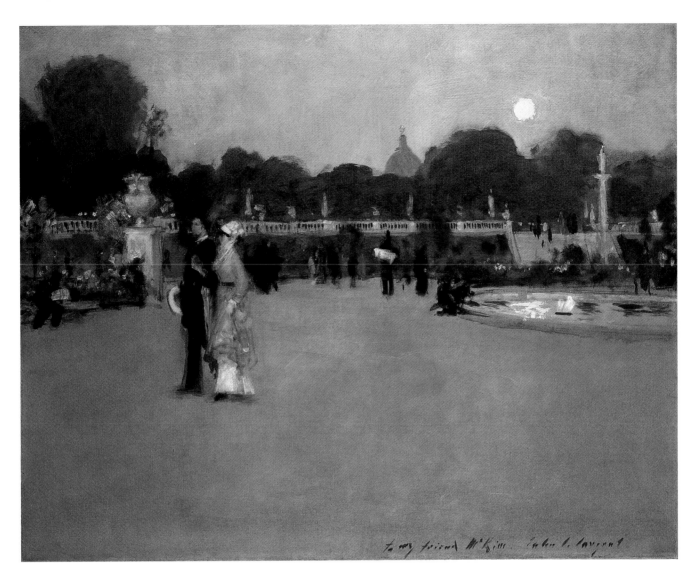

JOHN SINGER SARGENT
1856–1925

Luxembourg Gardens at Twilight, about 1879

Oil on canvas
29 x 36½ inches
The Minneapolis Institute of Arts
Gift of Mrs. C. C. Bovey and Mrs. C. D. Velie for the Martin B. Koon Memorial Collection, 16.20

John Singer Sargent was born in Italy, studied painting in France, and spent most of his career in England. But he visited America periodically and chose to retain his American citizenship—even after having been offered a knighthood in acknowledgment of his accomplishments.

Although the cosmopolitan expatriate Sargent earned his livelihood and fame with portraits, he sometimes painted landscapes for his own enjoyment. At the age of twenty-three, while completing his art studies in Paris, he produced this view of a fashionable park and elegantly dressed Parisians promenading in the summer twilight.

Like the French Impressionists whose work he respected, Sargent sought to transcribe the momentary appearance of an urban site, evoking the movement of figures and the particular diffuse light of Paris at dusk. The sketchy brushwork and wet-on-wet application of paint yield a fresh, immediate quality. Sargent might have learned this technique from Monet, or from his teacher Carolus-Duran, who encouraged direct painting, or from James McNeill Whistler, whose influence can be seen here in the horizontal structure and the pearly gray-and-white color scheme. The delicate harmony, accented by touches of vivid color, is pure Sargent.

The painter executed two versions of this subject. He sold the slightly more finished one (now in the Philadelphia Museum of Art), but this one he gave to Charles Follen McKim, the famous architect, and inscribed it "To my friend McKim." Asked in 1924 in which order he had painted the two works, Sargent could not remember, but from certain slight changes in the composition he thought perhaps he had made this version first. LA

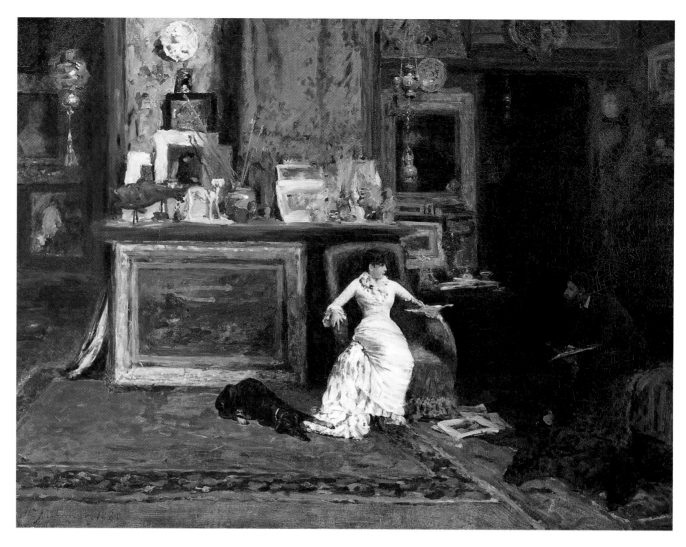

WILLIAM MERRITT CHASE
1849–1916

The Tenth Street Studio,
1880

Oil on canvas
36 x 48 inches
The Saint Louis Art Museum
Bequest of Albert Blair, 48:1933

William Merritt Chase was one of America's most influential artists and teachers at the turn of the century. As a young man he trained at the Royal Academy in Munich from 1872 until 1878. His free and facile brushwork resulted from his study of Frans Hals and Diego Velázquez, two 17th-century painters whom Chase admired.

After his European training, Chase returned to the United States in 1879 and set up a studio in the famous Tenth Street Studio Building in New York. His studio area had been converted from an unsuccessful gallery space originally designed for the building. In keeping with European models, the artist filled his studio with an amazing collection of props: wood carvings of saints, guns, swords,

bugles, a Renaissance chest, a Turkish coffeepot, a collection of women's footwear, a stuffed blowfish, the head of a polar bear, and three stuffed white-and-pink cockatoos.

Chase painted his studio so often that it became his principal subject. Much like self-portraits done throughout the course of an artist's career, Chase's studio paintings came to represent aspects of self-revelation and to symbolize his ideas about the artistic endeavor. And to the popular mind, scenes such as this one furthered the fascination with artistic bohemianism that characterized the world of art at the turn of the century. JKS

CHILDE HASSAM
1859–1935

Rainy Day, Boston, 1885

Oil on canvas
26⅛ x 48 inches
The Toledo Museum of Art
Purchased with funds from the Florence Scott Libbey Bequest in Memory of her Father, Maurice A. Scott, 1956.53

Painted at a time when city streetscapes were still a novel subject in America, *Rainy Day, Boston* depicts the intersection of Appleton Street and Columbus Avenue in Boston's South End. The layout of the South End, one of the largest urban projects in America, imitated the grand boulevards of Paris that had been created by Baron Haussmann for Napoleon III. The painting's wide angle of vision, uncluttered foreground, and deep perspective recall similar street scenes by the French Impressionists.

In this painting, Hassam accentuated the pictorial effects produced by the light and weather conditions. The rain causes the pavement to glisten with reflections and casts a soft rosy tone on the damp bricks. The overcast sky and pearly light produce a misty atmosphere that enshrouds buildings and pedestrians alike and, combined with the muted palette of dull pinks, grays, and blacks, unifies the composition.

EDG

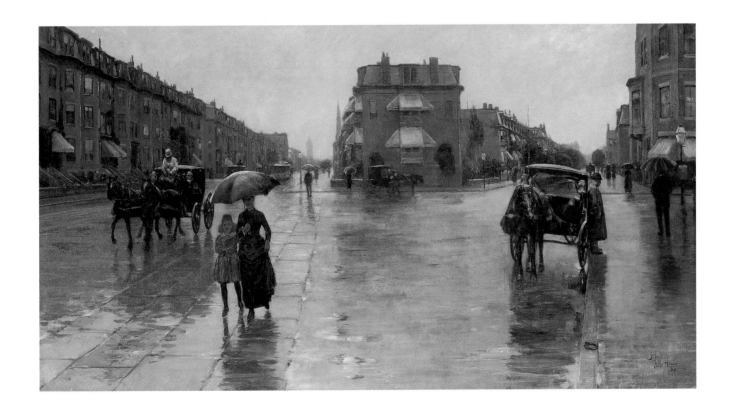

WILLIAM MICHAEL HARNETT
1848–1892

Still Life with the
"Toledo Blade,"
1886

Oil on canvas
22⅛ x 26³⁄₁₆ inches
The Toledo Museum of Art
Gift of Mr. and Mrs. Roy Rike, 1962.2

William Harnett is best known for his highly illusionistic painting style, called trompe l'oeil (literally "fool the eye"), which intrigued, challenged, and sometimes boggled his viewer's perceptions. *Still Life with the "Toledo Blade,"* painted for Isaac N. Reed, a Toledo druggist, features the domestic bric-a-brac that Harnett often used to evoke the modest pleasures of leisure activities and gentlemanly commerce. The folded newspaper is the September 17, 1886, issue of the *Toledo Blade* (renamed *The Blade*, it is still Toledo's daily paper). Reed probably asked Harnett to include the paper to indicate his hometown. Additionally, a

member of Reed's family may have been its managing editor. The reference was also a declaration of civic and regional pride, as the Toledo Blade was then a publication of national repute. The painting's pyramidal arrangement, dark earth-toned palette, and thinly applied, uniform brushwork are characteristic of Harnett's late work.
EDG

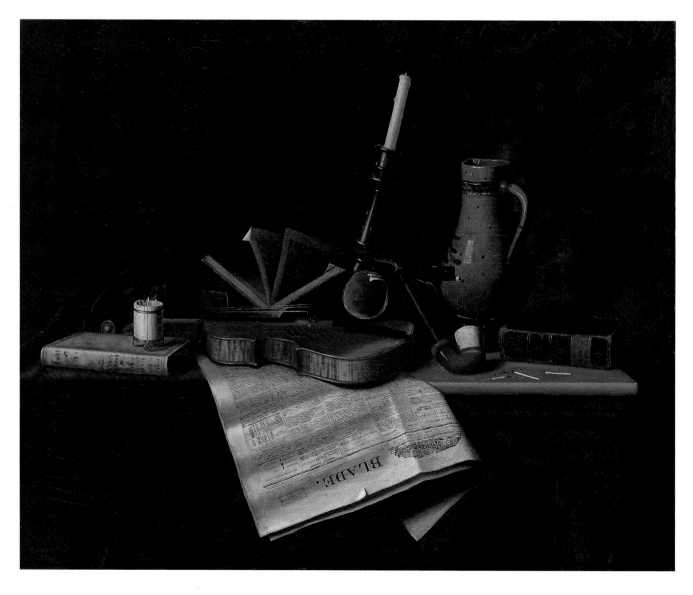

JOHN SINGER SARGENT
1856–1925

Mrs. Cecil Wade
(Frances Frew Wade),
1886

Oil on canvas
64½ x 53⅝ inches
The Nelson-Atkins Museum of Art
Gift of the Enid and Crosby Kemper
Foundation, F86–23

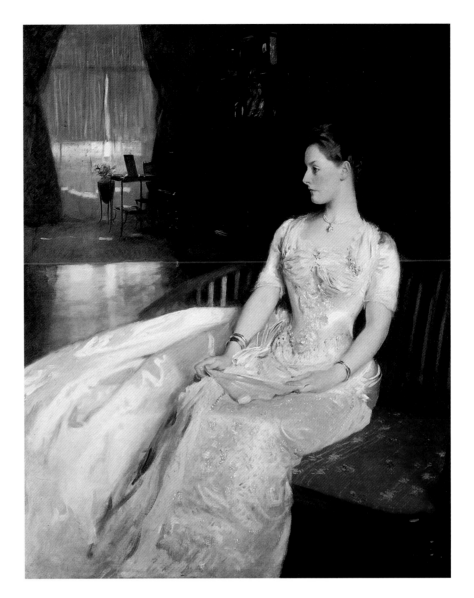

Sargent originally hoped to pursue his career in Paris, but his portrait of a society lady of dubious morals, *Madame X,* created a scandal when it was shown at the Salon and alienated his French clientele. At the invitation of Henry James, he moved to England, settling in James McNeill Whistler's former studio in Tite Street.

This painting of Mrs. Cecil Wade, the wife of a stockbroker, was Sargent's first major commission in England. The sitter's hourglass silhouette recalls Sargent's earlier painting of *Madame X,* but whereas Madame X looks brazenly risqué in her black dress, Mrs. Wade wears a white dress and looks primly respectable. Sargent's fluent brushwork creates the forms almost by magic. A stroke of green with one of brown becomes a bracelet; strange squiggles of different colors merge when viewed from a distance to evoke the satin of the dress.

Sargent achieved renown for his dazzling brushwork. This he applied without retouching; if a brushstroke erred, he scraped off whole sections of his painting with a palette knife. His practice was to place his canvas close beside his model and then stand off at a distance to study the effect. Having decided to apply a stroke, he would load his brush and rush at the painting, often puffing from the physical effort. When the brushstroke was down, he would retreat, study the effect, and prepare for another charge.

Both Sargent and his sitter were extremely shy, and they hardly spoke during the long sessions necessary to finish the portrait. HA

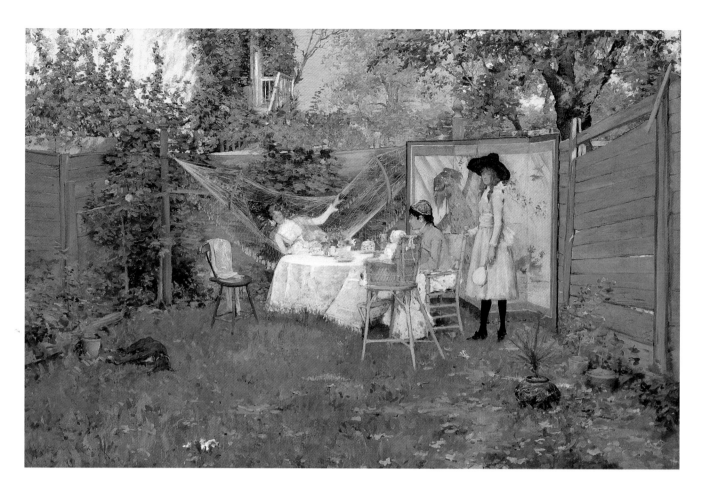

WILLIAM MERRITT CHASE
1849–1916

The Open Air Breakfast,
about 1888

Oil on canvas
37⁷⁄₁₆ x 56¾ inches
The Toledo Museum of Art
Purchased with funds from the Florence
Scott Libbey Bequest in Memory of her
Father, Maurice A. Scott, 1953.136

Chase's *Open Air Breakfast* captures a moment of domestic pleasure in the leisure life of a contented family. The scene is set in the artist's backyard in a fashionable Brooklyn neighborhood, where his wife, oldest child, sister, and sister-in-law relax. Although the figures seem to be the focal point of the painting, they are really just a part of the decorative array of unrelated objects that Chase assembled to create a pleasing effect. Stylishly dressed in shades of white, the women are sheltered from the outside world by a high wooden fence and lush summer vegetation.

The variety of accessories in view—Japanese screen, Spanish shawl, Dutch hat, Oriental porcelains, and potted palm—substantiates Chase's well-known taste for exotic objects as well as his role as a fashion setter. This appealing presentation of an idyllic backyard repast not only celebrates the artist's own private domain, but also reveals his sheer joy of painting through its technical virtuosity. EDG

WINSLOW HOMER
1836–1910

Sunlight on the Coast,
1890

Oil on canvas
30¼ x 48½ inches
The Toledo Museum of Art
Gift of Edward Drummond Libbey,
1912.507

Winslow Homer moved to Prout's Neck on the rugged Maine coast upon his return from England in 1883. For a year and a half he had lived in the English coastal fishing village of Cullercoats on the North Sea. Whereas formerly he had painted the New England Atlantic as a benign background for children and adults at play, in Cullercoats Homer's watercolors focused on the fishermen, their wives and children, and the sometimes awful drama of the sea. This oil painting from 1890 was the first of a series to depict the menacing power of the sea, without any human figures or story being told.

The subject of *Sunlight on the Coast* is the never-ending battle between the sea and the shore, captured under specific conditions of light and weather. A heavy blue-green wave rolls in and breaks over a shelf of brown rocks, spewing foam and spray. Homer successfully conveys the wave's heaving, weighty mass and the iridescence of the swirling countercurrent. The wave's bulk and its powerful sliding, rolling motion represent nature's might. Sunlight, barely piercing the darkness of the sky, sea, and fog, transforms the undertow of one wave into a glittering surface and illuminates a steamship and a portion of the distant horizon. EDG

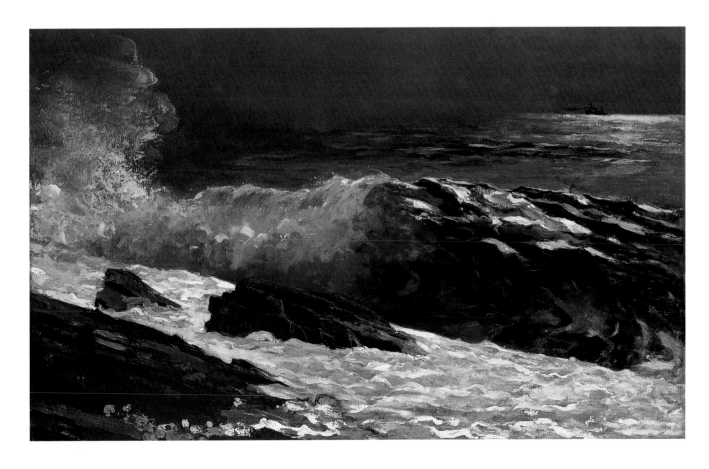

JOHN FREDERICK PETO
1854–1907

Reminiscences of 1865,

after 1890

Oil on canvas
30 x 20 inches
The Minneapolis Institute of Arts
The Julia B. Bigelow Fund, 44.25

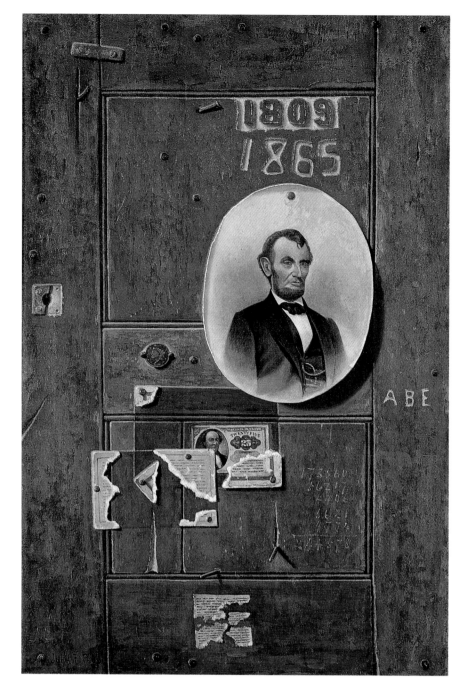

This painting is one of nearly a dozen pictures by John Frederick Peto that feature an image of Abraham Lincoln. Above the assassinated president's picture are his birth and death dates and, to one side, his nickname, "Abe." In the turbulent turn-of-the-century years, Peto shared the country's pervasive nostalgia for Lincoln's heroic leadership. But he may also have associated Lincoln with his own father, who had served in the Civil War and who died in 1895. Mourning his father, and suffering himself from a

serious kidney disorder called Bright's disease, Peto was preoccupied with themes of death.

Many elements of the painting convey a brooding mood. The artist has mimicked the appearance of a nicked and gouged door. The coins and currency probably allude to the corrupt materialism of the Gilded Age. Tacked-up cards have been ripped away, suggesting the destruction worked by time and human activity. The entire composition speaks of what is discarded, wrecked, or dying.

As recently as 1950, John Frederick Peto was virtually unknown. Today he

is considered an important American still-life painter of the late 19th century. He was rediscovered in the late 1940s by a scholar who was researching William Harnett, Peto's friend and most important influence. Because so many pictures by Peto were unsigned or bore Harnett signatures that were forged later, knowledge of this signed painting was crucial in reconstituting the artist's body of work. LA

MARY CASSATT
1844–1926

Young Women Picking
Fruit, 1891

Oil on canvas
51½ x 35½ inches
The Carnegie Museum of Art
Patrons Art Fund, 22.8

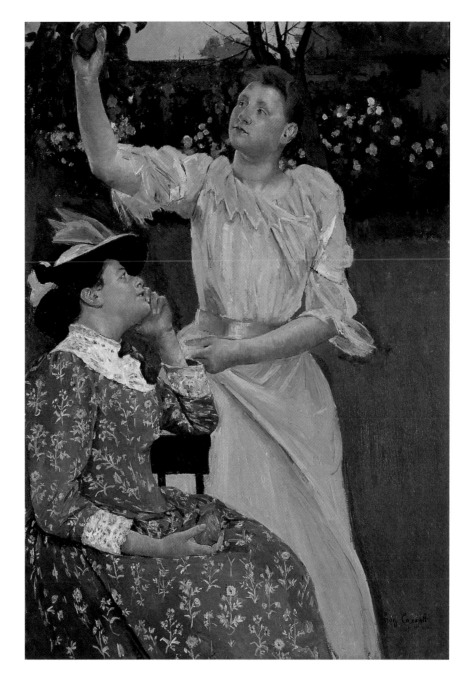

Mary Cassatt was a close friend of the French artist Edgar Degas and the only American to be invited to exhibit with the Impressionists in Paris, her home for most of her working life. She is famous for her intimate portrayals of women and children in domestic surroundings painted with the broad brushwork and light, bright colors exemplary of Impressionism.

The subject of women picking fruit was favored by Realists and Impressionists in the late 19th century, but here it takes on Symbolist overtones. Gathering fruit within a walled garden recalls Eve plucking apples from the Tree of Knowledge in the Garden of Eden and may also allude to female fertility. Perhaps it was the unusually rich symbolism of the theme that persuaded Cassatt to repeat it in the central panel of her mural *Modern Woman*, commissioned for the Woman's Building of the Chicago World's Columbian Exposition in 1893. That mural no longer exists. LWL

FREDERIC REMINGTON
1861–1909

Bronco Buster, 1895

Bronze
22⅞ inches high
The Saint Louis Art Museum
Gift of J. Lionberger Davis, 201:1955

Frederic Remington was already a successful illustrator and painter of romanticized scenes of the vanishing West, his images known through popular magazines such as *Harper's* and *Century*, when a sculptor friend suggested he try three-dimensional work. One of Remington's best-known images, *Bronco Buster* was the artist's first sculpture. Remington worked for a year on this project; the result was this graceful small sculpture, just under two feet high, that portrays dynamic tension and action in meticulous detail.

Cast in bronze and copyrighted in 1895, *Bronco Buster* proved to be popular and immensely profitable for Remington, with nearly 300 authorized casts made before the wax model was destroyed. Remington's late casts of this work reveal subtle changes made in the positions of the horse's tail, the rider's hat, and the whip. Remington went on to produce about two bronzes a year until his death, creating a variety of both simple and complex compositions that brilliantly reflect the command of detail and the astonishing balance already evident in *Bronco Buster.* EJV

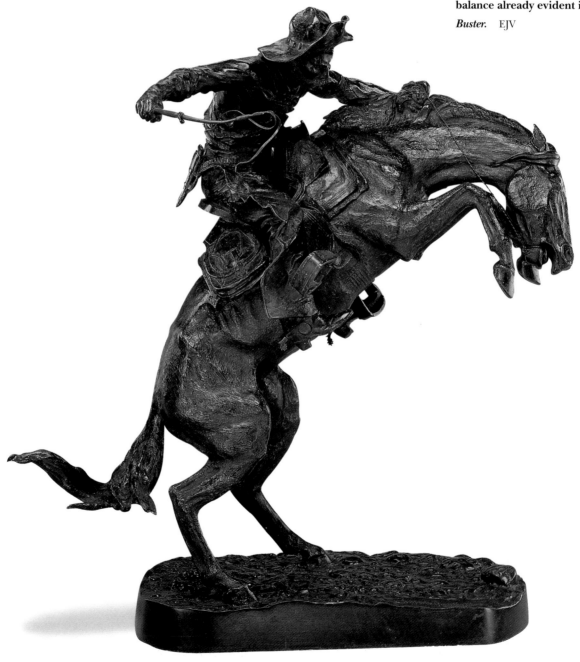

JOHN HENRY TWACHTMAN
1853–1902

The White Bridge,
after 1895

Oil on canvas
30¼ x 30¼ inches
The Minneapolis Institute of Arts
Gift of the Martin B. Koon Memorial
Collection, 14.114

In the mid-1890s the New England painter John Twachtman constructed a footbridge over the stream on his property near Greenwich, Connecticut, and painted it several times. This version of the scene is in its original frame, which the artist designed himself.

Twachtman arranged the landscape elements to create an ordered progression of forms in space, but in several ways he contradicted the illusion of depth to emphasize surface patterning. For example, the bridge's latticework mingles with the tree branches, abridging space and creating a linear web. Similarly, the use of a square canvas, high horizon line, and close-up view reduces space and stresses flatness. Not surprisingly, Twachtman admired the asymmetrical design, elegant patterning, and sharply tilting ground plane found in many Japanese woodblock prints.

The flickering brushstrokes, thick paint, and pale colors work to dissolve the sense of solidity, while at the same time creating an impression of atmosphere and light. These are the features of Twachtman's personal, spiritualized Impressionism, which he developed after 1889, partly under the influence of Monet and Whistler. Twachtman interpreted nature subjectively, extracting the poetry of a specific place: here he has distilled the delicate serenity of spring, fixing it in the pale tangle of lines, leaves, and reflections. LA

**MAURICE BRAZIL
PRENDERGAST
1858–1924**

The Flying Horses,
about 1902–6

Oil on canvas
23⅞ x 32⅛ inches

The Toledo Museum of Art

Purchased with funds from the Florence
Scott Libbey Bequest in Memory of her
Father, Maurice A. Scott, 1957.22

Maurice Prendergast recorded idyllic scenes of people at leisure in public places, adapting all his American pictures from sketches done on the spot at resort areas on the New England coast. Here the subject is a merry-go-round, probably in Nahant, a coastal resort near Boston. Rejecting conventional perspective and modelling, Prendergast simplified the figures and landscape into flat decorative patterns through broad brushstrokes. The mosaic-like strokes vary in size, shape, and direction and not only define the underlying forms, but also unify the pictorial surface by fusing the foreground and background into a flat pattern.

Although the painting was done in oil, a resonance of Prendergast's watercolor technique is seen in the thin layering of pigment and the small patches of canvas left bare for luminosity and dynamism. The intense, bold colors and the fluidity and spontaneity of the brushwork capture the festive gaiety of the subject. EDG

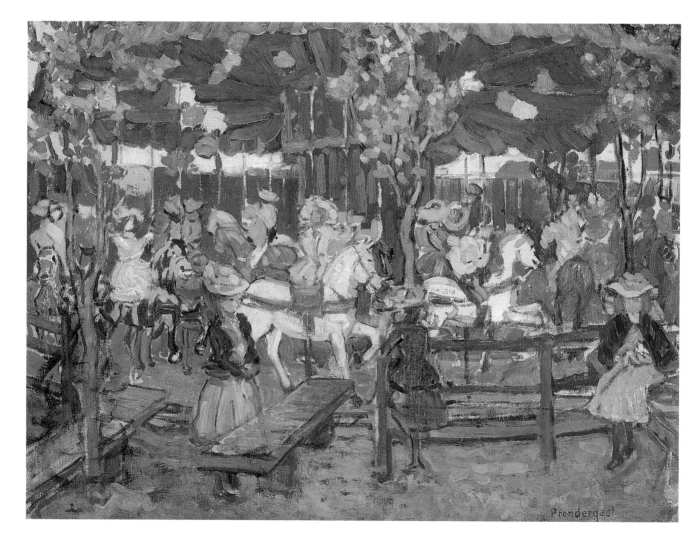

THOMAS EAKINS
1844–1916

Portrait of Elizabeth L. Burton, 1905–6

Oil on canvas
30 x 25 inches
The Minneapolis Institute of Arts
The William Hood Dunwoody Fund,
39.53

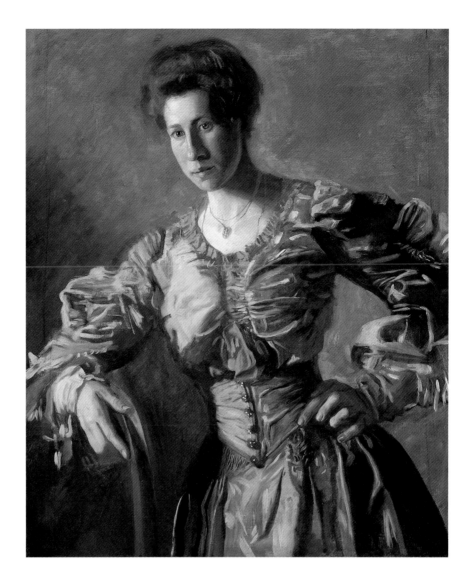

This picture is entirely typical of Eakins's late work in that it is a portrait, was not commissioned but painted at the artist's behest, and is profoundly realistic. Eakins would arrive at an unconventionally frank portrayal of personality, in part by exaggerating physical idiosyncrasies such as this sitter's slightly equine face and large hands. The brushy freedom with which the dress is executed contrasts with the more tightly controlled rendering of the pensive head.

Elizabeth Burton was a young artist in her twenties who lived with her parents next door to Eakins. Eakins's progress on her portrait was interrupted in 1906 when she married and moved to British North Borneo. Eakins wrote to her in June 1907: "I am sorry the portrait was never finished but it was not your fault nor mine either.... I take it that the portrait I painted of

you is half mine and half yours. I have given my half to your mother.... I suppose your climate is hot, perhaps hot and moist. I suppose you might go in to swim without much of a bathing suit. Susie [Eakins's wife] wishes to be remembered."

The odd comment about swimming reflects the artist's obsession with nudity. During his childhood, Eakins's mother, who suffered from manic-depressive psychosis, had periodically been given to wandering around in a state of undress. Although Burton is clothed, Eakins was known to have pressured other female sitters to pose in the nude, and to have generally enjoyed shocking and manipulating people. LA

THOMAS EAKINS
1844–1916

Monsignor James P. Turner, about 1906

Oil on canvas
88 x 42 inches
The Nelson-Atkins Museum of Art
Gift of the Enid and Crosby Kemper Foundation, F83–41

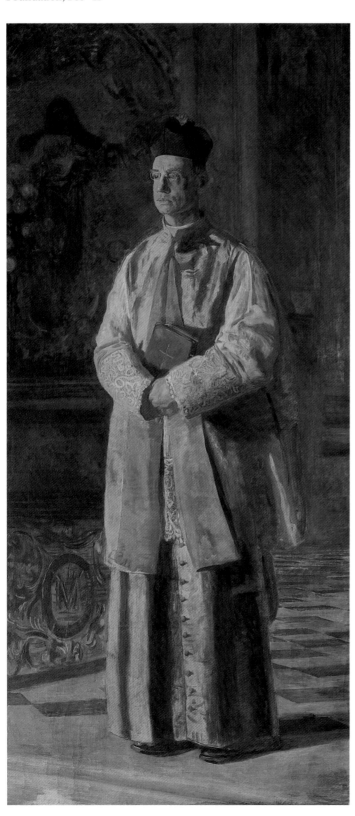

Born in Philadelphia, Eakins studied art in Paris and returned to his hometown to teach at the Pennsylvania Academy of the Fine Arts. Eakins concentrated chiefly on portraiture throughout his career, though few of his portraits were actually commissioned.

Without exception, Eakins's subjects look deeply unhappy, and for this reason many viewers have regarded Eakins's portrayals as marvels of psychological insight. More recent investigations, however, suggest that Eakins may have suffered from serious psychological problems that not only contributed to the air of scandal that plagued him during much of his career but also expressed itself in disturbing portraits.

Though he was an atheist himself, late in life Eakins became friendly with the clergymen at St. Charles Borromeo Seminary near Philadelphia through his pupil Samuel Murray; between 1900 and 1906 Eakins produced fourteen portraits representing the priests at the seminary. Interestingly, the only figure he painted twice was Monsignor Turner. This grand portrait shows the monsignor officiating at a funeral in the Cathedral of Saints Peter and Paul, located a few blocks from Eakins's home. The composition establishes a dramatic contrast between the splendor of the brightly lit vestments—a badge of Turner's high position in the church—and his face, almost obscured by shadow, which seems ravaged by inner torment. HA

THOMAS WILMER DEWING
1851–1938

The Letter, 1908

Oil on panel
19⅝ x 24 inches
The Toledo Museum of Art
Gift of Florence Scott Libbey, 1912.6

Thomas Dewing limited his subject matter to female figures placed in strangely sparse settings. His paintings, expressed in muted tonal harmonies, often possess an unsettling psychological atmosphere. Around 1904 Dewing turned from painting female figures in the out-of-doors to interior scenes, working almost exclusively with studio models, props, and costumes, a practice he learned during his days at the Académie Julien in Paris.

The Letter is a view of Dewing's studio at 12 West Eighth Street in New York. Typically austere, the room is decorated with only a few elegant objects, cherished for their association with Asia. The two women—thin, ethereal, and languid—appear suspended in time and place. The lack of communication between them heightens the painting's dream-like mood. The figure at the left neither reads nor does she seem to direct her attention toward the woman at the desk, who does not seem to be writing. Dewing's poetic work found favor with a small, elite audience that responded to his ideal of feminine purity. EDG

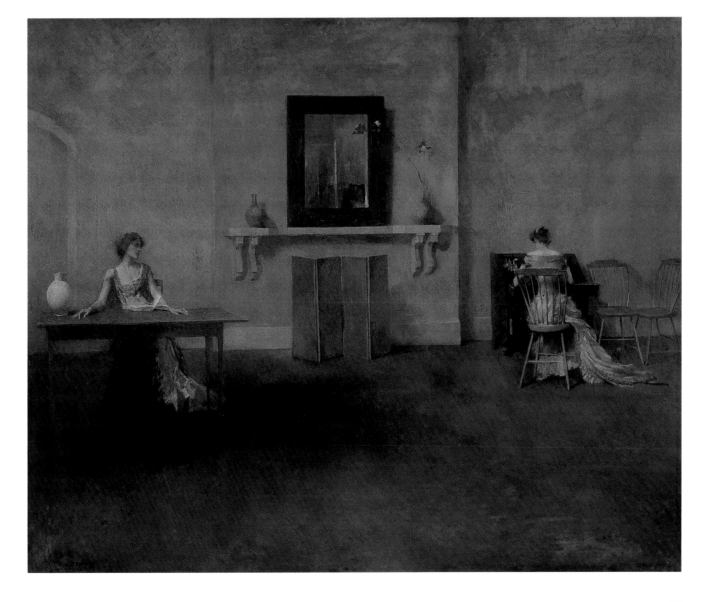

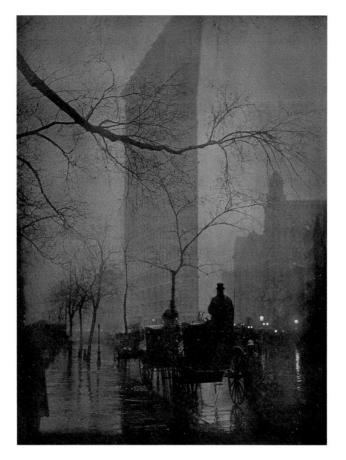

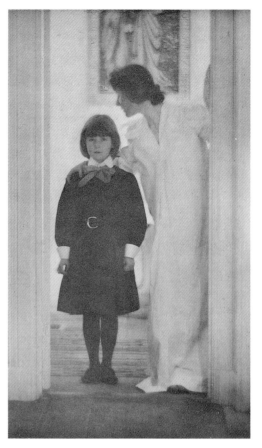

EDWARD STEICHEN
1879–1973

The Flatiron—Evening, 1904

From *Camera Work,* no. 14 (April 1906)
Halftone
8⅜ x 6½ inches
The Minneapolis Institute of Arts
The William Hood Dunwoody Fund, 64.34.14.8

GERTRUDE KÄSEBIER
1852–1934

Blessed Art Thou Among Women, 1899

From *Camera Work,* no. 1 (January 1903)
Photogravure
9⁵⁄₁₆ x 5⁹⁄₁₆ inches
The Minneapolis Institute of Arts
The William Hood Dunwoody Fund, 64.34.1.3

Pictorialism was a movement in photography that grew out of the same ideals that motivated the Arts and Crafts Movement at the end of the 19th century. Increasingly dissatisfied with a mechanical and materialistic society, artists who called themselves

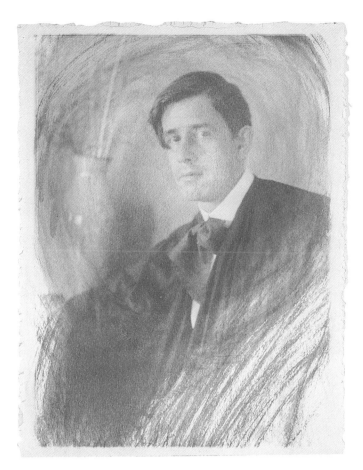

GERTRUDE KÄSEBIER
1852–1934

Portrait of Clarence H. White, about
1900

Gum-platinum print on hand-coated paper
8⅝ x 6⅝ inches
The Saint Louis Art Museum
Purchase: Friends Fund, 3:1987

CLARENCE H. WHITE
1871–1925

The Orchard, 1898

From *Camera Work,* no. 9 (January 1905)
Photogravure
8⅛ x 6⅛ inches
The Toledo Museum of Art
Harold Boeschenstein, Jr. Fund, 1977.57

Pictorialists sought to move beyond the transcriptive capabilities of photography to a more evocative and personal statement. Perfection of craft and the expression of emotion were paramount; in the age of X-rays, art and photography had to be more than the simple imitation of things in the world.

These photographers were interested in producing images that were more like painting than photography and more subjective than objective. Reflecting a belief in universal themes, these artist-photographers produced enigmatic images that represented an idealized world.

The Pictorialists experimented extensively with the medium, manipulating tonal range, color, and definition to create works that were unique and unrepeatable. Gertrude Käsebier's image of the photographer Clarence White represents the ultimate in pictorial idealism, using a painterly approach to portray the photographer as artist. OLG

Native American Art

For most Native American people, the late 19th century was a time of extreme hardship. The United States government had forcibly moved Indian tribes from almost every region in the country to fragmentary reservations, often far from their homelands. On the Great Plains, the long and brutal wars were coming to a close. Everywhere white schools, missions, and government agents pressed to eradicate traditional ways of life. Virtually every family was touched by hunger, poverty, and disease. Against tremendous physical and psychic stress, Indian people struggled to chart a path between old ways and new realities.

Paradoxically, however, the late 19th century was also a time of astonishing creative production. At a time when so many aspects of cultural life were under siege, it would seem that traditional arts might wither as well. Instead, the reservation period coincided with a blossoming of ceramics, basketry, weaving, and silver jewelry in the Southwest; wood and stone carving on the Northwest Coast; and beadwork and painting in the Plains and Woodlands regions. Much of the Native American art in museum collections around the world dates from this troubled but fertile period.

Certainly the growing availability of new materials helped to stimulate art production. Glass beads for beadwork became more and more plentiful, commercially produced and dyed woolen yarns were taken up by weavers in the Southwest, and silversmiths became increasingly skillful in the techniques of metalwork. Painters availed themselves of inks, paints, and all kinds of paper. These new media freed artists from the need to prepare their materials from scratch, and together with drastic changes in lifeways, gave many people more time to pursue the arts.

In part the artistic renaissance was economically driven. To enter the cash economy vital to their survival, Indian women and men produced more goods to sell as curios. A general and rather romantic interest in Indians, together with the tourism that grew as the rail-

roads penetrated remote areas of the West and Southwest, created a ready market among Euro-Americans for traditional arts adapted for tourist use. Baskets and ceramics became smaller, blankets to wear turned into decorative rugs, and totem poles shrank to miniature size. New forms appeared as well: ashtrays, beaded match holders, and carved wooden salad tongs among them.

It is important to note, however, that the opening of this new market for Indian arts did not necessarily result in any diminution of quality. Although there was a range of goods produced, from quick and easy birch-bark canoe models to the most elaborate and time-consuming items of clothing, the standards of craftsmanship for the best pieces were undiminished. And, as the objects in this exhibition eloquently testify, certain types of art, such as basketry and silver, came to their most fully realized forms in this period.

Art did not survive as tourist curios alone, however. Despite pressures to assimilate, many Indian people continued to make objects for their own use: formal or ceremonial clothing, household goods, and religious material. On the Northwest Coast, men continued to make masks and religious paraphernalia for ceremonies that increasingly had to be concealed from white missionaries and government agents. In the Plains and Woodlands regions, too, religious practice was carried out covertly, and religious objects continued to be an important means of passing on knowledge and tradition to younger generations.

In a time of overwhelming change, art made both for outside sale and for traditional use quickly became a means of retaining a sense of cultural and personal identity. Even when wearing conventional Euro-American dress, many Indian people retained some aspect of tradition: moccasins worn with a Victorian dress, or silver necklaces over a flannel shirt and jeans. Surprisingly, distinctions between regional styles became sharper in this period. Zuni silver differentiated from Navajo, Cheyenne beadwork from Arapaho, perhaps reflecting a greater interest in issues of identity. By the turn of the century some painters and other artists had begun to sign their work.

Some of these turn-of-the-century art forms—beaded clothing, turquoise-and-silver jewelry, or painted shields, for example—have become so familiar in museums, in the marketplace, or even in films, that they seem archetypal, and it is easy to forget that they belong to a specific time and place. In fact they reflect with considerable accuracy the reality of Indian peoples' lives: their careful protection of older ways and their creative adaptation to the new. Art that has survived to the present, sometimes in museum collections, sometimes within Indian or Euro-American families, remains an evocative reminder of complex times, and of the tenacious powers of tradition and innovation.

LOUISE LINCOLN

Dough Bowl

19th century

Cochiti, New Mexico
Fired clay
13½ inches diameter
The Nelson-Atkins Museum of Art
Purchase: Nelson Trust, 33–1149

Cochiti Pueblo produced less pottery than other Pueblo villages, but Cochiti work is very distinctive. This fine old dough bowl bears a geometric pattern on the exterior that derived from 17th-century designs, while the delicately painted images on the interior began to appear in the 19th century. The central floral motif is surrounded by alternating rain clouds and deer. The isolated, seemingly unrelated images are typical of Cochiti layout.

The stepped band on the inner rim of the bowl is left incomplete, and the line encircling the flower motif is also broken. Unfinished lines like these appear on most Pueblo pottery and, while theories about their significance abound, what these breaks mean remains uncertain. LL

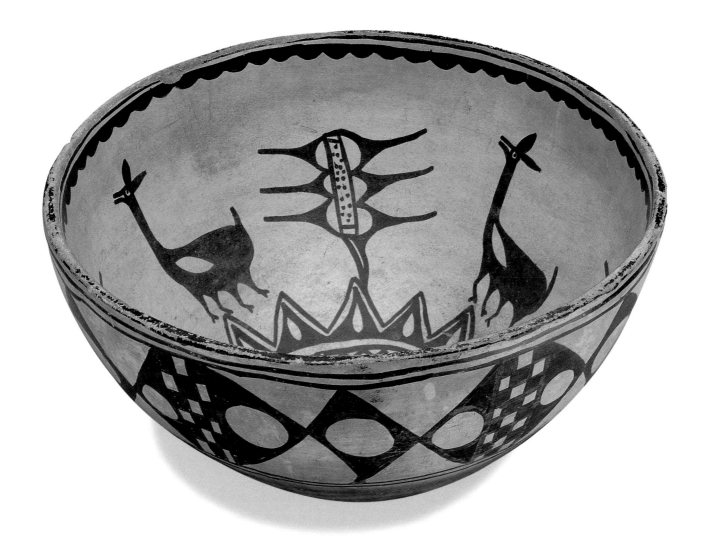

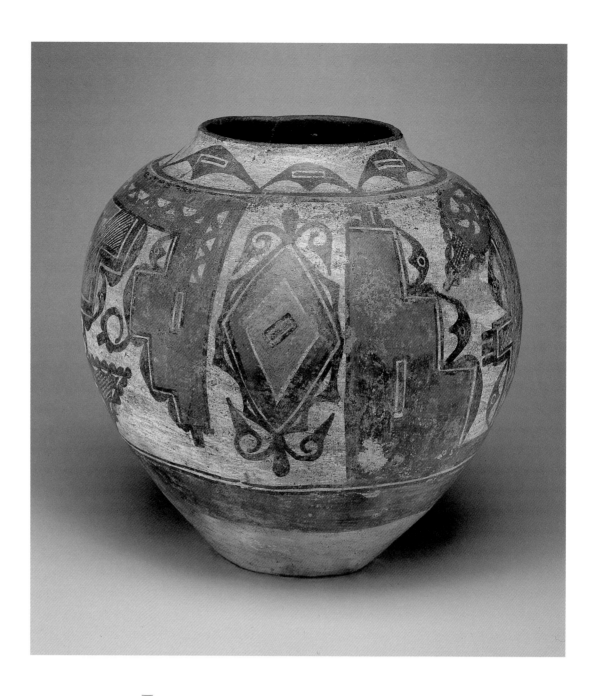

Vessel

19th century

Santa Ana or Zia, New Mexico
Fired clay
14 inches high
The Nelson-Atkins Museum of Art
Purchase: Nelson Trust, 33–1157

Jars from Santa Ana and neighboring Zia Pueblos are so close in shape and design that they are often indistinguishable. Pottery designs were an important arena of cultural distinction, but Zia and Santa Ana are an unusual example of a shared aesthetic vocabulary. This large container shows the high-shouldered, short-necked form characteristic of both villages. Bold painted designs featuring a diagonal orientation and red forms outlined in black are also seen on pieces from both places. LL

HUMPED WOLF
Crow, Northern Plains region

Shield, 19th century

Buffalo hide, pigments
21 inches diameter
The Minneapolis Institute of Arts
The Christina N. and Swan J. Turnblad
Fund and Gift of the Regis Corporation,
87.51

Humped Wolf, who lived in Montana in the latter half of the 19th century, made this shield after he was wounded in a battle against Lakota warriors and became separated from his Crow companions. To keep from freezing, Humped Wolf took shelter in the carcass of a dead buffalo and then dreamt of the image that he later painted on his shield.

All the details on the shield refer to war. The green band to the left alludes to summer, the preferred season for battle during the long period of Indian wars over territory. The small streaks and dots represent a hail of bullets, which the shield and its protective image will deflect. The buffalo, a source of sustenance and spiritual guidance for all Plains people, also suggests Humped Wolf's shelter and the spirit that appeared in his dream. The protective power of this and all other painted Plains shields derives not from their size and impenetrability but from their spiritual force. LL

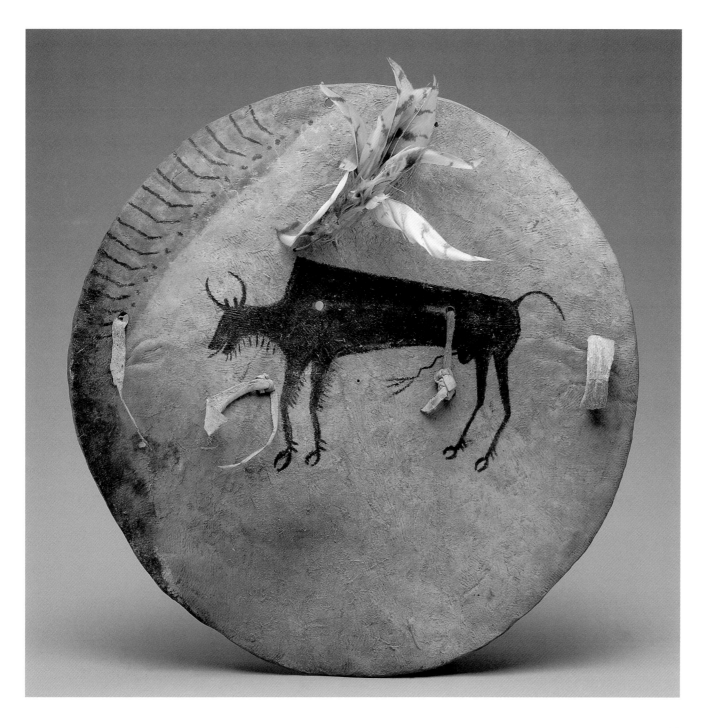

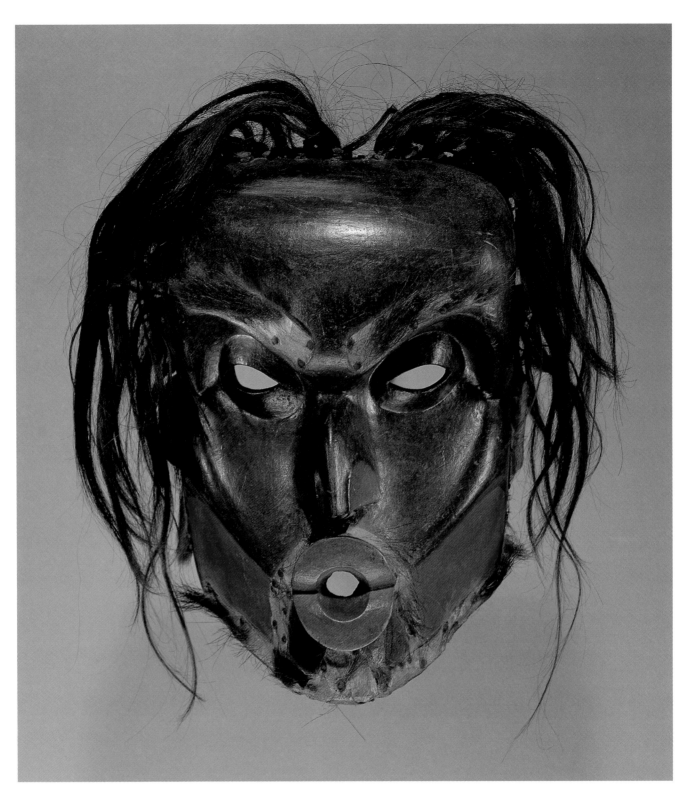

Tsonoqua Mask

19th century

Kwakiutl, Alert Bay, British Columbia
Wood, hide, cloth, metal, pigments
11½ inches high
The Saint Louis Art Museum
Gift of Morton D. May, 269:1982

A standard supernatural character in Northwest Coast mythology is the Tsonoqua, usually thought of as a fearsome giantess living deep in the forest. Powerful and violent, she is sometimes said to steal away children—especially disobedient ones! She also possesses great wealth.

With its disordered tangle of hair and bushy eyebrows, this mask suggests the wildness of Tsonoqua spirits. The prominent mouth forms a frightening cry. The mask was made to be worn during the season of ceremonial feasting, when a man would assert the wealth and power of his family before assembled guests. As he spoke, he would distribute lavish gifts to everyone so as to underscore his claim to prestige. His mask allied him to the power and wealth of Tsonoqua. LL

Grave-Figure Model

late 19th century

Haida, Queen Charlotte Islands
Alder wood, pigments
22 inches long
The Saint Louis Art Museum
Purchase, 132:1976

Anthropologists working on the Northwest Coast in the 1880s, believing that rapid social change might soon eradicate native peoples' traditional knowledge and culture, formed collections of artifacts, and sometimes commissioned small-scale models of larger traditional pieces such as sculpture, totem poles, and houses. This model of a grave-box figure is such a piece, probably made by the artist Gwaytihl, who produced several other small versions of the same subject.

According to an old label on another version of this grave-figure model, the figure represents a "Hydah medicine man. This man was lost in the woods. He fell and broke both legs and was found as represented here, starved to death." The shaman, identifiable by his distinctive topknot, reclines on his back. His knees protrude through a short skirt, probably made of shredded bark. His emaciated body and face show the effects of his starvation, but they may also refer to a shaman's ability to change form. LL

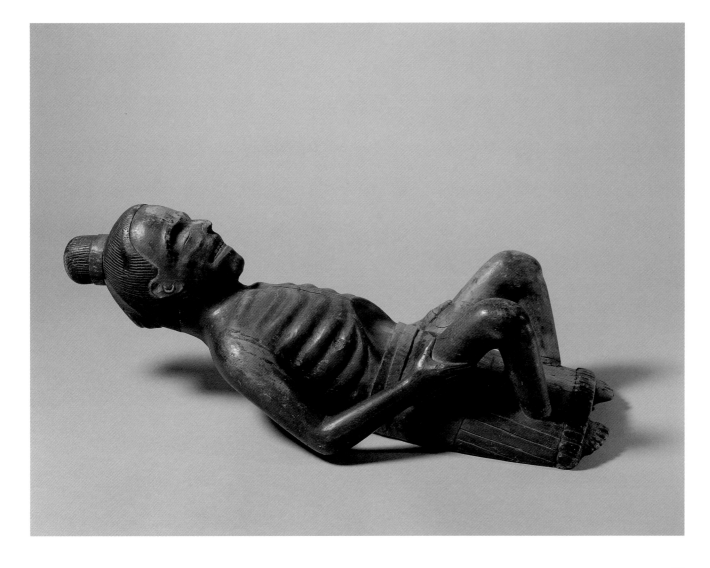

Basket

late 19th century

Tlingit, Alaska
Spruce root, grass
13 inches high
The Nelson-Atkins Museum of Art
Purchase: Nelson Trust, 33–1322

Along the Pacific Northwest Coast baskets were the most common form of household container until they were replaced by factory-made goods. Classic Northwest Coast baskets were woven so firmly and skillfully that many were watertight and could be used for cooking as well as for gathering berries and shellfish or storing food. For a brief period around the turn of the century, Tlingit women also made particularly fine baskets as trade items. This basket dates to that period and is similar in shape to a *sahkatonah*, or berry-picking basket.

Tlingit baskets are made of spruce root fibers, decorated by wrapping dyed grasses around the weft strands in a technique called false embroidery. Each of the pattern elements has a name, and several patterns can be combined according to the taste of the weaver. Here the central band of chevrons, called "flying goose," is enclosed by split crosses; the stacked triangle pattern is known as "spear barb." LL

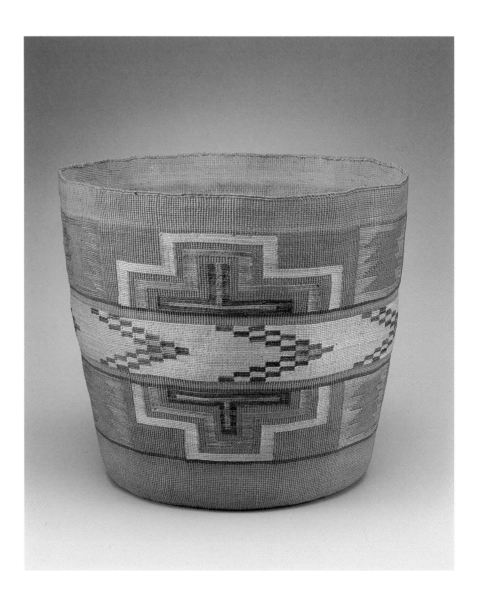

Headpiece

late 19th century

Bella Coola, British Columbia
Wood, paint, abalone shell, copper, mirrored glass
8¼ inches high
The Saint Louis Art Museum
Gift of Morton D. May, 272:1982

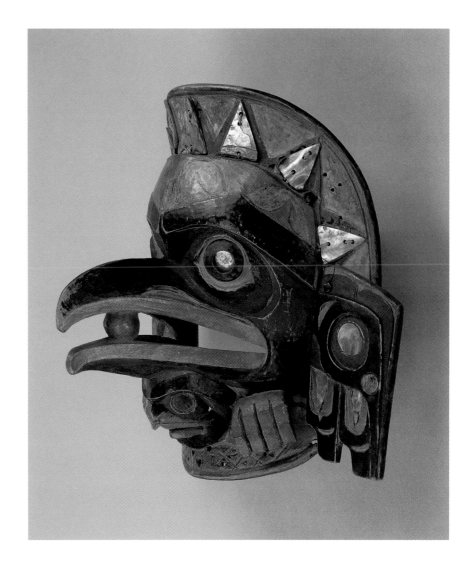

In the late 19th century Northwest Coast peoples observed an elaborate calendar of ceremonial obligations that required special costumes and ornaments. This spectacular headpiece, or frontlet, would have been part of the costume worn by a ranking man as he greeted guests arriving by boat for such occasions. A cascade of ermine skins, suspended from the headpiece, would have extended down the wearer's back, while a crown of sea-lion whiskers above, now missing, would have encircled eagle down. As the wearer danced to welcome his guests, the down was gently released, fluttering through the crowd as a gesture of hospitality.

This headpiece represents Raven, who in the mythic past stole the Sun from its hiding place and established it in the heavens, thus setting in motion the world that we know today. In his beak he holds the sun, while rays of light, represented by the abalone shell, shine around his head. LL

Vessel

late 19th century

Acoma, New Mexico
Fired clay
12 inches high
The Minneapolis Institute of Arts
Gift of the Hennepin County Historical
Society, 89.93

Potters from Acoma Pueblo are particularly known for their thin-walled, fine wares as well as for their sure, finely painted decoration. In the 20th century such ceramics have generally been made to sell to outside markets, but in earlier times they served as containers for water or food. Like all traditional ceramics from the American Southwest, Acoma pots are built by the coil method, without use of the wheel, then scraped smooth. Their decoration is painted on after they are fired.

This vessel uses a pattern of alternating geometric shapes and curved lines typical of Acoma painting styles. The way the complex pattern accommodates the swelling form of the pot reflects the careful process of decoration. As one Acoma woman explained, "First I draw the design with charcoal, and if it does not look right I rub it out and draw it over again and if it is not right I rub it out again and do it over. Sometimes I rub it out two or three times before it is right." LL

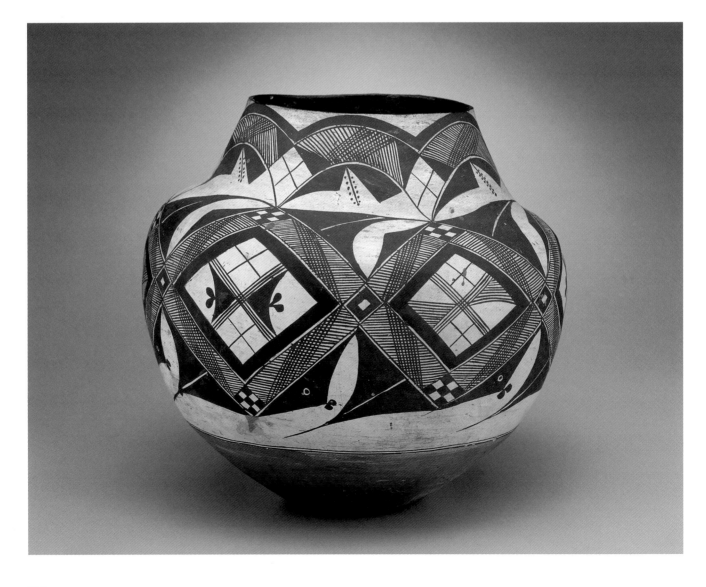

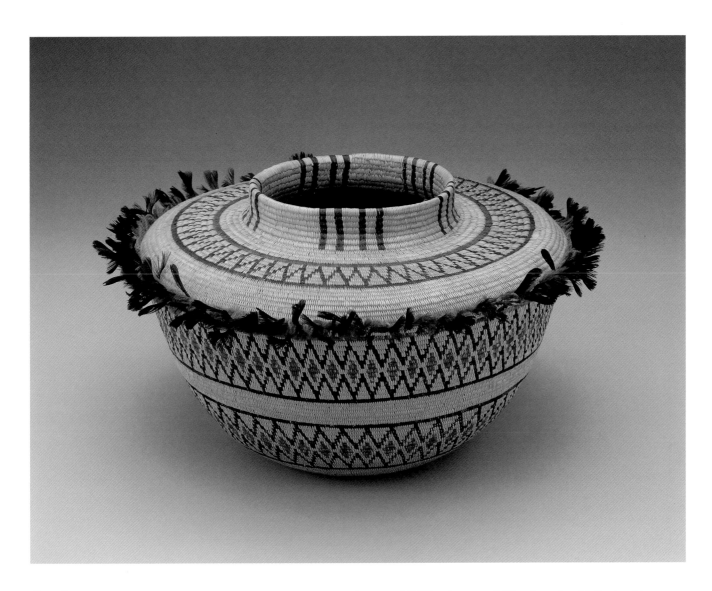

Basket

early 20th century

Yokuts, California
Willow, marsh grass, bracken fern,
redbud, wool, feathers
6¼ inches high
The Nelson-Atkins Museum of Art
Purchase: Nelson Trust, 33–1272

Yokuts women in central California produced extremely fine, delicately patterned baskets in a number of shapes. This type of basket, sometimes called a bottleneck basket, was commonly made for outside sale around the turn of the century. Like many Yokuts baskets, this one shows a pattern of bands of diamonds known as "rattlesnake." On some baskets where the snake motif is shown more directly, the head and tail are represented as well.

The use of feathers to decorate baskets has a long history in the California region. Following his voyage along the California coast in 1579, Sir Francis Drake described a similar use of feathers: "Their baskets were made in a fashion like a deep boale, . . . they were wrought upon with matted down of red feathers." On this basket colored yarns have been added as well.

LL

Basket (Olla)

early 20th century

Western Apache, Arizona
Devil's claw, cottonwood
21¼ inches high
The Nelson-Atkins Museum of Art
Purchase: Nelson Trust, 33–1312

As the Santa Fe Railroad brought adventurers and tourists to the Southwest at the end of the 19th century, weavers, potters, and basketmakers found a ready market for their work at depots all along the line. Many of these wares were adapted for new consumers: objects were smaller, lighter, and often showed more pictorial imagery. Although Apache women made small *ollas*, or urn-shaped baskets, to store food, accounts by travellers visiting Apache villages earlier in the century made no mention of tall *ollas* like this one. These large baskets seem to be the exception to the rule of reduced scale in pieces made for sale, perhaps because they could be impressive in size but light in weight.

The woman who made this basket combined human and animal figures in an overall pattern of connecting diamonds; her placement of figures against the dark background of the diamonds is unusual. The animals may be coyotes, an important character in Apache mythology. LL

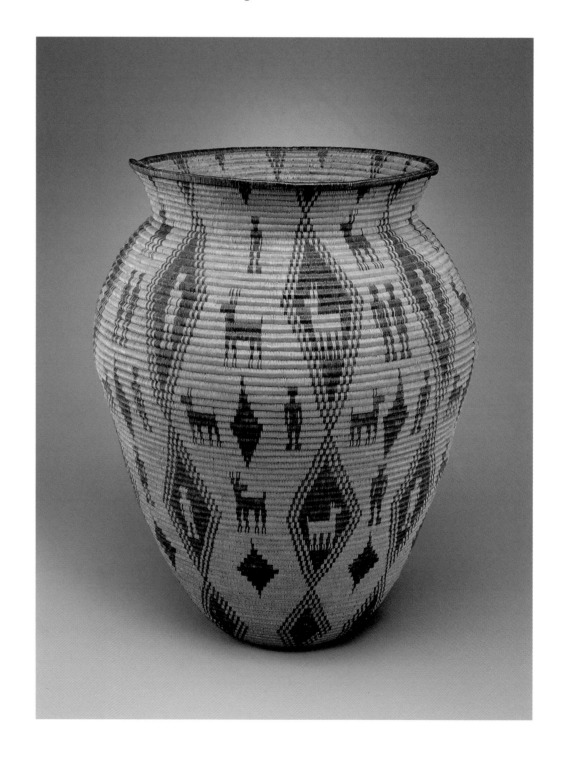

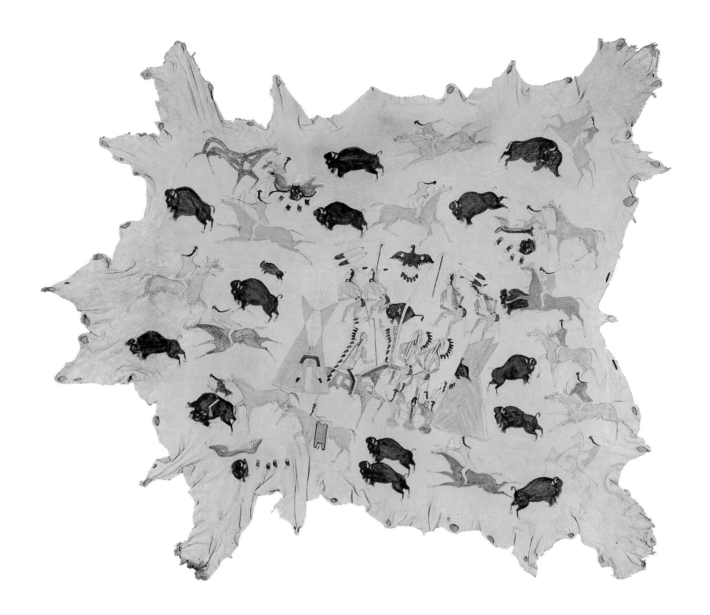

CADZI CODY
1866–1912
Shoshone, Wyoming

Painted Hide, about 1900

Elk hide, pigments
68 x 79 inches
The Minneapolis Institute of Arts
Gift of Bruce B. Dayton, 85.92

Although many pieces of late 19th-century Native American art were collected directly from their makers, it is nonetheless unusual to know the name of the artist. This painting is the work of a Shoshone man named Cadzi Cody who lived on the Wind River Reservation in Wyoming around the turn of the century. Unfortunately little is known about his life, but he made a number of similar paintings on elk or deer hide, mostly for sale to an outside market.

Cadzi Cody's early works portray performances of the Wolf Dance, but in later versions he added other images to suit the interests of his audience. In this hide, scenes of a buffalo hunt enclose an image of the central dance and, although the figures are still dressed for the Wolf Dance, they surround the center pole of the Sun Dance. As the most important event of the Plains ceremonial cycle, the Sun Dance had attracted the disapproval of missionaries and government agents as well as the curiosity of tourists. Cadzi Cody seems to have made so many of these paintings that he began to use a stencil for the buffalo images, but his freehand horses, in various poses, are unfailingly elegant. LL

Cradleboard and Cover

early 20th century

Kiowa, Plains region
Wood, leather, cloth, beads, metal
31 inches long
The Nelson-Atkins Museum of Art
Purchase: Nelson Trust, 33–1241

Throughout the Plains region, Indian families have sheltered their babies in cradleboards, which combined the functions of backpacks and infant seats. With the baby wrapped snugly inside, the cradleboard could be tied to the mother's shoulders or propped nearby while the family worked, ate, or socialized. Often the beautifully beaded covers were made by female relatives of the mother, and a woman might receive several as baby gifts. The undulating abstract designs and use of dark background colors are characteristic of Kiowa beadwork.

Cradleboards were generally made for use—they did not often appear as tourist goods or curios—and most of the examples that have survived show considerable wear. This cradleboard, however, is in unusually good condition. When it was purchased for the museum, it contained a doll. LL

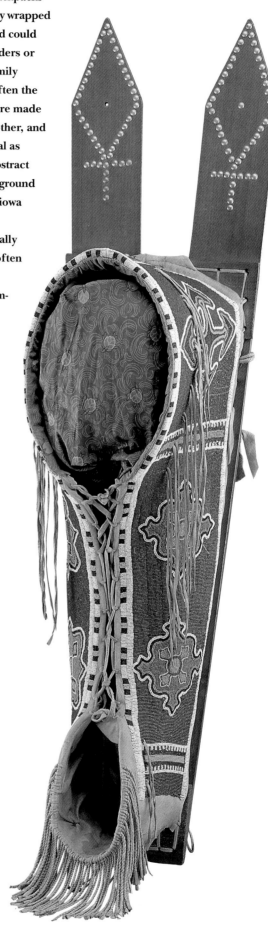

Dancing Blanket

20th century

Chilkat, British Columbia
Wool, cedar bark
52 x 65 inches
The Nelson-Atkins Museum of Art
Purchase: Nelson Trust, 33–125/6

With the seemingly unlikely materials of shredded cedar bark and spun mountain-goat hair, weavers of the Chilkat subgroup of the Tlingit people created one of the great textile traditions of the world. This blanket, or cape, would have been one element of a man's elaborate ceremonial dress, in addition to a tunic, an apron, and a headdress or frontlet. Working on a bark warp, Chilkat women used goat-hair yarn in a tapestry technique to reproduce designs made by the men; this is one of many examples of Native American men and women working collaboratively in the production of art.

Although the use of shredded bark for outer garments has a long history on the Northwest Coast, it seems likely that these elaborate clothing traditions developed later, in the 18th or early 19th century. The highly stylized design shows multiple clan animals in overlapping patterns. LL

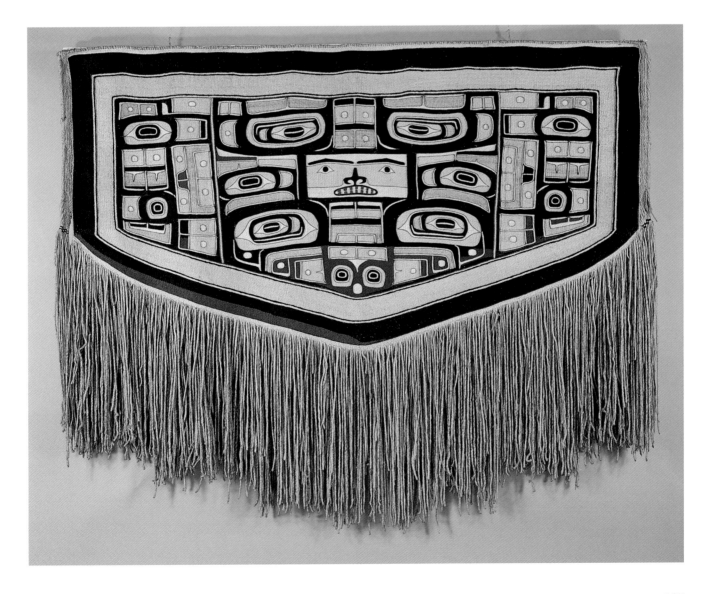

Wrist Guards (Ketoh)

about 1920

Navajo, Arizona or New Mexico
Silver, turquoise, leather
Each about 3½ inches long
The Minneapolis Institute of Arts
Bequest of Virginia Doneghy, 90.58.351,
354

For centuries, jewelry of stone and shell had played an important role in personal adornment for many Southwest peoples, but new jewelry forms were developed around the 1860s, when Navajo men began to learn silversmithing. By the end of the 19th century they had developed a number of new kinds of jewelry, most famously the squash-blossom necklace and the concha belt. Native men and women alike wore quantities of silver on special occasions.

One of the most distinctive jewelry forms is the *ketoh*, a silver-ornamented leather band worn by male archers to protect their wrists from the snap of the bowstring. In these two exam- ples, which carry all the hallmarks of the mature Navajo style, silver is treated as a sculptural medium and turquoise is used sparingly. The strong quadrilateral symmetry and focus on the center point relate to the impor- tance of the cardinal directions in Navajo cosmology. LL

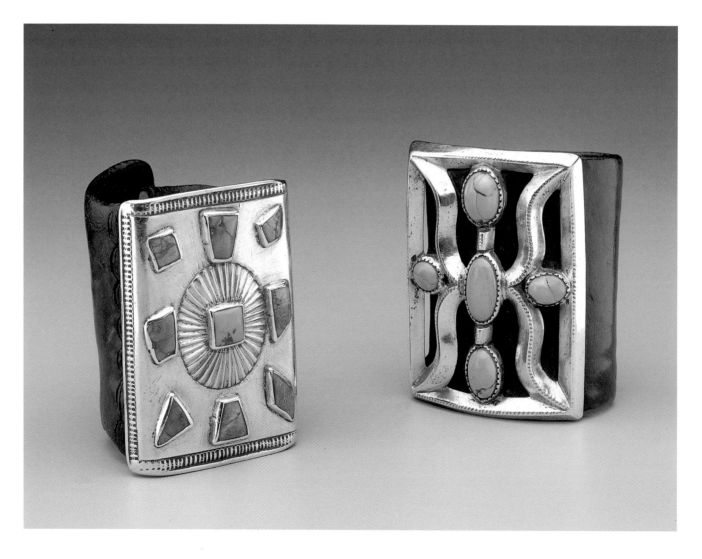

Squash-Blossom Necklace

about 1930

Zuni, New Mexico
Silver, turquoise
16½ inches long
The Minneapolis Institute of Arts
Bequest of Virginia Doneghy, 90.58.150

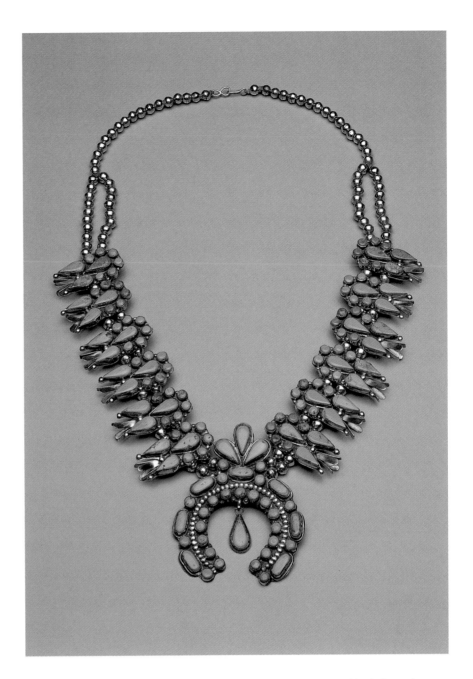

Silver jewelry made by Zuni men in the 19th century closely resembled the jewelry made by the Navajo metalsmiths, but by the early 20th century a distinctive Zuni style had appeared. Whereas Navajo work exploited the sculptural qualities of silver, the newer Zuni pieces made greater use of turquoise, setting many small stones of identical shape in arcing or grid-like patterns. On this lavishly set necklace, the silver squash blossoms virtually disappear beneath the precisely shaped stones. As on much Zuni silver, the bezels that hold the stones in place are serrated, unlike Navajo bezels, which are smooth. Together, the complex stonework and serrated cuts produce a dazzling effect. LL

Artistic
Interiors

As the 19th century progressed, industrialization allowed some people to amass tremendous wealth and cities west of the Eastern Seaboard to expand rapidly. The new magnates of industry in places as far west as Minneapolis and San Francisco made use of improved transportation to employ the leading interior decorators of the day, Herter Brothers of New York, to furnish their homes. Artists still turned to New York as the cultural mecca, although its appeal, particularly for architects and decorative artists, weakened as other cities and their inhabitants sought to develop their own artistic environments and manufacturing bases.

A spirit of internationalism prevailed in the United States in the fifteen years or so on either side of 1900. The opening of Japan to the West in 1854 by the American fleet commanded by Commodore Matthew C. Perry led to new opportunities for trade and cultural exchange. In the following decades the works of many European and American artists reflected Japanese influence. Artists, especially those associated with the decorative arts, continued to leave their native countries to establish themselves in America, either founding their own businesses like the Herter Brothers or working for others, such as Kataro Shirayamadani at the Rookwood potteries in Cincinnati.

American artists also travelled abroad, sometimes for formal study or more often simply to see for themselves, and returned home inspired by the artistic ideals of Paris, Rome, London, or even Japan. European architects, designers, and artists travelled to America to meet with their American counterparts. There were numerous international exhibitions held across America in this period, such as the 1893 World's Columbian Exposition in Chicago and the 1904 World's Fair in St. Louis, bringing the arts of many nations to the front doorstep of the American artist as well as the consumer. At these exhibitions, American works of silver, glass, ceramics, and furniture could be viewed in an international context and, since manufacturers often produced virtuoso pieces especially for show, the best were celebrated.

With its motto of "Art for Art's Sake," the Aesthetic Movement encouraged the making and appreciation of art that revelled in exotic ornamentation, ethereal forms, and an elegance that overrode useful function. Artists of the Aesthetic Movement created paintings, sculpture, and decorative arts whose beauty and ornamental quality were so highly valued that distinctions between the fine and the decorative arts began to disappear.

The Aesthetic Movement had paved the way for the Arts and Crafts Movement by encouraging artists and designers to turn to nature for inspiration and to look to the past for styles untainted by the Industrial Revolution. The ideals of the Arts and Crafts Movement were eloquently expounded in the writings of the English social philosophers John Ruskin and William Morris. They advocated that art be made from materials and designs appropriate to the place of its creation; crusaded for the well-being of the artisans; questioned the relationship of art and design to industry; and raised the issue of the role of women in society and the arts.

Influenced by these concerns, Frank Lloyd Wright in Chicago designed his buildings and furnishings with both geography and function in mind, and the Prairie School was born. In Pasadena, Greene and Greene combined Wright's thinking with their own interest in Asian art, and the California Bungalow style evolved. The women decorators at the Newcomb Pottery, New Orleans, sought out local flora and fauna for inspiration for their designs. Elbert Hubbard, who believed that work should be meaningful as well as enjoyable, founded the Roycroft Community near Buffalo in 1895 as a commercially viable craft organization; at its height, around 1910, the community employed over 500 people. In Cincinnati, Maria Longworth Nichols started Rookwood in 1880 as an art pottery with facilities specifically designed for hand construction and decorating.

American artists studied, changed, adapted, and even rebelled against external influences and imbued their creations with a sense of both time and place. It was Europe's turn to sit up and take notice of what was happening across the Atlantic. A display of Rookwood pottery won a gold medal at the Universal Exposition in Paris in 1889. In the early 1890s Samuel Bing, the French entrepreneur, art historian, and promoter of Louis Comfort Tiffany and John La Farge, visited New York, Boston, Albany, Chicago, Cincinnati, Pittsburgh, and Washington, D.C., to research his book *Artistic America* (published 1895). Bing also obtained a contract that gave him exclusive rights for the distribution of Tiffany glass in Europe. Tiffany glass was readily available through his shop in Paris, and in 1894 he sold the first Tiffany vase to the Louvre.

Art objects made in America were reaching a new and receptive audience. To the outside world, America, unlike Europe, embodied a new spirit of democracy. It welcomed the machine instead of rejecting it. Even though architects like Frank Lloyd Wright and Greene and Greene created houses and interiors for the wealthy and elite few, craftsmen like Gustav Stickley, with his furniture "for well built, democratic homes," were bringing the Arts and Crafts ideal to the middle classes. As Bing wrote in 1903, "America, more than any other country in the world, is the soil predestined to the most brilliant bloom of a future art which shall be vigorous and prolific."

SARAH NICHOLS

EDWARD C. MOORE
1827–1891, designer
Tiffany and Company,
New York City, founded 1837

Pitcher, about 1878

Silver
10 1/16 inches high
The Toledo Museum of Art
Purchased with funds from the
Decorative Arts Purchase Fund and
Museum Art Fund, 1985.32

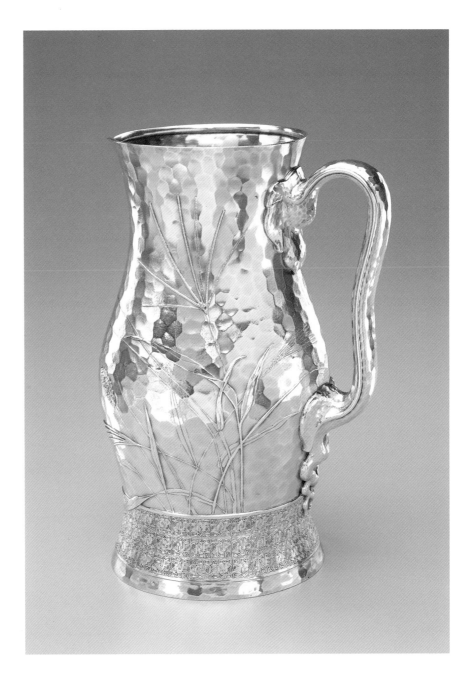

Edward C. Moore, the chief designer for Tiffany and Company, incorporated fashionable Asian taste in both this water pitcher's inventive design and its virtuoso techniques. Japanese taste is evident in both the asymmetrical composition, applied grasses, hand-hammered surface, applied and engraved butterfly, and highly sculptural handle suggestive of organic, aquatic life. The flared base and its interlaced cast design, by contrast, were based on ancient Chinese metalwork. Works such as this contributed to Moore's international reputation; it is known, for example, that he exhibited a pitcher of similar design at the 1878 Paris Universal Exposition. RB

LG, designer
Whiting Manufacturing
Company, North Attleboro,
Massachusetts

Vase, about 1880

Silver
7½ inches high
The Toledo Museum of Art
Purchased with funds from the Florence
Scott Libbey Bequest in Memory of her
Father, Maurice A. Scott, 1987.70

The garden flowers around the body of this vase—including lily, jonquil, iris, fuchsia, geranium, rose, and pansy—stand out in high, naturalistic relief. They contrast with the flat, geometrically stylized band of Egyptian lotus plants decorating the neck. On one level, this contrast represents the eclectic nature of designs popular in Europe and America during this period, but on another level it illustrates the artistic controversy of the time over naturalism versus stylization

as the proper source for ornament.

This controversy was an aspect of the Aesthetic Movement, which originated in England and was at its height in America in the 1870s and 1880s. This movement emphasized art for its own sake and focused on utilitarian objects, believing that art could and should improve the objects of everyday life. An indication of this belief is that even this small vase was considered important enough to include signatures by the artist LG and the chaser L. Goerak (?). More commonly, such an object would have had the manufacturer's name as the sole identification.
RB

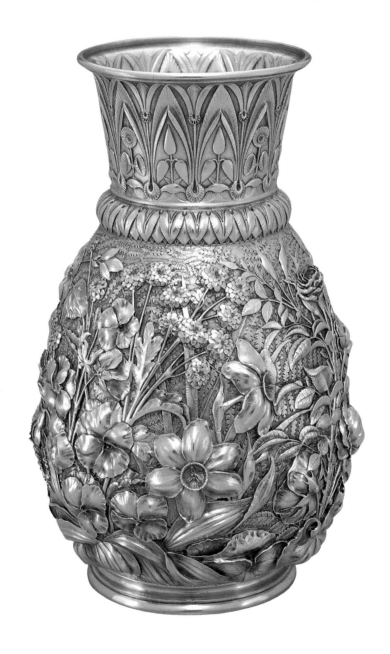

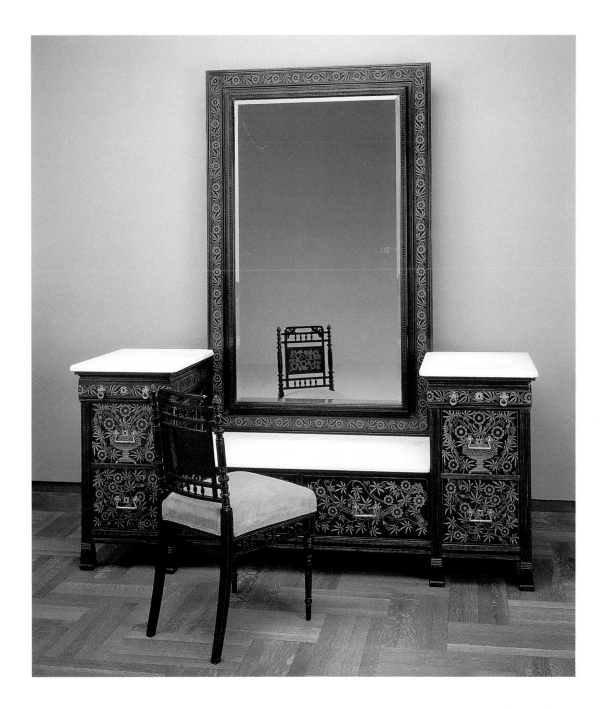

HERTER BROTHERS,
New York City
1865/66–85

*Dresser, Mirror, and
Side Chair,* about 1881–84

Ebonized cherry, purple heart, white
pine, perhaps padouk, holly, marble,
brass
Dresser with mirror: 84⅜ inches high
The Saint Louis Art Museum
Purchase and Funds given by Mrs.
Harold Baer, Mrs. Ernest Eddy in
memory of William P. Williams, the Weiss
Foundation in memory of Edith N. Weiss,
Mr. and Mrs. L. K. Ayers, and the
Decorative Arts Society, 183:1977.2a, b
and 183:1977.6

This dresser, mirror, and side chair are part of a large suite of furniture owned by the railway magnate Collis Potter Huntington, a founder of the Central Pacific and Southern Pacific lines, and his socialite wife, Arabella Worsham Huntington. The suite was used in a guest bedroom in the Huntingtons' residence at 2 East 57th Street in New York.

These three pieces display characteristics typical of the Herter Brothers' Anglo-Japanese furniture from the early 1880s. The forms are rectilinear, simple, and restrained; the ebonized cherry ground with light wood marquetry is a masterwork of delicacy and definition and, superimposed on the massive shapes, creates a lively contrast of two- and three-dimensional features. The set incorporates Asian design elements that Christian Herter was exposed to during his studies in Paris, with the choice of bamboo, passionflower, and chrysanthemum motifs attesting to the current fashion for all things Japanese. ML

115

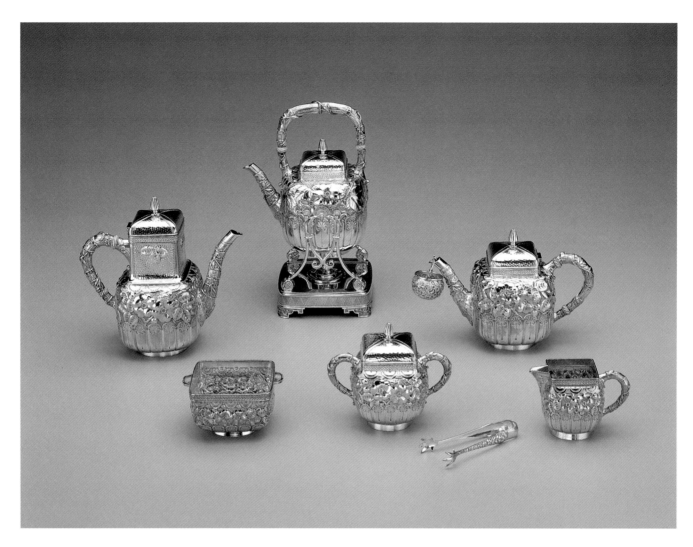

GORHAM MANUFACTURING COMPANY, established 1865

Tea and Coffee Service, *1883*

Silver
Coffeepot: 8½ inches high
The Minneapolis Institute of Arts
Gift of the Decorative Arts Council,
84.87.1–8

In 1831 Jabez Gorham added silver spoons to his line of jewelry; by mid-century the Gorham Manufacturing Company had become one of the largest firms of silversmiths working in the United States. Like many other silver-manufacturing establishments of the 19th century, Gorham produced silver in a number of eclectic styles. The square forms of the individual pieces in this service, the surface patterns of Asian fans and flower blossoms, and the rustic handles and spouts are typical of the Anglo-Japanese style. Although Europeans had been familiar with Japanese objects and motifs for several decades, it was not until the Centennial Exposition of 1876 in Philadelphia that Americans were first exposed to this new style.

The 1882 Gorham Company sale catalogue states that the pattern for this service was called Eglantine, after the wild English rose that decorates the upper half and shoulder of each piece. Company records indicate that such services first became available in 1880 at the cost of $575 and remained in production until 1888. Like most silver produced by Gorham, this set was marketed by an outside retailer, in this case the firm of Bailey, Banks & Biddle of Philadelphia. Their mark appears on the bottom of each piece along with the Gorham hallmarks. JAN and WBR

TIFFANY AND CO.,
New York City, established 1837

Presentation Tray, 1884

Silver
29 x 33⅝ inches
The Minneapolis Institute of Arts
Gift of Mr. and Mrs. G. Richard Slade,
81.5

This tray commemorates the completion of the Stone Arch Railroad Bridge over the Mississippi River on November 22, 1883. It was presented to James J. Hill by 17 prominent businessmen on behalf of the citizens of Minneapolis in gratitude for his role in the St. Paul, Minneapolis and Manitoba Railroad, the company that constructed the bridge to provide easy transport for cargo and goods to the heart of the business district. The central scene shows the bridge and many of the early industries of Minneapolis, including the Pillsbury Mill on the right. Hill is depicted in profile in the medallion at the top. Framing the tray are eight vignettes representing scenes from Hill's life, interspersed with heads of animals indigenous to the Northwest Territory.

The central portion is made of one large sheet of silver upon which additional thin sheets were layered to give a three-dimensional effect. The border was cast separately, with the vignettes decorated by hammering the design out from behind (repoussé). The animal-head trophies were also cast and applied separately, with the finer details being chased or worked with a hammer or punch to raise patterns and pick out details. About 7,000 hours were expended on the custom fabrication of the tray, at a labor cost of $2,975 in 1884. The tray was never intended to be used, as its design is far too elaborate and its weight at forty pounds impractical. JAN and WBR

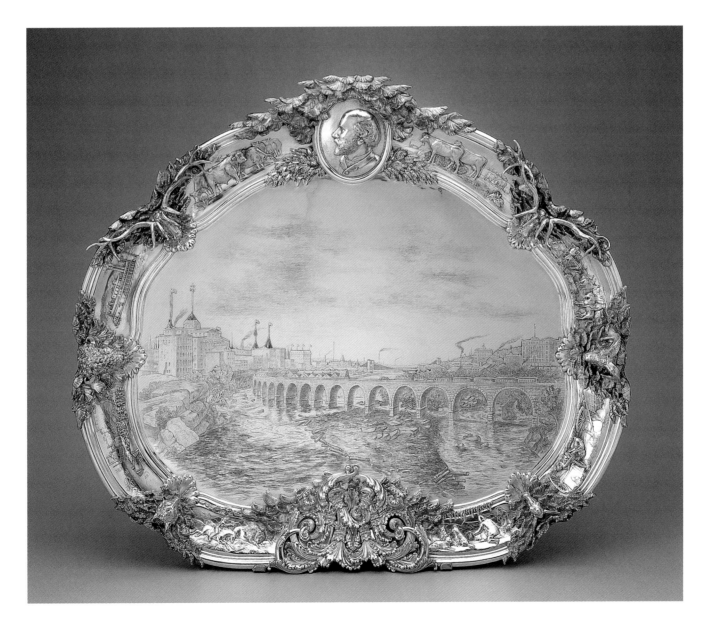

JOHN LA FARGE
1835–1910

Peonies Blowing in the Wind with Kakemono Border, 1889

Leaded and stained glass
56½ x 26½ inches
The Nelson-Atkins Museum of Art
Gift of the Enid and Crosby Kemper Foundation, F88–34

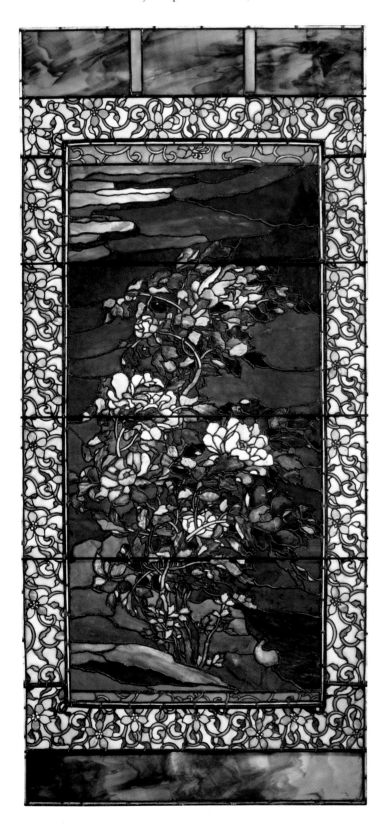

In 1879, while lying in bed during an illness, John La Farge happened to look up at a tooth-powder jar that was sitting on his windowsill. Such jars were made of glass to which calcifier had been added to produce a cheap imitation of marble. But the container had been defectively produced, so that the glass had become translucent, streaky, and variegated. La Farge immediately recognized that such a material could be used to produce new color effects in stained glass, and soon after he began experiments with glass manufacturers in Brooklyn to reproduce these unusual textures and color effects. His first windows with this new glass were so striking that imitators began to spring up, among them Louis Comfort Tiffany, whom La Farge unsuccessfully tried to sue for infringement of patent. Because of La Farge's poor business skills, he was commercially less successful than Tiffany and other designers, but artistically his best work in stained glass remains without rival.

Peonies Blowing in the Wind relates to one of La Farge's most important projects. In 1889 he was commissioned by the writer and statesman John Hay to produce two stained-glass windows, one of a peacock, the other of a peony, for the dining room of his newly constructed Washington residence, which stood just across Jackson Square from the White House, on the present site of the Hay-Adams Hotel. Overwhelmed by the importance of the commission, the artist produced several versions of each window. He then sent this version to an exhibition in London. There it was purchased by an English art lover and disappeared for nearly a century.

The most versatile American artist of his age, La Farge painted still lifes and landscapes, designed murals and stained glass, produced watercolors documenting his trips to Japan and the South Seas, and wrote art criticism as well as travel memoirs. His friends included the novelist Henry James, the philosopher William James, the historian Henry Adams, and the painter Winslow Homer. HA

KATARO SHIRAYAMADANI
1865–1948, designer
Rookwood Pottery,
Cincinnati, 1880–1960

Vase, 1890

Painted and glazed earthenware
18 inches high
The Minneapolis Institute of Arts
The David Draper Dayton Fund, 84.90

This vase reflects many of Rookwood Pottery's characteristic formulas of design and decorative techniques. Much of Rookwood's decoration was floral, and the ceramic artists carefully studied their subjects from nature; some were even accomplished botanical artists. As in scientific botanical prints, these flowers were extracted from their natural context and presented alone. Although the daffodils are shown in scrupulous detail, the rich colors and glazes evoke a sense of romanticism. The floral designs appear to be a haphazard, spontaneous display of nature, unaffected by any artifice, but they are, in fact, an exquisite illusion, carefully arranged to harmonize with the shape of the object.

The Rookwood Pottery was founded by Maria Longworth Nichols in 1880. She had been so impressed with the arts sent by Japan to the Centennial Exposition of 1876 in Philadelphia that she had originally planned to import Japanese ceramists to set up a pottery in the United States. She abandoned this idea and instead organized an experimental ceramic workshop, initially subsidized by her wealthy father.

By the mid-1880s Rookwood had become a thriving business and received international acclaim by winning a gold medal at the Universal Exposition of 1889 in Paris. Kataro Shirayamadani, the designer of this vase, was born in Japan in 1865 and was employed at the Cincinnati pottery by 1887. He was the first Japanese craftsman to be hired by Nichols and worked continuously at Rookwood, except for a few years between 1912 and 1920, until his death in 1948.

JAN and WBR

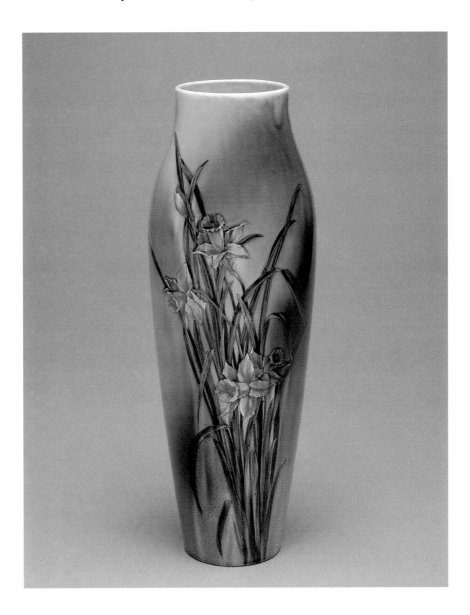

FRANK LLOYD WRIGHT
1867–1959, designer
Probably John W. Ayers
Company, Chicago

Dining Chair, about 1903

Stained oak, leather
55⅞ inches high
The Saint Louis Art Museum
Purchase: Funds given by the Decorative
Arts Society, 239:1977

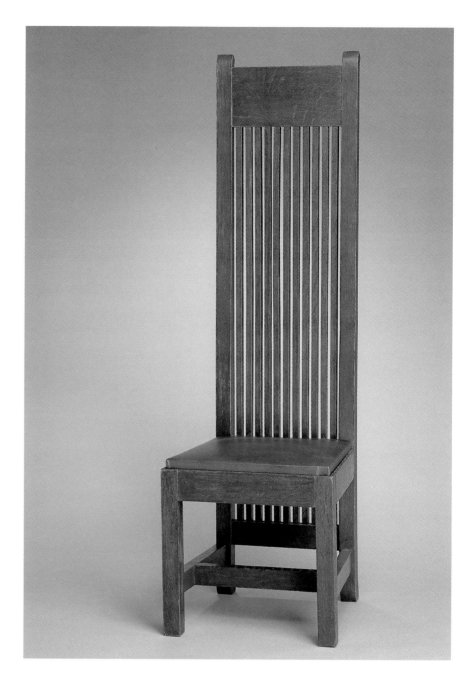

Throughout his career, Frank Lloyd Wright designed furniture to complement and help define the interior spaces of his architecture. Built-in or movable, each piece was created as part of the overall architectural scheme of a specific room and contributed to the feeling of unity and harmony. This high-back chair, designed for the dining room of the Ward Willits House in Highland Park, Illinois, was used around a large dining table, creating the effect of an intimate room within a room.

Wright's designs are important in the history of American furniture. He first used high-back chairs in his own home in 1895 and continued to make variants like this one for many of his Prairie School interiors. Compared to most cluttered Victorian furniture produced at the time, this chair appeared strikingly modern. Its straight lines are derived from the architecture of the Willits house itself, which was characterized by long horizontal lines, ceiling heights that shifted from low to high, alternately compressing and then dramatically opening space, and natural materials such as stone and untreated wood. Wright, unlike many of his contemporaries, believed that the clean, strong forms of his furniture could be adapted to machine production. CM

AUGUSTUS SAINT-GAUDENS
1848–1907

Victory, *1892–1903,*
cast about 1912

Gilded bronze
41⅞ inches high
The Carnegie Museum of Art
Purchase, 19.5.2

Augustus Saint-Gaudens studied principally in Paris, where he turned his back on the stiff classical forms favored by Roman-trained artists earlier in the century. He was also influenced by the British sculptor Alfred Gilbert. Consequently, even his classical subjects are treated with a lively realism and freedom of handling that enhance their decorative appeal.

The figure of a classically draped, winged female striding boldly forward as the embodiment of military triumph can be traced back to the monumental Greek sculpture *Nike of Samothrace,* about 200 B.C., now in the Louvre in Paris. This figure of Victory was originally part of the design for a monument to General William Tecumseh Sherman that was installed in New York's Central Park in 1902. It was later cast as an independent piece, probably after the artist's death. LWL

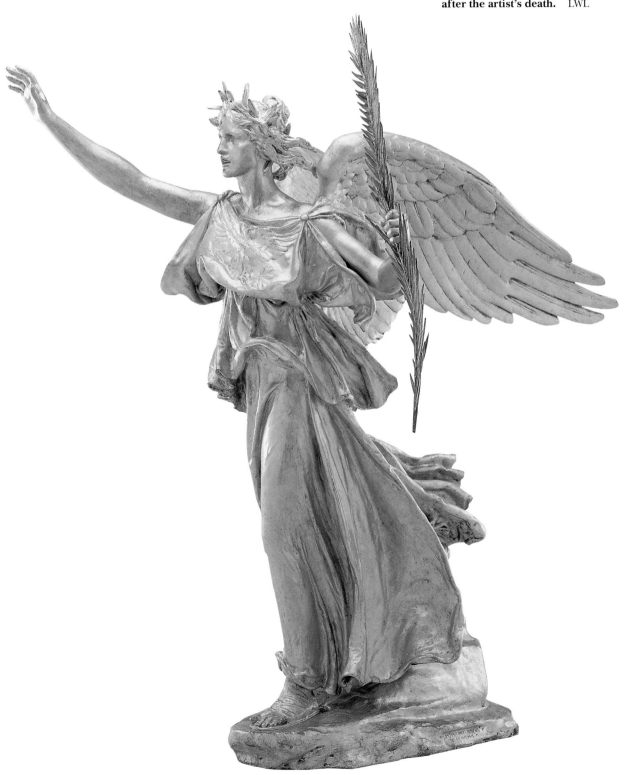

HARVEY ELLIS
1852–1904, designer
Craftsman Workshops of
Gustav Stickley, 1899–1915

Armchair, about 1903

White oak, copper, pewter, wood, rush
46⅞ inches high
The Carnegie Museum of Art
Decorative Arts Purchase Fund; Gift of
Mr. and Mrs. Aleon Deitch, by exchange,
82.50

Gustav Stickley, an expert in mass marketing and publicity, was the chief promoter of the Arts and Crafts Movement in the United States. His simple, sturdy furniture, made from American white oak and based on traditional, pre-industrial forms, appealed to the sensibilities and pockets of the rapidly expanding middle class. Stickley was influenced by the theories of art and labor expounded by the British artist and social reformer William Morris, but unlike Morris, Stickley accepted the machine as the only solution to producing furniture on an economically viable basis.

In 1903 Stickley hired the architect Harvey Ellis to create designs for his firm. Ellis added a graceful elegance and refined line to the Stickley style. He also introduced inlaid decoration in metals and contrasting woods. Unfortunately Ellis's designs were labor-intensive and costly to make, often too expensive for Stickley's middle-class market. Stickley stopped production of these designs after Ellis died in 1904, although his sophisticated designs continued to influence the Craftsman Workshops long after his death. SN

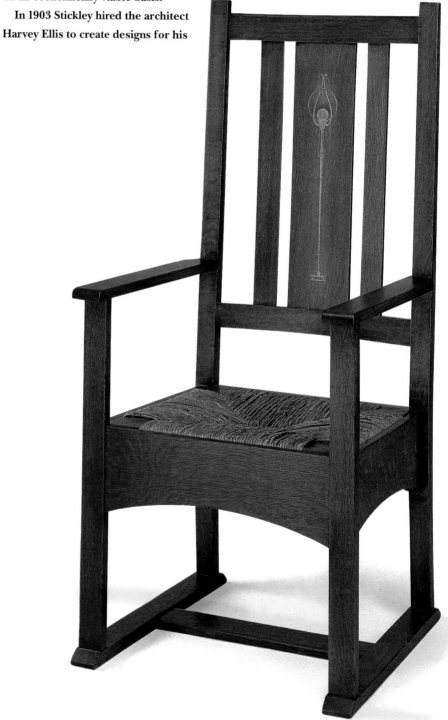

CHARLES GREENE
1868–1957,
and HENRY GREENE,
1870–1954, designers
Peter Hall Manufacturing
Company, Pasadena, 1906–22

Chair, 1907

Mahogany, ebony, mother-of-pearl,
copper, pewter, leather
42½ inches high
The Minneapolis Institute of Arts
The Putnam Dana McMillan Fund, 83.1

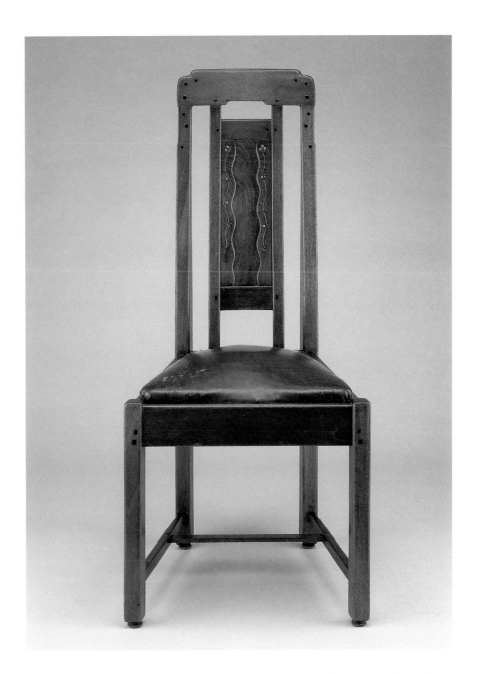

This chair, which was designed for the dining room of the Robert Blacker house in Pasadena, California, shows the influence of Asian prototypes, specifically Chinese furniture of the Ming dynasty. The simple design, fine craftsmanship, and undisguised construction, as seen in the prominent use of pegs, were all tenets of the Arts and Crafts philosophy. However, unlike many rigidly rectilinear pieces of Arts and Crafts furniture, the angles on this chair have been softened and the corners rounded. The stepped motif (called a cloud) on the crest rail is directly adapted from 17th-century Chinese furniture, as are the low, thin stretchers. Even the inlaid decoration —a vine with stylized florettes of mother-of-pearl, copper, and exotic woods—echoes the sinuous curves of Chinese furniture.

Greene and Greene were not strict adherents of Arts and Crafts doctrines. They designed houses and interiors for very wealthy patrons and their objects were not available otherwise. They saw themselves as creators of individual works of art and often used such expensive and exotic materials as mahogany, ebony, and mother-of-pearl, as opposed to the more common woods and metals favored by contemporary craftsmen. The Blacker house of 1907 was their largest and most elaborate commission, costing $100,000 at the time. JAN and WBR

LOUIS H. SULLIVAN
1856–1924,
and **GEORGE G. ELMSLIE**,
1871–1952, designers
**Winslow Brothers
Company, Chicago**

Bank Teller's Wicket,

1907–8

Copper-plated cast iron
41 x 23 inches
The Toledo Museum of Art
Purchased with funds from the Florence
Scott Libbey Bequest in Memory of her
Father, Maurice A. Scott, 1982.99

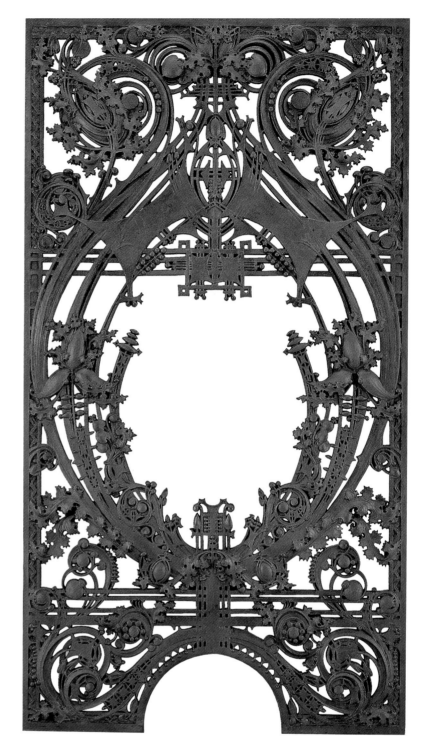

The National Farmers' Bank in Owatonna, Minnesota, was one of eight banks in small midwestern towns to commission the architect Louis H. Sullivan to design their buildings. Sullivan's individualistic style, aided by that of his chief draftsman, George G. Elmslie, was expressed not only in the bank's bold and colorful exterior, but in its interior as well. This teller's wicket, which separated the teller from the customer, was prominently located as one entered the bank so that it immediately and dramatically identified the building's purpose, thus uniting form and function. The wickets were removed from the bank during a remodelling in the 1940s.

The wicket's intricately swirling ornament of abundant leaves, vines, seed pods, branches, and berries represents Sullivan's belief that ornament was an integral part of his architecture, that it should express the "inner vitality" of a building, and that both ornament and architecture should rely on the forms of nature. RB

FRANK LLOYD WRIGHT
1867–1959

Stained-Glass Windows,

1912

Leaded and stained glass, white pine
44 x 14¼ and 44 x 9¼ inches
The Minneapolis Institute of Arts
The David Draper Dayton Fund,
72.11.2f, 3a

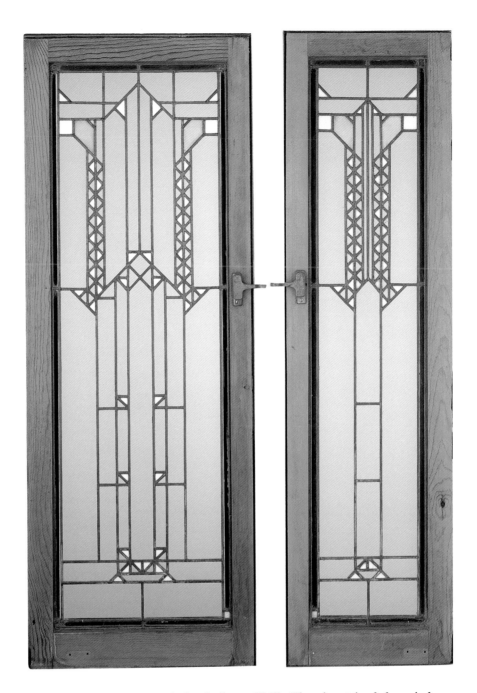

These windows are two of a band of ten from the hallway that led to the master bedroom of Northome, a house overlooking Lake Minnetonka in Wayzata, Minnesota. Frank Lloyd Wright designed the house for the Francis W. Little family in 1912. The house was dismantled in 1972; the living room/music room, which accommodated large musical events organized by Mrs. Little, is now installed in the Metropolitan Museum of Art in New York.

Wright created total architectural environments in which every decorative feature was integral to the whole.

Unlike Victorian stained-glass windows in which opaque glass often obscured the view outside, these designs used lead strips and white and clear glass to frame the view, much like a picture frame surrounds a painting. When seen from the outside, the white triangles gave the effect of aspen leaves twirling in the breeze; from the inside they recalled the sailboats that could be seen beyond the glass. KJ

ROYCROFT SHOPS,
East Aurora, New York, 1895–1938

Vase, about 1912

Copper
21½ inches high
The Minneapolis Institute of Arts
The Ethel Morrison Van Derlip Fund,
85.1

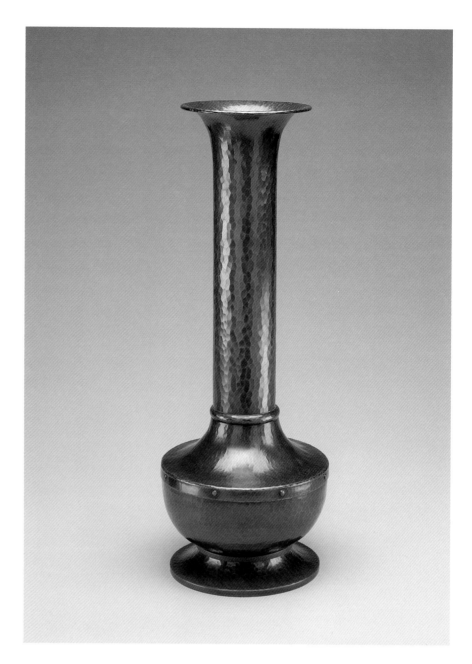

The Roycroft Community was founded by Elbert Hubbard in 1895 after a trip to Europe, where he became a convert to William Morris's theories of art and labor. Like other Arts and Crafts communities that sprang up around the turn of the century, the Roycrofters believed that labor would be both enjoyable and meaningful if objects for daily use were made by hand. Honesty of construction, the use of simple materials, and the idea that an object should be made by the same person who designed it were also commonly held Arts and Crafts principles.

This vase exhibits many of the elements that made up the aesthetic mission of the Roycroft Shops. Copper, a commonplace material, was used instead of a more precious metal, and the construction of the vase—lapped seams secured with rivets—is undisguised. The decoration consists only of the rippling surface, and no effort has been made to smooth away the result of hammering the metal into shape by hand. The products of the Roycroft Shops were meant to appeal to a wide audience and were therefore marketed by catalogue. Vases like this one were illustrated in the Roycroft catalogue from about 1910 and could be ordered by mail for $10. JAN and WBR

TIFFANY STUDIOS,
New York City

Jack-in-the-Pulpit Vase,
about 1913

Glass
20 inches high
The Toledo Museum of Art
Gift of Helen and Harold McMaster
1986.62

The name Louis Comfort Tiffany is associated with a variety of luxury items, including stained-glass windows and lamps, but he and his firm are best known for blown glass forms made after 1892. The Tiffany Studios earned an international reputation for developing a process to make iridescent glass whose surfaces were reminiscent of glass from the ancient world. Tiffany's blown glass was America's response to the sinuous lines and undulating natural forms of the Art-Nouveau style dominant in Europe at the turn of the century.

The Jack-in-the-Pulpit design was arguably the firm's most famous. Like the flower whose name it took, the form soars upward from a circular base to a sinuous, elongated neck and an exaggerated mouth and lip. The peacock blue color of this vase, a result of subjecting the lead glass to oxidizing and reducing processes, was one of the most admired within Tiffany's repertoire. DST

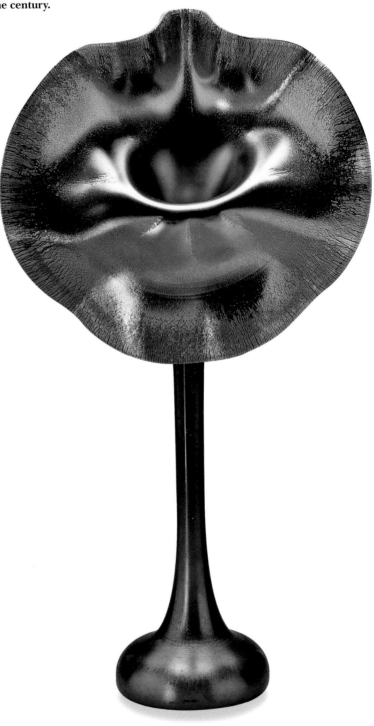

127

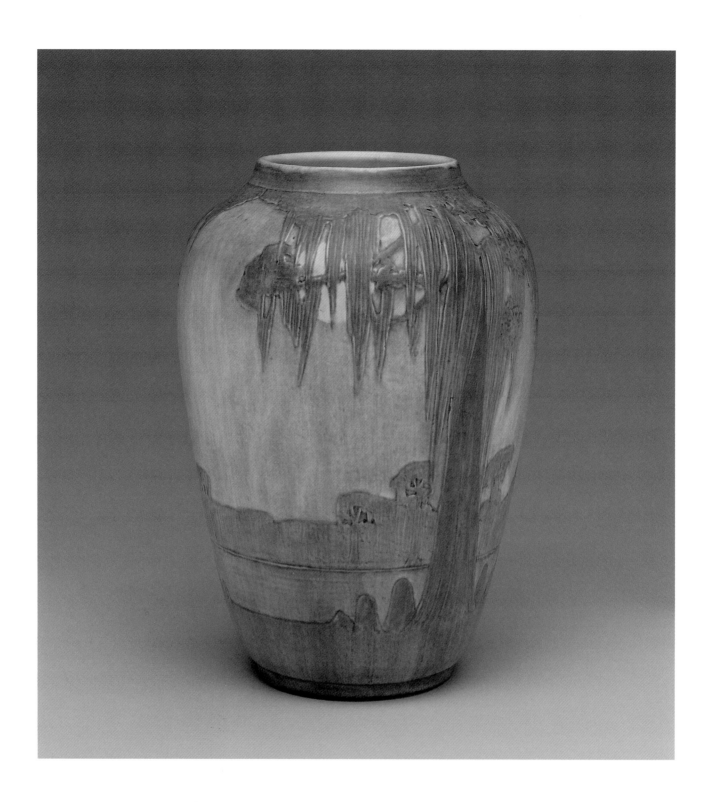

HENRIETTA BAILEY
1874–1950, decorator
Newcomb Pottery,
New Orleans, 1894–1941

Vase, 1916

Painted earthenware
10 inches high
The Carnegie Museum of Art
John Berdan Memorial Fund, 81.53

The production of hand-painted pottery was an important aspect of the Arts and Crafts Movement, particularly for women artists and designers. Pottery decoration was one of the few ways young women with artistic training could put their education to use to earn a living.

Newcomb Pottery was part of the Sophie Newcomb Memorial College for Women; it was conceived as a practical training ground for the students and graduates of the college's china-painting classes. Following Arts and Crafts principles, the pottery produced there was made primarily from southern clays; the artists drew upon the flora and fauna of the region for their decorative motifs (such as the trees dripping with Spanish moss on this vase); and no two pieces were alike, for fear that repetition would make the decoration mechanical. SN

The Modern Age

For American art, the 19th century ended eight or ten years late. The first great scandalous American art exhibition of the century, a display of work by the group called The Eight that assaulted viewers with the crudities of urban life, opened in 1908. In that same year, Alfred Stieglitz held his first show of modernist European art—a display of etchings by Henri Matisse—at his Photo-Secession gallery on Fifth Avenue in New York. In 1910 the two greatest 19th-century American painters, Winslow Homer and Thomas Eakins, laid down their brushes forever: Homer died and Eakins became too ill to paint. And in 1913 the famous Armory Show brought European modernism to this country on a massive scale, scandalizing most viewers, but stirring up enormous interest in modern art at the same time.

These developments roughly coincided with social trends that marked the beginnings of a new kind of modern, hedonistic, consumer culture. Automobiles, radios, chain stores, jazz, rayon, short skirts, smoking and drinking in mixed company, true-confession magazines, beauty parlors, looser sexual mores, professional sports, and odd fads like marathon dancing and flagpole sitting were all symptoms of this new way of life.

At its heart, the consumer culture suffered from an inherent paradox. On the one hand, it glorified sex, pleasure, and conspicuous consumption in order to sell consumer goods. It is in this period that we find the first blatant use of sex in advertising—the suggestion that if you buy the product, the pretty girl in the ad will come with it. On the other hand, to produce these new goods, the society glorified strict puritan morals and hard work. Indeed, the large corporations of the 20th century increasingly inhibited the old 19th-century notions of self-reliant individualism. Eccentricity was not allowed: corporate efficiency depended on complex systems of interdependence and regimentation.

With diabolical cunning, advertising often played on fear as well as pleasure—on the fear that one might not conform. One's life

could easily be ruined, advertisers hinted, by one's lack of "socks appeal" (that is, by a pair of sexually unenticing socks); or one might be ostracized from society by a case of halitosis. In times of prosperity, such principles took on the force of divine edicts, but they came to seem utterly ridiculous during the Great Depression, when the logic of the entire modern economic system collapsed.

How should one rank America's contribution to Modernism? In fact, it was both great and small, depending on how one defines the term. On the one hand, Modernism can refer to the art of modern society, and this society developed most quickly and most distinctively in the United States. Networks of transcontinental transportation, enormous factories, gigantic corporations, national advertising, and national distribution all developed more quickly and powerfully in the United States than anywhere else. For this reason, America often established preeminence in those arts, such as architecture and product design, that are most directly connected to the practical aspects of modern life. Thus, for example, America gave birth to the most quintessentially modern of building forms, the skyscraper, as well as to the two great father figures of modern architecture, Louis H. Sullivan and Frank Lloyd Wright. Similarly, Americans excelled at photography, an art that used a modern invention to hold up a mirror to modern life. Such Americans as Alfred Stieglitz, Paul Strand, Walker Evans, Edward Weston, and Dorothea Lange are universally recognized as major figures in the history of the medium.

On the other hand, Modernism often refers to a specific lineage of artistic styles that developed mostly in Europe, among them Impressionism, Post-Impressionism, Fauvism, and Cubism. Only a few American artists, such as Stanton Macdonald-Wright, played even a minor role in these developments. For the most part American painters were followers rather than leaders. American painting of this period has often been represented as a kind of fugue, in which some painters responded to modern subject matter, and others to modern styles. According to this view, the painters of the Ashcan School and the so-called Regionalists sought to create a record of American life through direct, unflinching realism, while the artists of the Stieglitz group, more self-consciously, sought to emulate abstract European styles.

There is some truth to this, of course, but when looked at closely, the issues turn out to be rather more complex. Thomas Hart Benton's Regionalism, for example, grew directly out of Synchromism, a modern style; and one of the most intriguing artists of the period, Edward Hopper, a lover of French Symbolist poetry, used the tools of old-fashioned Realism to create unsettling portraits of 20th-century alienation. In general, styles that were blatantly decorative or abstract were the product of good times, which encouraged an atmosphere of creative and often frivolous experiment, whereas bad times encouraged a more tough-minded realism, a harder look at the humbling realities of daily life.

HENRY ADAMS

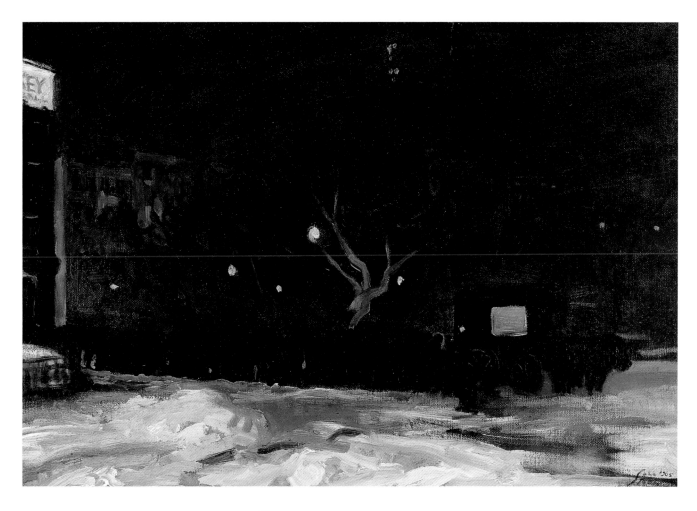

JOHN SLOAN
1871–1951

The Coffee Line, 1905

Oil on canvas
21½ x 31⅝ inches
The Carnegie Museum of Art
Fellows of the Museum of Art Fund,
83.29

John Sloan had pursued a successful career as a newspaper and magazine illustrator before turning his hand to oil painting in the early 1900s. *The Coffee Line,* one of his first important oils, brought him quick recognition at the Carnegie International exhibition of 1905.

The gritty realism of the subject—the poor lining up for free coffee on a desolate night in New York's Madison Square—and Sloan's rapid brushwork are emblematic of the work of a group of artists known as The Eight. This influential band of artists, who exhibited together for the first time in 1908, pursued realistic, contemporary subject matter in the face of both the idealistic styles preferred by the art academies and the experimental abstraction of the European avant-garde. Their preference for urban themes and their sense of moral urgency allied them with the efforts of reformers and muckraking journalists of the era. LWL

ALFRED STIEGLITZ
1864–1946

The Steerage, 1907

From *Camera Work*, nos. 7–8
(October 1915)
Photogravure
13¹⁄₁₆ x 10⅜ inches
The Carnegie Museum of Art
Gift of the Carnegie Library of Pittsburgh, 83.76.15

LEWIS W. HINE
1874–1940

"So This Is America," Ellis Island,
about 1905

Gelatin silver print
13¾ x 10⅜ inches
The Carnegie Museum of Art
Gift of Mr. and Mrs. Walter Rosenblum, 81.82.16

Between 1880 and 1921, the open-door immigration policy of the United States allowed over 23 million people to begin new lives on American soil. In 1888 the journalist and reformer Jacob Riis took on the "immigrant experience" as a subject, photographing the abominable conditions under which many immigrants lived and worked in New York. In 1890

ANONYMOUS

Chinatown, San Francisco, *about 1880*

Albumen print (porthole camera)
5⅛ inches diameter
The Carnegie Museum of Art
Director's Discretionary Fund
74.42.29

LEWIS W. HINE
1874–1940

Untitled (Cotton Mill Worker, Texas), *1913*

Gelatin silver print
4½ x 6⁹⁄₁₆ inches
The Minneapolis Institute of Arts
The Ethel Morrison Van Derlip Fund,

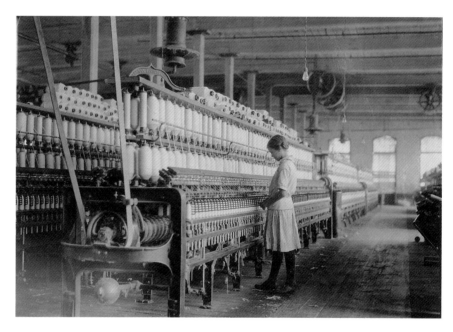

he published the seminal book *How the Other Half Lives*, a series of photographs and text that provided an unflinching exposé of conditions in the city's slums.

Beginning in 1903 Lewis Hine carried on the Riis legacy of using photography as an agent for social change with his documentations of child labor, tenement life, and the experiences of immigrants at Ellis Island. Hine wrote detailed captions that incorporated observations, conversations, names, and addresses, which he then used with the images as "evidence" of the plight of these people.

Concurrently, Alfred Stieglitz looked for truth and reality in art, producing what he considered his benchmark photograph, *The Steerage*, in 1907. Like a vision, the moment presented itself, and Stieglitz recognized it as an image that was monumentally symbolic on several levels. Travelling first class on a voyage from New York to Paris, Stieglitz saw in the steerage the simple and unpretentious life that he had sought in earlier trips to rural Europe and later at his home in Lake George in New York State. Ironically, the people in Stieglitz's photograph are returning to Europe via the steerage from the "Land of Opportunity."

OLG

GEORGE BELLOWS
1882–1925

Frankie, the Organ Boy,
1907

Oil on canvas
48¼ x 34¼ inches
The Nelson-Atkins Museum of Art
Purchase: acquired through the bequest
of Ben and Clara Shlyen, F91–22

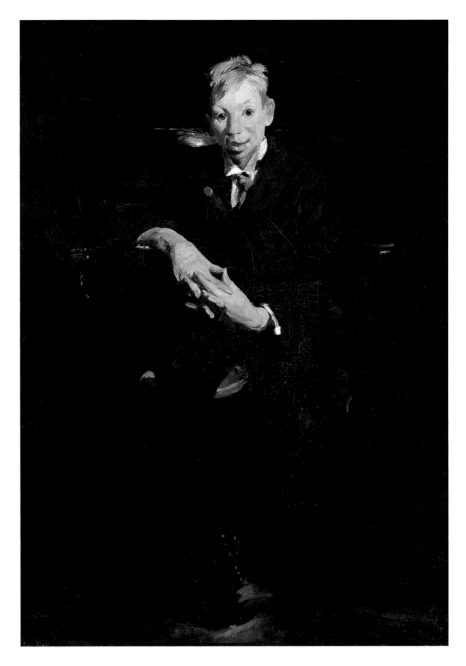

George Bellows, who grew up in Columbus, Ohio, turned down a professional baseball contract in 1904 to go East and study painting. Working in the realistic style of the so-called Ashcan School, Bellows painted the energy and squalor of New York—construction sites, boxing matches, street gangs, urban bullies, and vagrants—and he achieved immediate success. One of his paintings was purchased by the Metropolitan Museum before he was thirty, and he was the youngest painter ever elected to the National Academy of Design.

Frankie, the Organ Boy is one of Bellows's first mature paintings. It strongly reflects the influence of Robert Henri, who specialized in portraits of poor children, often engaged in the work of adults. Henri, however, tended to sentimentalize his subjects, while Bellows counterbalanced such saccharine qualities with a dose of the grotesque. This painting strikes an interesting balance between the appealing and the off-putting. Frankie's bulging eyes, nervous hands, and ill-proportioned body are ungainly and unattractive, but these negative features are offset by the appealing eagerness with which he leans toward the viewer. HA

HENRY OSSAWA TANNER
1859–1937

The Disciples on the Sea,
about 1910

Oil on canvas
21⅝ x 26½ inches
The Toledo Museum of Art
Gift of Frank W. Gunsaulus, 1913.127

Perceiving the American art scene as inhospitable, a judgment heightened by his own experiences with racial prejudice, Tanner moved in 1891 to Paris, where he established an international reputation. He began painting religious subjects in the mid-1890s as a natural expression of his devout character. Between 1908 and 1914, Tanner painted a number of scenes depicting the miracles that Jesus worked by the Sea of Galilee.

The subject of *The Disciples on the Sea* loosely derives from a passage in the New Testament (Mark 6:45–52), which describes how Jesus calmed a storm and his disciples' fears. The figures are sketchy, reduced to abstract forms, so that it is impossible to read their actions or imagine their thoughts. As a result, the drama centers on the surge of the boat against the rough water, a theme enhanced by the billowing sail, the energetic, loose brushstrokes, and the thick paint. EDG

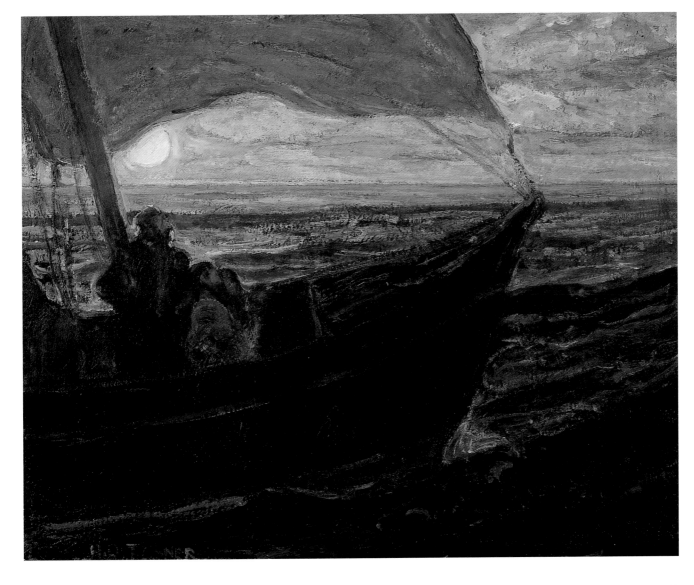

137

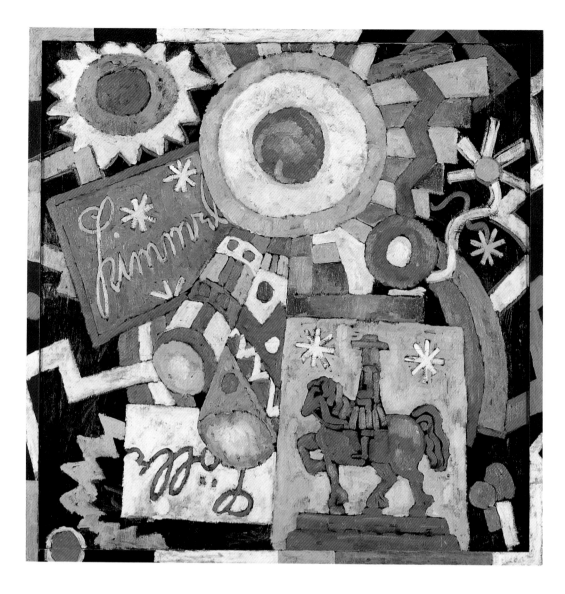

MARSDEN HARTLEY
1877–1943

Himmel, 1915

Oil on canvas
47⅜ x 47⅜ inches
The Nelson-Atkins Museum of Art
Gift of the Friends of Art, 56–118

Marsden Hartley belonged to the small group of Modernists who were championed by the photographer, dealer, and promoter Alfred Stieglitz. Hartley changed style frequently over the course of his career, but his most important works were those that he created in Berlin around the time of the outbreak of World War I. There, Hartley made contact with Wassily Kandinsky and Franz Marc, the leaders of the Blue Rider group, whose bold brushwork and intense colors affected him deeply. He also developed a relationship with a German army officer, Karl von Freyberg.

In October 1914 Hartley learned that von Freyberg had been killed in action. Deeply distraught, Hartley was unable to paint for a month, but then began producing a powerful series of semi-abstract compositions, which used elements of German military uniforms to symbolize his lost friend. *Himmel,* one of the most powerful of the tributes to von Freyberg, includes an image of a soldier on horseback and contains both the words *Himmel* (Heaven) and *Hölle* (Hell). The split between Heaven and Hell seems to have a double meaning, since it alludes both to the magnificence and horror of war, and to the pleasure and pain of love.

Hartley exhibited his German uniform paintings in 1916 at Stieglitz's gallery, but they were poorly received probably, in part, because of the anti-German mood in America at that time. Not until years later were they recognized as among the finest of early American abstractions. They have since inspired painters as diverse as Stuart Davis and Jasper Johns. DES

PAUL MANSHIP
1885–1966

Flight of Night, 1916

Bronze
37⅜ inches high
The Toledo Museum of Art
Gift of Florence Scott Libbey, 1925.1024

Paul Manship was born in 1885 in St. Paul, Minnesota, where he studied painting and modelling. He was awarded the Prix de Rome, a three-year internship for aspiring sculptors; at age 23 he was the youngest ever to win the prize. Although his sources were never limited to one time or one culture, the classical sculpture that surrounded him in Rome had an immeasurable influence on his own art. Among Manship's best-known commissioned works are the north gate of New York's Bronx Zoological Gardens and the heroic figures commissioned for Rockefeller Center.

Paul Manship always referred to himself as a classicist. His own contemporaries who were drawn to his work appreciated his turn toward tradition, as many other artists of his time were working to eliminate it. Borrowing from ancient Greek vase painting, he used line to articulate a bold sense of silhouette and to create an illusion of levitation or a denial of weight and mass. This weightlessness is seen in *Flight of Night,* where a crescent-shaped allegorical figure of the night arches in space. The globe may represent the earth, the setting sun, or the moon.

KJ

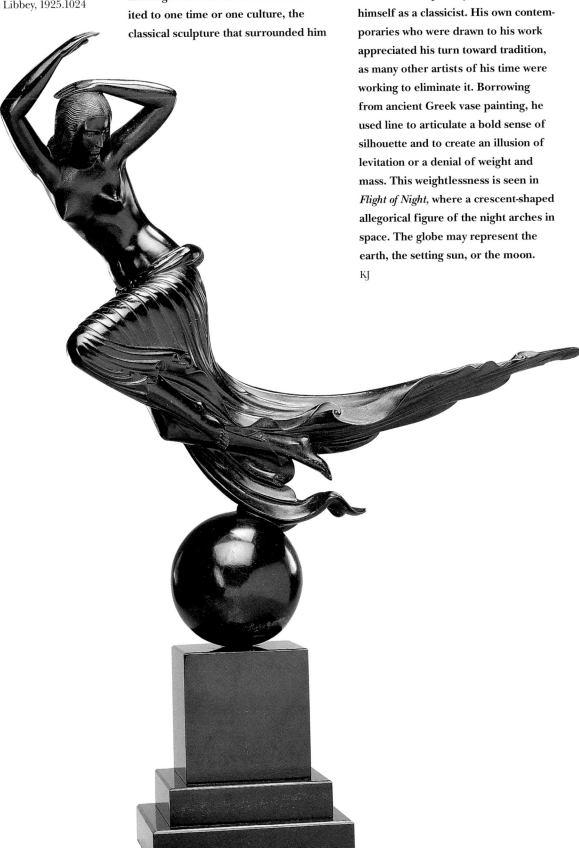

STANTON MACDONALD-WRIGHT
1890–1973

Sunrise Synchromy in Violet, 1918

Oil on canvas
35⅞ x 54¼ inches
The Carnegie Museum of Art
Living Arts Foundation Fund and
Patrons Art Fund, 56.16

Stanton Macdonald-Wright invented the term *synchromy* (with color) to describe the governing concept behind his art: the use of brilliant color harmonies to abstract and enliven compositions of sculptural forms. The artist and his friends developed the manifesto for a short-lived movement they called Synchromism (1916–18). It was the first American abstract art movement that was recognized by the Paris art scene.

Seen in retrospect, *Sunrise Synchromy in Violet* is an odd combination of the old (a reclining classical male figure) and the new (Cubist form, expressive color). All of its elements evoke sunrise by suggesting the gradual emergence of an awakening form under the shifting light and color of early morning. LWL

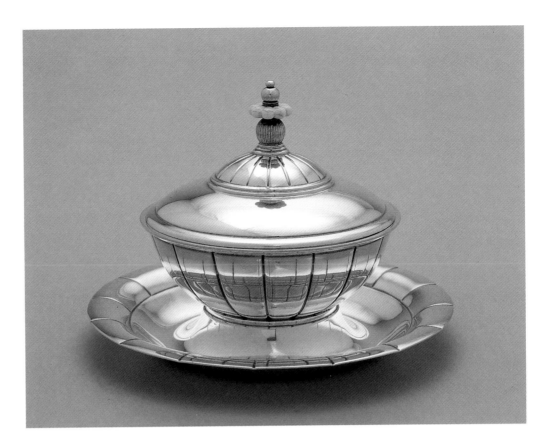

ERIK MAGNUSSEN
1864–1961, designer
Gorham Manufacturing Company,
Rhode Island, established 1865

Caviar Server,
about 1925–29

Sterling silver, ivory
5½ inches high
The Carnegie Museum of Art
DuPuy Fund, 89.13.1 a, b, c

In 1925 the well-known Danish silversmith Erik Magnussen moved to the United States and immediately started working for the Gorham Manufacturing Company as a "designer (special work)," acting completely independently of Gorham's chief designer, William Codman. Magnussen was inspired by the Danish avant-garde group led by Georg Jensen, in contrast to the conservative, traditional stance of Codman. Magnussen's presence was a clear signal of Gorham's interest in developing modern alternatives to period revival silver and the firm's desire to remain at the forefront of innovative silverware, a position it had established in the 1870s and 1880s.

This caviar server is clearly aimed at the luxury end of the market. The seemingly simple design is deceptively complex, with its gently curving soft lines and the contrast of plain and incised surfaces. Through Magnussen, Gorham brought the richness and clarity of Scandinavian silver design to an American audience. SN

GEORGIA O'KEEFFE
1887–1986

*Birch Trees at Dawn
on Lake George,*
about 1923–24

Oil on canvas
36 x 30 inches
The Saint Louis Art Museum
Gift of Mrs. Ernest W. Stix, 14:1964

Georgia O'Keeffe is the best known of the circle of artists associated with the photographer and gallery owner Alfred Stieglitz. She was the first American female artist whose work was widely published and promoted to the American public. While O'Keeffe's later flowers, skulls, and Southwest landscapes are firmly anchored in the popular imagination, her most remarkable work is the series of abstractions and near-abstractions that she produced in the second two decades of this century. *Birch Trees at Dawn on Lake George* exemplifies O'Keeffe's motto, adapted from the critic Arthur Dow, that painting "is filling space in a beautiful way."

Throughout the 1920s O'Keeffe spent her summers painting at the Stieglitz family home at Lake George in upstate New York. One of her favorite subjects there she later described as "a big old birch tree with many trunks." That subject is only barely recognizable in this painting in the tubular shapes that swell and curve across the canvas. The shapes appear soft and sensual, their colors closer to flesh than to bark. Nature serves as a pretext for abstraction, an abstraction nevertheless tied to the sensual apprehension of the natural world. JS

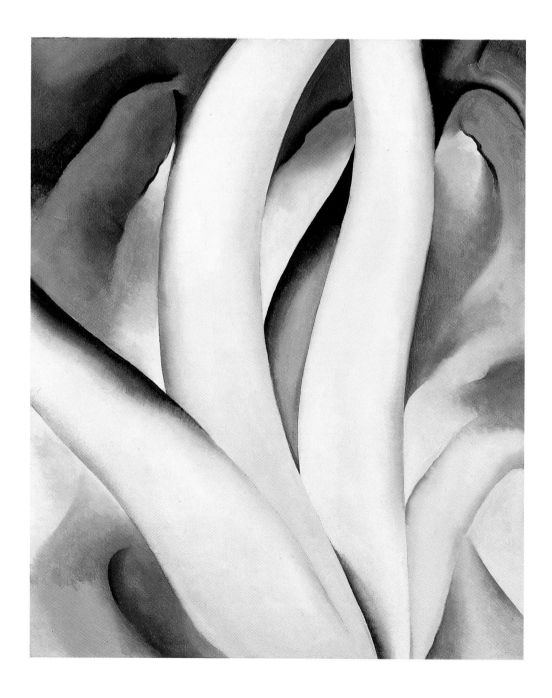

GEORGIA O'KEEFFE
1887–1986

City Night, 1926

Oil on canvas

48 x 30 inches

The Minneapolis Institute of Arts

Gift of the Regis Corporation, Mr. and
Mrs. W. John Driscoll, the Beim
Foundation, the Larsen Fund, and by
public subscription, 80.28

As a pioneer of modern abstract painting, Georgia O'Keeffe is best known for her evocations of landscape, flowers, and other natural elements. She also executed a small group of New York cityscapes. In 1925 Georgia O'Keeffe and Alfred Stieglitz moved into an apartment on the 28th floor of the Shelton Hotel, from which they could see the many skyscrapers being constructed during those boom years. O'Keeffe remembered later, "I had never lived up so high before and was so excited that I began talking about trying to paint New York. Of

course, I was told that it was an impossible idea—even the men hadn't done too well with it. . . . I was accustomed to disagreement and went on with my idea." Ultimately, O'Keeffe found the city stifling; she abandoned urban subjects in 1929.

In *City Night*, the buildings fill the canvas; the pedestrians' point of view accentuates the soaring verticality of the skyscrapers. Their inward tilt is an exaggeration of the visual phenomenon known as vertical convergence. Through Stieglitz, O'Keeffe was aware of how early modern photographers

used it expressively in their urban images. The hard-edged, architectonic forms of this city view also call to mind the work of O'Keeffe's friends Charles Demuth and Charles Sheeler. Was her painting, like theirs, intended to celebrate the energy of the modern industrial metropolis? Or did its dizzying composition and dark colors express a sense of disquiet and claustrophobia? The two interpretations of the picture suggest that it is best understood as an expression of O'Keeffe's ambivalence about the city.
LA

143

JAMES VAN DER ZEE
1886–1983

Couple, Harlem,
1932 (printed later)

From *Eighteen Photographs* portfolio
Gelatin silver print
7⅜ x 9⁷⁄₁₆ inches
The Minneapolis Institute of Arts
The Stanley Hawks Memorial Fund,
74.36.16

PAUL STRAND
1890–1976

Double Akeley, 1922

Gelatin silver print
9⅝ x 7½ inches
The Saint Louis Art Museum
Purchase, 72:1978

From 1910, the city was increasingly popular as a subject for Pictorialist photographers. At first, atmospheric effects were characteristic of these city photographs, but Alfred Stieglitz soon confronted the status quo by proclaiming the ability of the "straight" photograph to capture the essence of modern life. During this time, the machine and the city became substitutes for nature. City streets were depicted as mountainous canyons, and machinery became the viscera of the modern experience.

Images from this era were made as both a celebration and, to a certain degree, a critique of modern life. Photographers like Berenice Abbott, Paul Strand, and Alfred Stieglitz captured the vibrancy and sensuality of the city from all angles, while James Van Der Zee recorded the dynamic cultural atmosphere of a flourishing Harlem in his studio portraits of the African-American community. Luke Swank documented the brooding and dramatic structures of the Pennsylvania steel mills in a clear, crisp vision that was the keynote of the modernist style. OLG

BERENICE ABBOTT
1898–1991

Exchange Place, New York, about 1935

Gelatin silver print
13 x 3¼ inches
The Saint Louis Art Museum
Purchase: National Endowment for the Arts and Anonymous Matching Fund, 513:1978

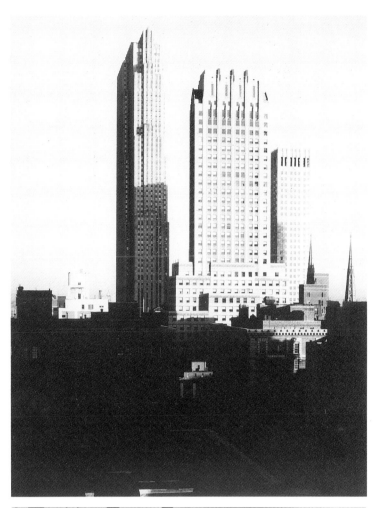

ALFRED STIEGLITZ
1864–1946

From the Shelton, West, 1935
(top right)

Gelatin silver print
9⅝ x 7⁹⁄₁₆ inches
The Saint Louis Art Museum
Anonymous gift, 177:1984

LUKE SWANK
1890–1944

Industry—Street and Mill, about 1930 *(right)*

Gelatin silver print
13¼ x 10¼ inches
The Carnegie Museum of Art
Gift of the Carnegie Library of Pittsburgh, 83.76.57

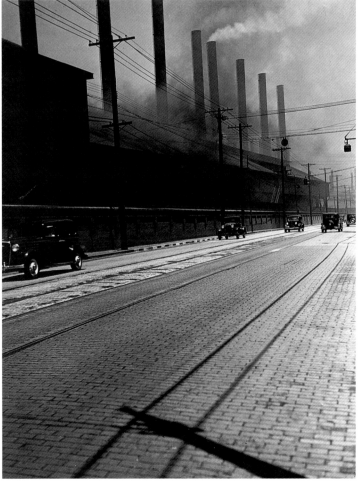

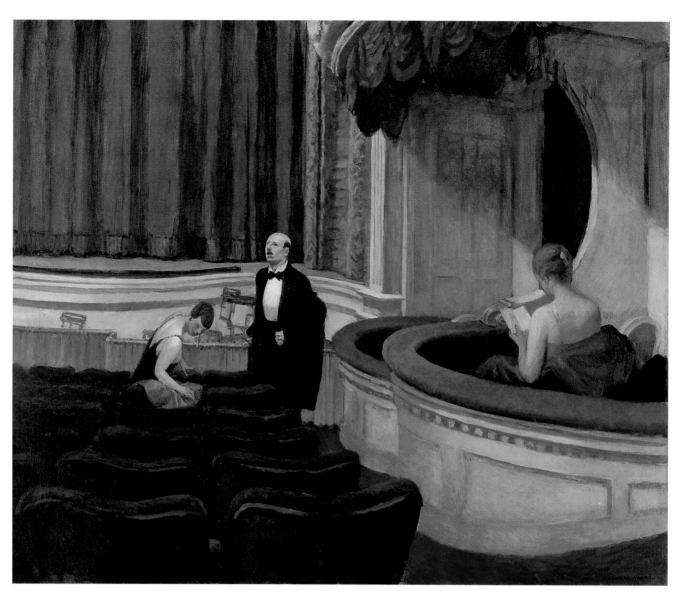

EDWARD HOPPER
1882–1967

Two on the Aisle, 1927

Oil on canvas
40⅛ x 48¼ inches
The Toledo Museum of Art
Purchased with funds from the Libbey
Endowment, Gift of Edward Drummond
Libbey, 1935.49

Passionate about the theater since his youth, Edward Hopper celebrated this interest in *Two on the Aisle,* his first major painting of a theater scene and a theme to which he returned frequently. Here Hopper presents a moment of anticipation in which the seductiveness of the theater atmosphere—an effect heightened by warm hues subtly suffusing the scene —becomes the focal point. Bright light from unseen ceiling fixtures illuminates the setting. The arriving audience is the protagonist, and the pair settling their coats provides the only activity; that point is reinforced by the sole pure colors in the painting: the bright green satin of her dress and his gleaming white shirtfront. The couple is, in fact, Hopper and his wife—an autobiographical note with a light-

hearted undercurrent since he portrays the frequently tardy couple as not only prompt, but early. Although usually sensitive about his appearance, here Hopper abandons his customary hat, revealing both his balding scalp and his large nose.

Hopper saw the theater as a metaphor for life. Using his wife, Jo, as the model for all his female figures, he cast her in many different roles by changing her face and hair to reflect specific types. The artist's ledgers indicate that the couple also assigned names and identities to some of the figures as well as scenarios to the pictures, thus carrying the storytelling and playacting one step further. EDG

PATRICK HENRY BRUCE
1881–1936

Abstract, about 1928

Oil and graphite on canvas
35 x 45¾ inches
The Carnegie Museum of Art
Purchase: Gift of G. David Thompson,
56.47

Patrick Henry Bruce destroyed many of his paintings from the 1920s before committing suicide in 1936. Consequently, only about twenty canvases, including *Abstract*, testify to the important achievements of this elusive Modernist, who was associated with Matisse and Robert and Sonia Delaunay in Paris before World War I.

In *Abstract*, geometric forms range across a flat surface in a composition reminiscent of a traditional tabletop still life. These spare shapes cannot be identified with conventional objects, however, and their pastel colors seem similarly separate from reality. Bruce's continual refinement of both color and form reflects the influence of such diverse artists as the Dutch painter Piet Mondrian and the Renaissance master Piero della Francesca, whose work Bruce admired for its quiet, geometric perfection. LWL

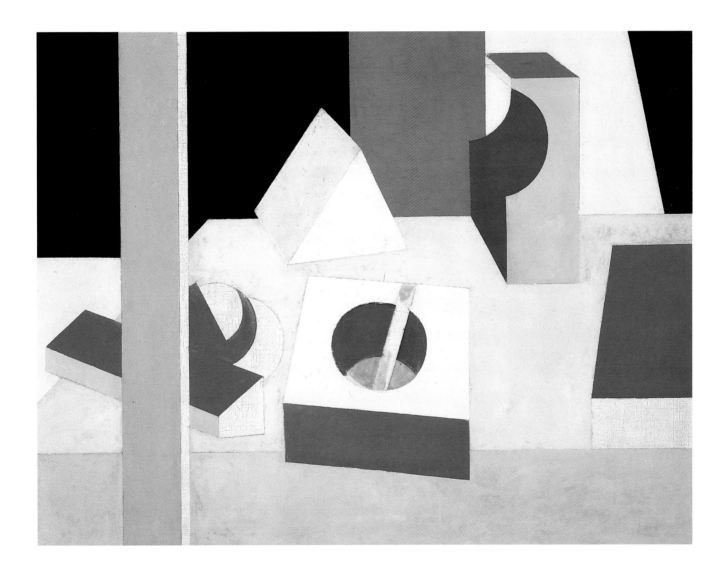

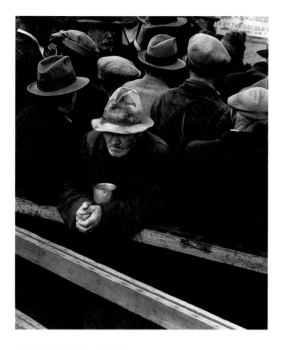

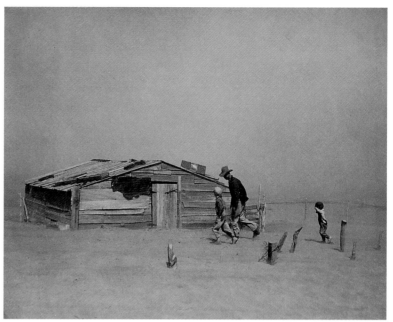

DOROTHEA LANGE
1895–1965

White Angel Breadline, San Francisco, *1933*

Gelatin silver print
10½ x 8¾ inches
The Minneapolis Institute of Arts
The John R. Van Derlip Fund, 91.82

ARTHUR ROTHSTEIN
1915–1985

Dust Storm, Cimarron County, Oklahoma, *1936*

Gelatin silver print
10⅞ x 13⅝ inches
The Minneapolis Institute of Arts
Gift of funds from Alfred and Ingrid Lenz Harrison, 92.76

During the Great Depression, President Franklin D. Roosevelt's administration set up a government agency (first called the Resettlement Administration, later the Farm Security Administration) to document the progress of the New Deal, whose programs included soil rebuilding and conservation, communal farming for displaced farmers, and camps for migrant farm workers and the shifting rural population. The photographs created for this agency remain some of the most noteworthy images in the American history of the medium.

The documentary program was headed by Roy E. Stryker. Very much interested in the quality of the images as well as in their ability to communicate the ideologies of the New Deal, Stryker hired photographers who were artists in their own right. During its seven-year history, the RA/FSA utilized the talents of Jack Delano, Walker Evans, Dorothea Lange, Russell Lee,

Carl Mydans, Gordon Parks, Marion Post-Wolcott, Arthur Rothstein, Ben Shahn, and John Vachon.

Already a recognized artist with a number of awards to his credit, Walker Evans was hired as senior photographer for the FSA in 1935. In 1936 Evans left to work with James Agee on the book *Let Us Now Praise Famous Men*, a realist piece of prose poetry and photographs that told the story of sharecropper families from Hale County, Alabama.

Whereas Evans used an objective approach, Dorothea Lange wished to create images that would evoke an immediate and compassionate response in the viewer. Irony tinges many of her images; viewpoint and juxtaposition of situations within the frame—as in *Three Families, Fourteen Children on U.S. 99, San Joaquin Valley, California*—were used to make powerful statements about the plight of travelling farm workers. OLG

WALKER EVANS
1903–1975

Floyd Burrough's Bedroom, Hale County, Alabama, 1936

Gelatin silver print
7⅝ x 9⁹⁄₁₆ inches
The Minneapolis Institute of Arts
Gift of Arnold H. Crane, 75.42.7

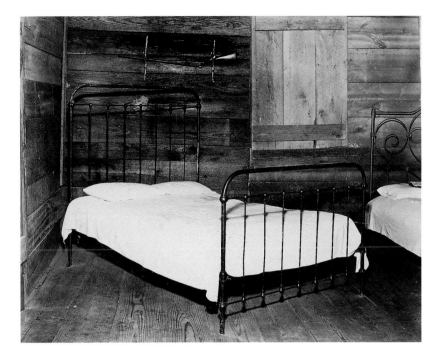

WALKER EVANS
1903–1975

A Miner's Home, West Virginia, July, 1935,
1935
(printed about 1949–55)

Gelatin silver print
9⅞ x 8 inches
The Saint Louis Art Museum
Purchase: The Martin Schweig Memorial Fund for Photography, 67:1985

DOROTHEA LANGE
1895–1965

Three Families, Fourteen Children on U.S. 99, San Joaquin Valley, California, 1938

Gelatin silver print
9⅝ x 7½ inches
The Saint Louis Art Museum
Purchase: Museum Shop Fund, 148:1987

GRANT WOOD
1892–1942

The Birthplace of Herbert Hoover, West Branch, Iowa, *1931*

Oil on composition board
29⅝ x 39¾ inches
The Minneapolis Institute of Arts
The John R. Van Derlip Fund, 81.105, jointly owned with the Des Moines Art Center, 1982.2

Born in Iowa and the first American artist to be featured on the cover of *Time* magazine, Grant Wood was part of the Regionalist movement of the 1930s. Just southeast of his home in Cedar Rapids was the town of West Branch, where Herbert Hoover had been born in a three-room cabin. The painting depicts the cabin, half-hidden behind a recently constructed prosperous farmhouse and signalled by a tiny, pointing figure.

In 1931 President Hoover was already seeking a second term. The son of a village blacksmith, he had made his humble beginnings part of his campaign pitch, and his cottage in West Branch had become an attraction for tourists fascinated by the story of his rise to success.

The painting uses a pronounced stylization of forms and precisely drawn, highly glazed technique to create the effect of a sparkling, tidy, well-ordered rural world. Wood was simultaneously honoring small-town America while spoofing the stereotyped and obsolete

vision of it as clean, simple, and prosperous. The idealized "simple life" was being revealed in all its misery during the Great Depression; in 1931 Hoover vetoed federal relief to the unemployed, effectively turning many families out of their "cottages."

Ironically, the picture was commissioned by a group of Iowa businessmen who wanted to present it to Hoover. Not surprisingly, Hoover did not like it because, he said, it obscured the cabin by including the later house. Did he detect Wood's subtle satire of the rags-to-riches myth? In the end, the businessmen refused to buy the painting, and Wood sold it through a dealer. LA

THOMAS HART BENTON
1889–1975

Persephone, 1938

Tempera with oil over casein on linen
over panel
72⅛ x 56 inches
The Nelson-Atkins Museum of Art

Purchase: acquired through the
generosity of the Yellow Freight
Foundation Art Acquisition Fund, Mrs.
H. O. Peet, Richard J. Stern, the Doris
Jones Stein Foundation, the Jacob L. and
Ella C. Loose Foundation, Mr. and Mrs.
Richard M. Levin, and Mr. and Mrs.
Marvin Rich, F86–57

Thomas Hart Benton, the son of a Missouri congressman, became famous in the 1930s both for his paintings and for his mouth. His paintings brought subjects from the Midwest, particularly of his native Missouri, into the realm of "high art" for the first time. His mouth, which seemingly never shut, challenged the supremacy of European painters and the utterances of New York art critics. Although his statements made him many enemies, they also brought Benton considerable public attention and created a strong market for his work.

Benton's mural of 1936, *A Social History of Missouri*, which adorns the State Capitol in Jefferson City, initiated an explosion of protest across the state because of its depiction of bank robberies, slave auctions, whiskey trading, back-room dealings, and other unsavory features of American life. As a result of this stir, Benton received no further mural commissions for a decade and was obliged to shift his attention to easel pictures.

The largest and most important of these paintings was *Persephone*, 1939, whose composition is based on a painting by the 16th-century master Correggio. In Benton's hands Greek myth took on a modern vitality: Persephone became a corn-fed American girl, sunbathing in the nude; Pluto became a grizzled Missouri farmer, whose chariot is a mule-drawn cart. With conscious irony, Benton at once gave a pin-up girl the respectability of mythology and an Old Master format, while he hinted at the coarse lusty-mindedness of the Old Masters. A consummate showman who enjoyed working an audience, Benton executed *Persephone* in the middle of his painting class at the Kansas City Art Institute, while his students struggled to produce miniature versions of the same subject.
HA

PETER MÜLLER-MUNK
1904–1967, designer
Revere Copper and Brass
Company, Rome, New York,
1935–about 1941

Normandie, 1935

Chrome-plated brass
11¹⁵⁄₁₆ inches high
The Toledo Museum of Art
Purchased with funds from the Florence
Scott Libbey Bequest in Memory of her
Father, Maurice A. Scott, 1991.86

This pitcher, which epitomizes aerodynamic, streamlined American design of the 1930s, was inspired by the leaning, elliptically shaped smokestacks of the French ocean liner SS *Normandie,* which made its maiden voyage from New York to Le Havre in 1936. In contrast to designs of the late 1920s, in which zigzag lines were used to suggest speed and an erratic world, the smooth teardrop-shaped curves (made possible by using sheet metal) and undecorated surfaces convey some sense of national pride and economic confidence that Americans were beginning to rediscover in the mid-1930s as the Great Depression was finally coming to an end.

This inexpensive, mass-produced object was one of a number of modern, decorative accessories being manufactured in metal by American companies at the time. Revere Copper and Brass Company was active in the development of this market, contracting some of the leading industrial designers of the period like Norman Bel Geddes and Müller-Munk to develop a distinctive line. DST

PITTSBURGH PLATE GLASS COMPANY
1883–present

Armchair, about 1939

Glass, metal, fabric
29¼ inches high
The Carnegie Museum of Art
DuPuy Fund, 83.78.2

Visitors to the 1939 World's Fair in New York saw a dramatic shift away from individually made hand-crafted objects toward the machine-age belief in mass production, industrial design, and the exploitation of new or improved materials. Among its many glass exhibits, the fair included the Glass Center Building with model rooms decorated by *Good Housekeeping* and glass furnishings made by the Pittsburgh Plate Glass Company. The Glass Center's model dining room contained a glass-topped table, a glass-panelled sideboard, and chairs like this one, whose frames were made of plate glass and whose seats were upholstered with fiberglass fabric.

Although heralded by *House and Garden* magazine as one of "the decorative prophecies that will shape our World of Tomorrow" because it would contribute to the "comfort, convenience and delights" of the modern house, glass furniture did not capture the public imagination; its weight and fragility were too impractical for the new age. SN

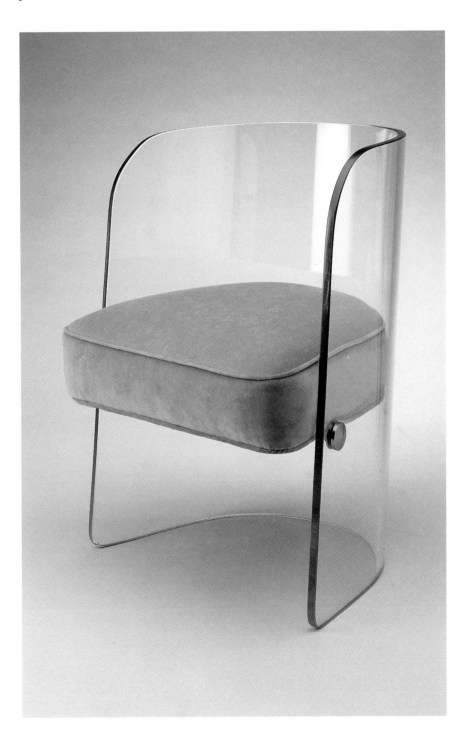

PHILIP GUSTON
1913–1980

Martial Memory, 1941

Oil on canvas
40⅛ x 32¼ inches
The Saint Louis Art Museum
Purchase: Eliza McMillan Trust Fund,
115:1942

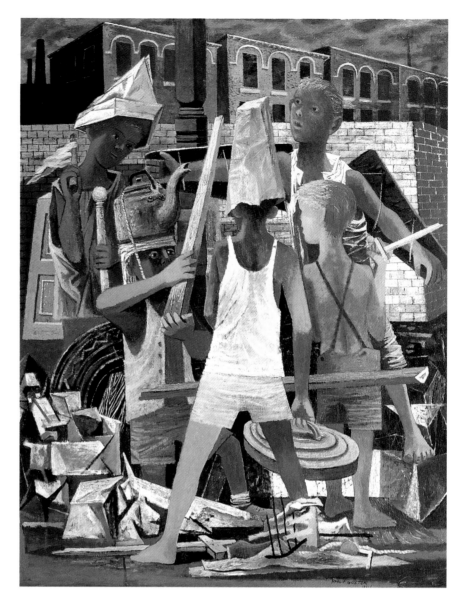

Philip Guston's artistic style moved through many dramatic phases, including figuration, lyrical abstraction, and cartoon-like representations. In this powerful painting, Guston combines the flat patterning and angularity of Cubism with the bold figures and forms that appeared in the murals he had painted under the Works Progress Administration in the 1930s. The solemnity of the figures and traditional oil technique reveal Guston's interest in early Italian Renaissance painting.

The five boys in *Martial Memory* all carry "military" gear, which on closer examination is seen to be garbage-can lids, scraps of wood, and other urban debris. The painting is a whimsical tribute to youth's resourcefulness in turning cast-off objects into toys as well as a serious statement showing the parallel between the boys playing at war and the devastating conflict in Europe at that time. Using playful, almost child-like compositions to portray serious subject matter was a device that Guston returned to in his later career. DAR

ROMARE BEARDEN
1914–1988

Factory Workers, 1942

Gouache and casein on kraft paper
39¾ x 31¼ inches
The Minneapolis Institute of Arts
The John R. Van Derlip Fund, 92.24

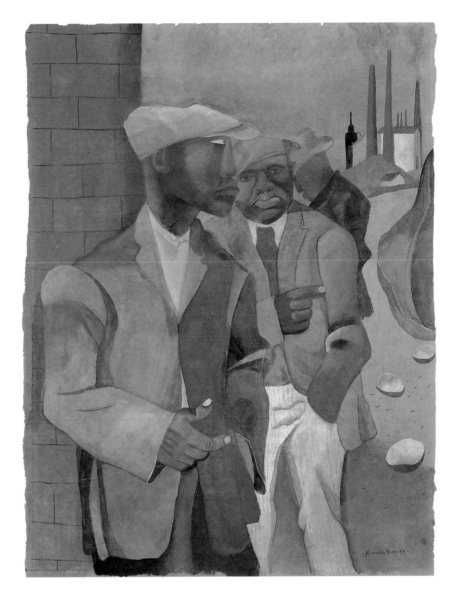

Romare Bearden sought first and foremost to reveal certain underlying truths of human experience. In a statement written in 1940 for his first solo exhibition, Bearden eloquently expressed his creative philosophy: "I believe the function of the artist is to find ways of communicating, in sensible, sensuous terms, those experiences which do not find adequate expression in the daily round of living and for which, therefore, no ready-made means of communication exists."

Bearden's belief in the interpretive role of the artist is seen in *Factory Workers*, a drawing commissioned by *Fortune* magazine to serve as the frontispiece for an article in the June 1942 issue. Entitled "The Negro's War," the article detailed the high social and financial costs of racial discrimination during wartime and strongly advocated full integration of the American workplace. Bearden's somber yet dignified portrayal of African-American jobseekers turned away from a steel mill evokes the sense of frustration experienced by those subjected to unjust hiring practices. Bearden used this simplified, representational style of depiction until the mid-1940s, when he turned to collage as his preferred medium. DMJ

The American landscape has been represented in numerous incarnations from the pastoral to the sublime. In the history of American photography, the West has served as the muse for more photographers than any other landscape in North America. In the spirit of the great 19th-century landscape photographers, Ansel Adams, Edward Weston, and Laura Gilpin chose to represent the 20th-century western landscape as a sublime and contemplative place.

The Romantic ideal of the wilderness was perpetuated in the photographs of Ansel Adams, whose images of the "unspoiled" West became the symbol of perfection in landscape as well as in the medium itself. Edward Weston in many cases chose to picture the landscape with reference to the presence of man; however, his photographs of the Oceano dunes and the coastal landscape echo his passionate interest in the profundity of natural forms. Laura Gilpin did not aspire to be objective in her presentation. Although they are only a small portion of her work, Gilpin's images of landscape were always dramatic, capturing dark skies and brilliantly lit water to accentuate the physical presence of the land.

"Subjective" photography, which extolled the medium's ability to render personal or cerebral experiences, gained popularity in the 1950s. Both abstract and recognizable forms were used to create symbolic images. A student of Eastern religions, Minor White created landscape images that reflected his belief in a transcendent reality, while Jerry Uelsmann used the land as an element in fabricated, Surrealist scenes of America. OLG

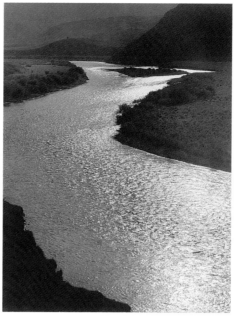

LAURA GILPIN
1891–1979

Rio Grande, 1946

Gelatin silver print
18½ x 14³⁄₁₆ inches
The Saint Louis Art Museum
Gift of Mr. and Mrs. Joseph L. Tucker
in honor of Polly Wyles Day, 94:1978

JERRY UELSMANN
born 1934

Untitled, 1964

From *Jerry N. Uelsmann Portfolio*
Gelatin silver print
13½ x 9¹⁵⁄₁₆ inches
The Minneapolis Institute of Arts
The Kate and Hall J. Peterson Fund, 72.42

MINOR WHITE
1908–1976

Easter Sunday, Stony Brook State Park, New York, 1963

Gelatin silver print
9⅝ x 3½ inches
The Saint Louis Art Museum
Purchase: The James Marchael Memorial Fund, 139:1982

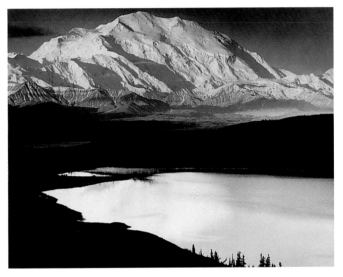

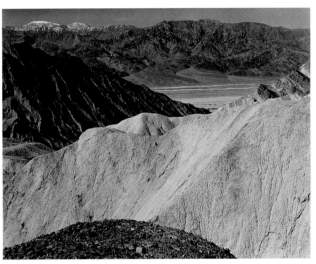

ANSEL ADAMS
1902–1984

Clearing Winter Storm, Yosemite Valley, 1944

Gelatin silver print
10½ x 13¼ inches
The Saint Louis Art Museum
Purchase, 62:1945

Mt. McKinley and Wonder Lake, Alaska, 1947 *(printed 1971)*

Gelatin silver print
16 x 20 inches
The Toledo Museum of Art
Harold Boeschenstein, Jr. Fund, 1971.173

EDWARD WESTON
1886–1958

Oceano, 1936

Gelatin silver print
7½ x 9½ inches
The Nelson-Atkins Museum of Art
Gift of Mr. and Mrs. Milton McGreevy through the Mission Fund, F57–76/25

Golden Canyon, Death Valley, 1938

Gelatin silver print
7½ x 9½ inches
The Nelson-Atkins Museum of Art
Gift of Mr. and Mrs. Milton McGreevy through the Mission Fund, F57–76/34

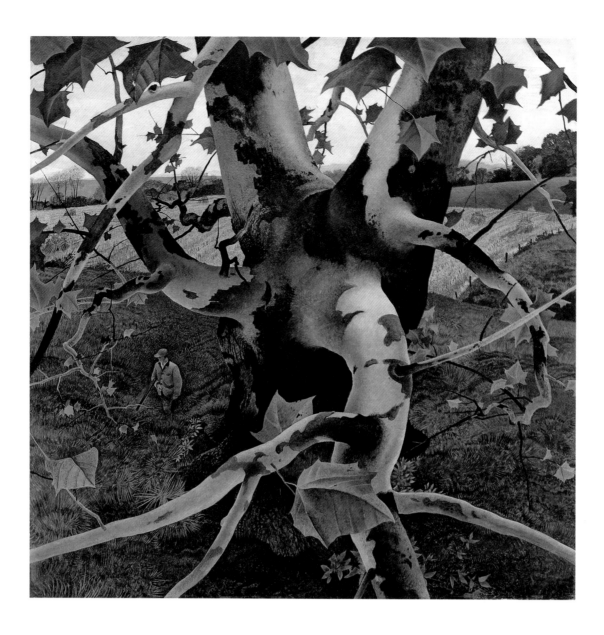

ANDREW WYETH
born 1917

The Hunter, 1943

Tempera on Masonite
33 x 33⅞ inches
The Toledo Museum of Art
Elizabeth C. Mau Bequest Fund, 1946.25

Andrew Wyeth's immensely popular, seemingly literal images of rural landscapes and their local inhabitants have meaning beyond their deceptively simple facades. His paintings reveal hidden themes of isolation, loneliness, and nostalgia and include a wide range of pictorial effects. Wyeth draws his subject matter from two locales, his home in Chadds Ford, Pennsylvania, and his summer residence in Cushing, Maine. The buttonwood tree in this painting towers over Lafayette's Headquarters, a historic building in Chadds Ford.

In *The Hunter,* Wyeth altered the compositional elements to intensify the effect of the original visual experience. His use of a bird's-eye vantage point disorients the viewer. Furthermore, because the angle of vision foreshortens the tree, its limbs and leaves create an abstract pattern superimposed on the fields and sky in the background. By enlarging the vivid bark and leaves, Wyeth further generalizes the composition, emphasizing its abstract design within a wealth of explicit detail. EDG

Art after World War II

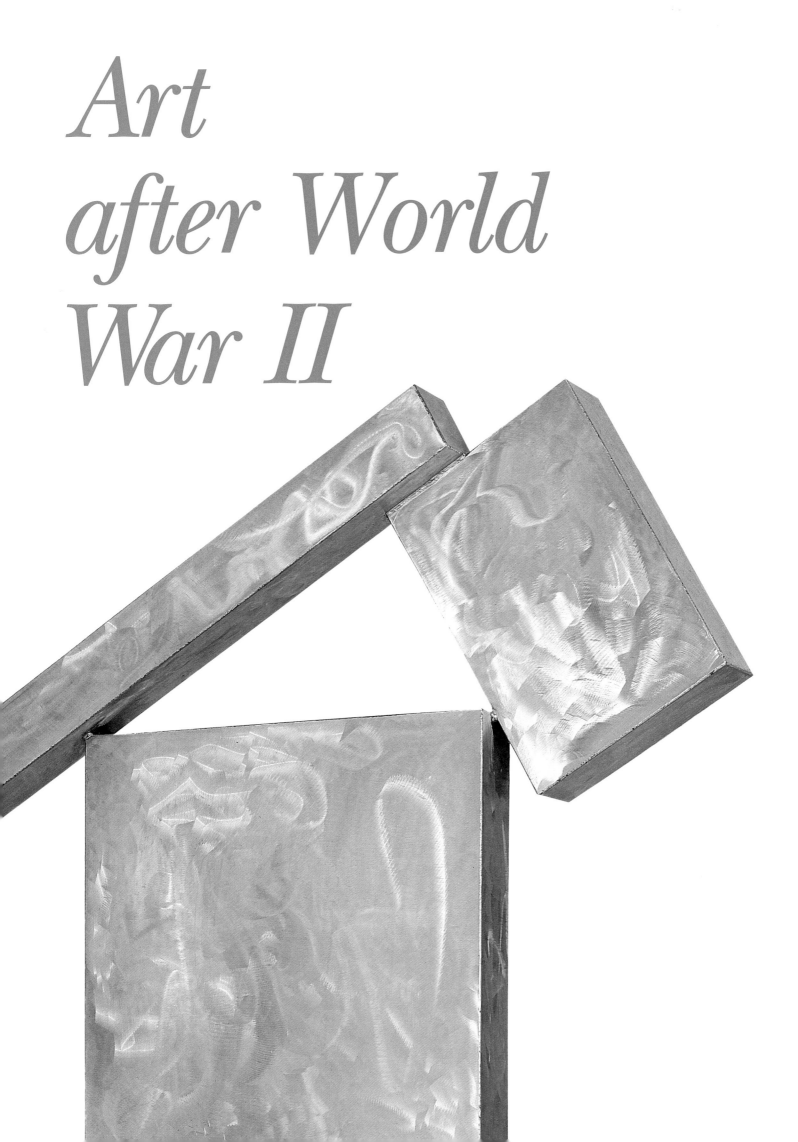

In the 25 years following World War II, American culture reached its peak of worldwide influence. Twice spared the ravages of modern war, the country's productivity and collective self-confidence were without peer. America's cities and its countryside were largely reconfigured by the wide availability of automobiles and housing. New realities of social space emerged: architecture assumed monolithic, corporate proportions in urban centers, while the commercial transactions of daily life, formerly centralized and mostly pedestrian, were dispersed and fragmented. Information and entertainment that previously had been available only through the press, radio, and the movies became nationally homogeneous via television. Many of the era's watershed events, including the Cuban missile crisis and the growing war in Vietnam, as well as the Civil Rights Movement and the Kennedy and King assassinations, were instantaneously apprehended. These enormous societal changes found parallels in art.

In the immediate aftermath of World War II, European creativity regained only part of its previous vitality. The emigration of many European artists ended the domination of the School of Paris and brought artistic vitality to cities like New York, Chicago, and Los Angeles. Firsthand acquaintance with some of modern art's greatest practitioners, especially the French Surrealists, proved catalytic for the New York community. A strong interest in both Freudian and Jungian ideas of the subconscious fueled the turn toward a more internalized vision. A reevaluation of primeval signs and the imagery of Native Americans further nurtured this emphasis on alternative realities.

The gestural painting adopted by Jackson Pollock, Willem de Kooning, and Franz Kline represented one pole of this emerging New York School known as "Abstract Expressionism." The subtly modulated fields of color that are characteristic of other New York School painters such as Mark Rothko and Ad Reinhardt stood as another pole. In part, personality traits and the seeming rawness of

their work contributed to the celebrity status of these and other American artists of the period. Their work found acceptance with a new generation of collectors and the burgeoning numbers of American museums committed to contemporary art.

As evident in the work of Peter Voulkos and Harvey Littleton, an increasing number of artists began using the traditional craft media in new ways. They began creating works that discounted function in favor of some of the same conceptual and material concerns that so stimulated their peers in painting and sculpture.

By the late 1950s a reaction to the heroics of the New York School had set in. Robert Rauschenberg and Jasper Johns, who actually began to incorporate real objects into their work, developed a new and more inclusive style. The era's exuberant proliferation of images was integral to the art of Rauschenberg and Johns as well as to the Pop imagery of Roy Lichtenstein and Andy Warhol. Pop's adaptation of the techniques as well as the symbols of the mass media lent this work an unprecedented legibility, and it attracted a wide and approving audience. Literally flat, recognizable, and narrative, Pop spoke a universal language.

The impulse toward simplification was common to artists working outside Abstract Expressionism and Pop as well, and the devaluation of nuance affected media other than painting. Minimalism began as a sculptural style in the mid-1960s; it was characterized by shapes fabricated from industrial materials. Most often presented on the floor without a base, Minimalist sculpture spoke to architecture's gargantuanism by attempting to engage the scale of the human body as personified in the spectator moving through the gallery. A comparable sense of scale—one that fuses anatomy and architecture—distinguishes many of Ellsworth Kelly's vivid abstractions, which seek to suppress the artist's hand in favor of a more anonymous-looking art object. Despite its meticulous and systematic rendering, this sense of removal is also evident in Chuck Close's paintings. His exploitation of the uniform, allover detail of a photograph (the source for his imagery) lends his portraits a hyperreality that separates them from traditional representation.

In many ways the story of postwar American art is the substitution of old Parisian verities for those of the New World. America's phenomenal economic growth during the period—a doubling of the gross national product and an exponential growth of consumer credit—was tempered by the real and imagined tensions of the struggle with Soviet and Chinese Communism. The militarism and related intellectual intolerance that gripped the country throughout these years were costly materially and spiritually. By the late 1960s, the schism between those in favor of and those who were against American involvement in Southeast Asia had become personified in the figure of President Johnson; his decision to forgo renomination in 1968 marked the collapse of the old order. Artistic change had come about more quickly than political change; the optimistic reform of Modernism had ended.

RICHARD ARMSTRONG

DAVID SMITH
1906–1965

Cockfight, 1945

Steel
45 inches high
The Saint Louis Art Museum
Purchase, 188:1946

David Smith was the first American sculptor to use the process of welding as the basis for his life's work. He brought together elements of many of the prevailing traditions of his time to form a body of sculpture that remains one of the most significant achievements of 20th-century art. Influenced by Pablo Picasso, Julio Gonzalez, and Alberto Giacometti, Smith's art was resolutely modernist, deeply personal, and distinctly American.

Cockfight, although less abstract than Smith's mature work of the 1950s, nevertheless exhibits key features of the artist's style. Relying on outline rather than mass to suggest volume, Smith silhouetted his forms in space in a manner that suggests the compositional freedom and direct energy of drawing. The brash extension of forms into space is accomplished through the technique of welding steel—a technique that Smith mastered in response to the work of Picasso and Gonzalez. JS

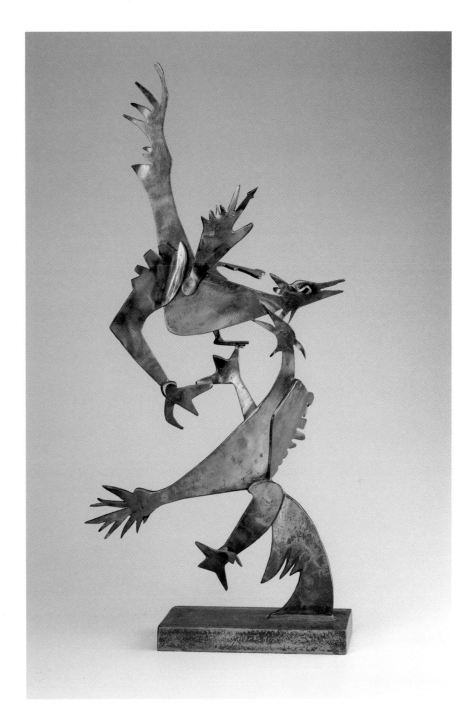

CHARLES EAMES
1907–1978,
and RAY KAISER EAMES,
1912–1988, designers
Herman Miller Furniture Co.,
Michigan

Low Side Chair, 1946

Molded plywood, bent plywood,
rubber, metal
26⅝ inches high
The Saint Louis Art Museum
Gift of Tom and Jean Wolff in
memory of Charles Eames, 47:1985

During the last 150 years, developments in wood-bending techniques have led to a number of innovative furniture forms. Several of the most important and influential chair designs of this century have been the work of the husband and wife team Charles and Ray Eames.

The Eameses were able to establish new standards of furniture design and production through technical innovations that they developed and applied to a variety of seating. They are best known for the low-cost techniques that allowed for the mass production of strong yet lightweight furniture made of molded plywood. Most significant was a dining chair of which this example is a variation. The chair uses a wooden seat and back that, for the first time, were bent in more than one direction, as well as a rubber "shock mount" system that joined the various parts to create a greater resilience. No attempt was made to conceal the hardware. The contoured seat and back offer a level of comfort that eliminates the need for upholstery, thereby reducing costs and making the chairs available to a large market. CM

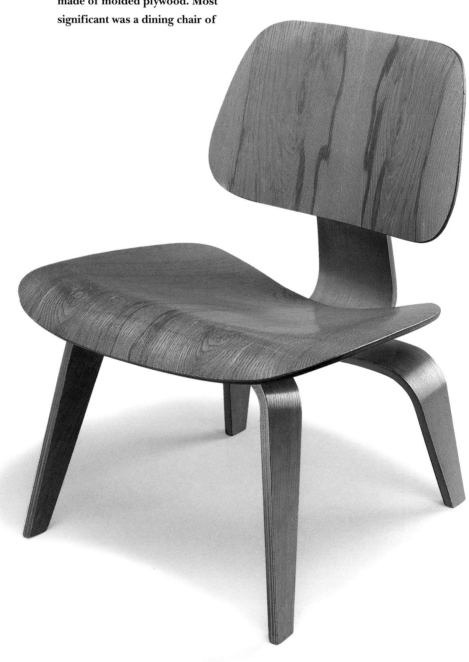

MAIJA GROTELL
1899–1973

Vase, 1948

Glazed stoneware
13 inches high
The Toledo Museum of Art
Purchase, 1949.17

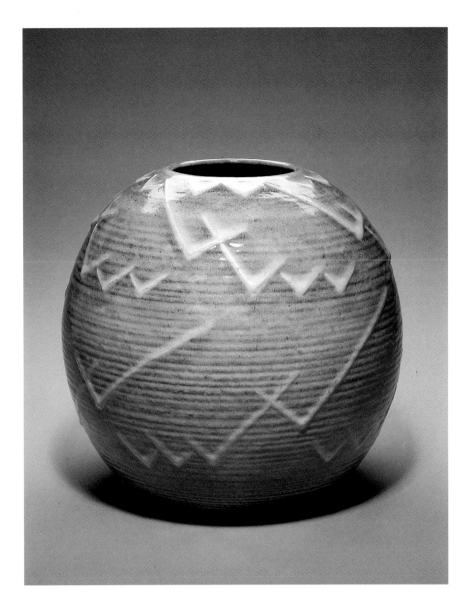

Among the numerous artists who emigrated from Europe to the United States in the 1920s and 1930s to escape political and economic oppression, the Finnish-born potter Maija Grotell had enormous influence on this country's ceramics at mid-century. As head of the ceramics program at the Cranbrook Academy of Art in Bloomfield Hills, Michigan, from 1938 to 1966, she shifted the American trend in ceramics away from sculpture and reasserted the vessel form.

This vessel is one of a series of large globe-shaped vases decorated with connecting, angular motifs that Grotell started soon after arriving at Cranbrook. Its powerful, spherical form, combined with the rhythmic pattern of the off-white decoration set in low relief against the grayish blue background, is typical of Grotell's wheel-thrown ceramics. DST

MARIA MARTINEZ
1881–1980

Plate, about 1950

Slipped earthenware
14½ inches diameter
The Saint Louis Art Museum
Gift of Mr. and Mrs. Charles Shucart in
memory of Margo Jester, 526:1982

A resident of San Ildefonso Pueblo in New Mexico's Rio Grande valley, Maria Martinez was the most famous Native American artist in this century. She learned to make polychrome pottery from her aunt and demonstrated that art at the Louisiana Purchase Exposition, also known as the St. Louis World's Fair, in 1904. Influenced by archaeological discoveries in Frijoles Canyon, she learned about the burnished black wares of the ancient past and revived their production. She led the larger revival of Pueblo pottery that successfully negotiated the transition from local use to artistic enterprise.

This plate is from the period when Maria Martinez preferred to work in the popular black-on-black style. The feather motif that radiates from the center is similar to designs on prehistoric Mimbres vessels that were found in archaeological excavations around the turn of the century. JDB

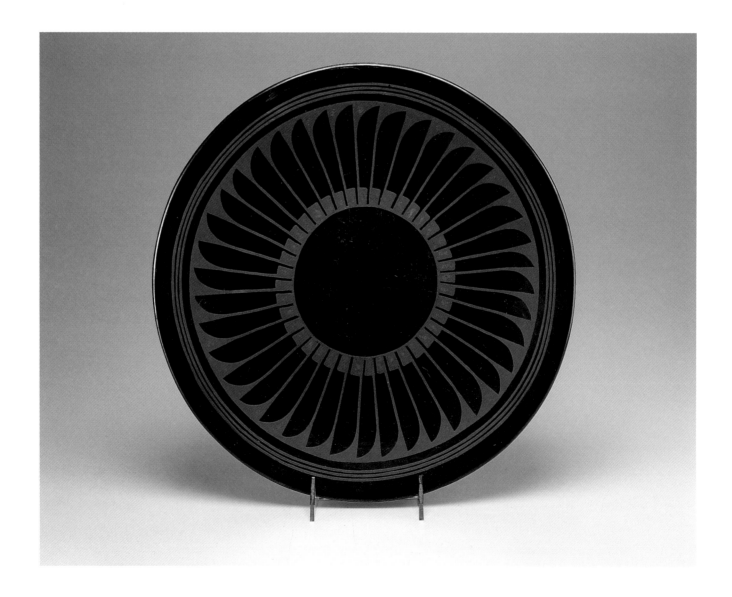

JACKSON POLLOCK
1912–1956

Number 4, 1950

Oil, enamel, and aluminum
paint
on canvas
48⅞ x 37⅞ inches
The Carnegie Museum of Art
Gift of Frank R. S. Kaplan, 54.15

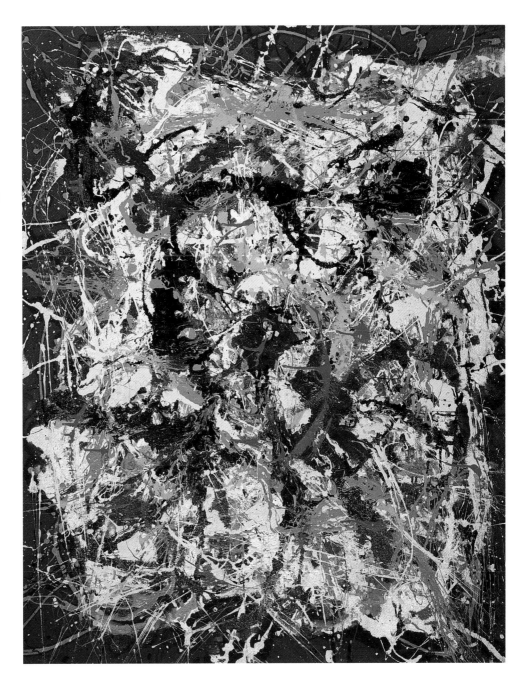

During and after World War II, American artists freely experimented with styles that mingled aspects of both abstraction and representation—all of them in pursuit of adequate means to express the subconscious. "Automatic drawing," a technique devised by the Surrealists to elicit the free expression of the creative unconscious, was one of the methods artists used to liberate themselves from approaches to painting that were either dogmatically figurative or dogmatically nonobjective. Few pursued this liberation with the vigor and invention of Jackson Pollock.

A westerner by birth and upbringing, Pollock studied with the painter Thomas Hart Benton after arriving in New York. Though he later rejected Benton's Renaissance-derived compositions and midwestern imagery, the emphasis on subject matter and the writhing space of the older artist's work profoundly influenced Pollock. He also looked to the tribal imagery of the Native American and to classical mythology for inspiration, often combining the two. By 1947 Pollock had devised a working method that featured linear tangles of dripped paint, and he considered his paintings to be records of his own intense activity. He numbered, rather than titled, most of these works to avoid references and expectations. Pollock's dense swirling skeins of paint heralded the style that became known as Abstract Expressionism. RA

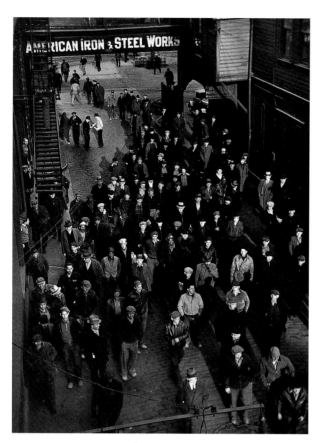

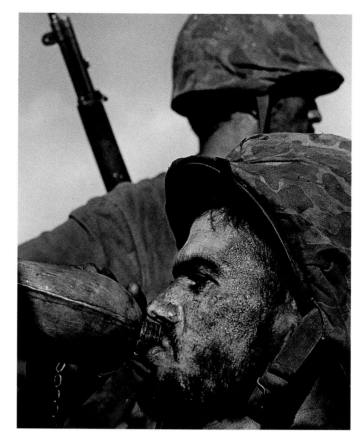

MARGARET BOURKE-WHITE
1904–1971

Workers Leaving Mill, about
1956

Gelatin silver print
13½ x 10 inches
The Carnegie Museum of Art
Gift of the Carnegie Library of Pittsburgh, 83.6.23

W. EUGENE SMITH
1918–1978

Saipan, 1944

Gelatin silver print
12¾ x 10½ inches
The Saint Louis Art Museum
Purchase: National Endowment for the Arts and
Anonymous Matching Fund, 166:1978

GORDON PARKS
born 1912

Malcolm X, Harlem, 1963

Gelatin silver print
15⁵⁄₁₆ x 19¼ inches
The Minneapolis Institute of Arts
The Christina N. and Swan J. Turnblad Memorial
Fund, 88.72.5

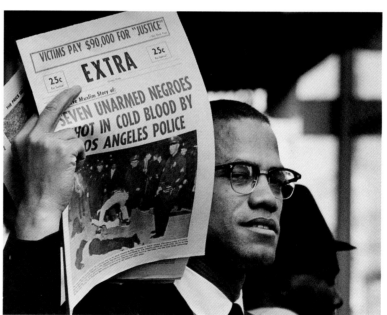

With World War II the new tech-
nology for the dissemination of
news and photography became firmly
entrenched. Picture magazines such as
Look, Life, and *Fortune* had taken hold
in the 1930s; *Our World* and *Ebony*
were serving the interests of African-
American communities as early as
1936.

ROBERT FRANK
born 1924

Trolley, New Orleans,
1958

Gelatin silver print
8⁹⁄₁₆ x 12⁹⁄₁₆ inches
The Toledo Museum of Art
Harold Boeschenstein, Jr. Fund, 1978.18

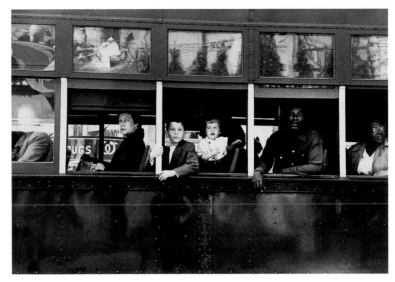

ROY DeCARAVA
born 1919

Dancers, New York,
1956 (printed 1986)

Gelatin silver print
13 x 8⁷⁄₈ inches
The Toledo Museum of Art
Purchased with funds from the Libbey Endowment,
Gift of Edward Drummond Libbey, 1988.57

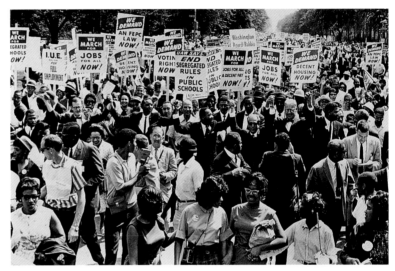

MONETA SLEET, JR.
born 1926

The March on Washington, 1963

Gelatin silver print
11⅛ x 17³⁄₁₆ inches
The Saint Louis Art Museum
Gift of the Johnson Publishing Company

The establishment of the picture press relied on a new breed of photographers who documented events and provided the up-to-the-minute coverage demanded by these dynamic and glossy publications. The 35-millimeter camera, with its small format and ease of handling, made it possible to capture split-second activities and events and present them with spontaneity as well as intimacy. As the key figure of this period, Robert Frank turned a seemingly journalistic photograph into an aesthetic object by selecting the elements of his pictures according to texture, shape, and contrast. Margaret Bourke-White, Roy DeCarava, Gordon Parks, Moneta Sleet, Jr., and W. Eugene Smith were among those who worked both for the picture magazines and independently, documenting public events and private life. The images they created were disseminated around the world and gave the viewing public firsthand experiences of world events before television made the picture press almost obsolete. OLG

GARRY WINOGRAND
1928–1984

Albuquerque, New Mexico, 1958

Gelatin silver print
8⅝ x 12¹⁵⁄₁₆ inches
The Minneapolis Institute of Arts
Anonymous Gift of Funds, 78.92.6

HELEN LEVITT
born 1918

Untitled, New York,
about 1942

Gelatin silver print
10⅜ x 6⅞ inches
The Toledo Museum of Art
Gift of Frederick P. and Amy McCombs
Currier, 1987.268

WILLIAM EGGLESTON
born 1939

Memphis, about 1970

Dye transfer print
12¹⁄₁₆ x 17³⁄₁₆ inches
The Minneapolis Institute of Arts
The Kate and Hall J. Peterson Fund, 79.34.1

One of the most prominent themes in postwar photography is the analysis of domestic life. The postwar era was characterized by a return to home and hearth; yet even before the Vietnam War, the comfort and security of the home were interrupted by a growing unease. The Women's Movement highlighted a new awareness of social problems, and the Korean and Vietnam wars heightened a climate of protest.

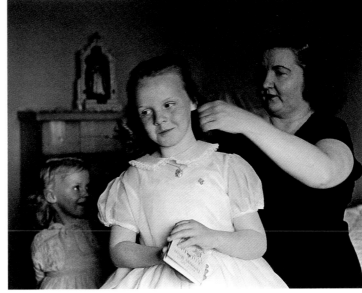

DIANE ARBUS
1923–1971

Triplets in Their Bedroom,
New Jersey, 1963

Gelatin silver print
14⁹⁄₁₆ x 14¾ inches
The Saint Louis Art Museum
Purchase, 177:1977

LARRY FINK
born 1941

First Communion,
Bronx, New York, 1961

From *Making Out* portfolio
Gelatin silver print
15⅛ x 19¼ inches
The Minneapolis Institute of Arts
Gift of Mr. and Mrs. Paul N. Rifkin, 82.124.36

EMMET GOWIN
born 1941

Nancy and Dwayne, Danville,
Virginia, 1970

Gelatin silver print
6⅝ x 6¼ inches
The Saint Louis Art Museum
Purchase: National Endowment for the Arts and
Anonymous Matching Fund, 158:1978

During this period, both the formal and metaphorical capabilities of photography were tested. A new generation of photographers—Diane Arbus, William Eggleston, Larry Fink, and Garry Winogrand were among them—used the medium to make critical and cynical commentary on the tensions and anomalies lurking under the appearance of domestic bliss. Emmet Gowin and Helen Levitt turned their cameras on more intimate moments of family life that were both enigmatic and revealing. OLG

171

HARRY BERTOIA
1915–1978, designer
Knoll Associates, Inc.,
Pennsylvania, established 1938

Side Chair, 1952

Vinyl-coated steel wire, black-painted
steel rods, elastic Naugahyde seat pad
28¾ inches high
The Saint Louis Art Museum
Purchase, 280:1979

Known primarily as a sculptor, Harry Bertoia studied at the Cranbrook Academy of Art in Bloomfield Hills, Michigan, and later taught metalwork there. For a brief period, from 1950 to 1952, while working for Knoll Associates, Bertoia explored the potential of metal in furniture design, producing a series of wire-shell chairs that made use of extremely thin, lightweight metal sections.

Bertoia's chairs demonstrate the 20th-century conviction that furniture should be as minimal as possible. He wanted to reduce the chair's size and weight and to make as much of it out of one material as possible. The wire construction was inspired by the common plastic-coated dishrack. Bertoia's chairs are really functional variations of his metal sculpture. When describing them, Bertoia stated that "many functional problems have to be satisfied first, . . . but when you get right down to it, the chairs are studies in space, form, and metal too. . . . If you will look at these chairs, you will find that they are mostly made of air, just like sculpture. Space passes right through them." CM

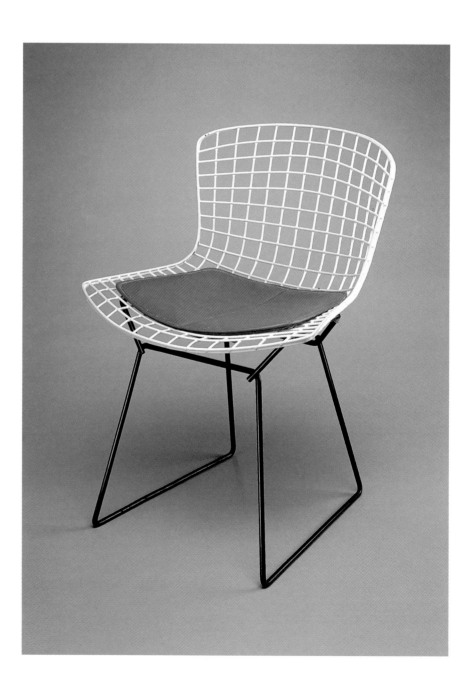

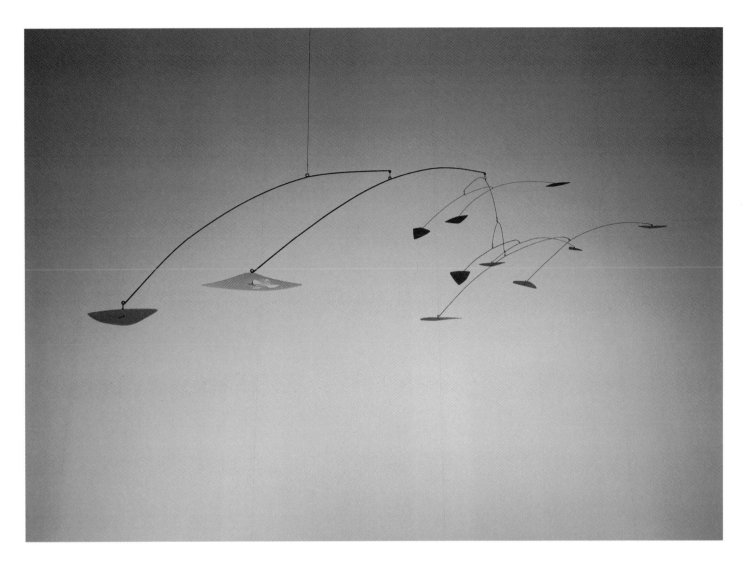

ALEXANDER CALDER
1898–1976

Mobile: Horizontal
Black with Red Sieve,
1957

Sheet steel and wire, painted red and
black
9 feet long
The Toledo Museum of Art
Purchase, 1960.27

Alexander Calder indulged his
own mechanical ingenuity, inter-
est in popular science, and humor and
applied them to the abstracted, bio-
morphic art popular in Paris during
the 1930s to create a new form of
sculpture based on motion. Works such
as *Mobile: Horizontal Black with Red
Sieve* consist of flat, suspended shapes
of different sizes and weight that were
painted the three primary colors,
black, or white and attached to curved
wires. The term *mobile* was specifically
invented for these sculptures because
of their kinetic energy. Buoyant in
mood and appearance, mobiles are
governed by the delicate balance of
their components and by air currents.

Despite their abstract nature, their
shapes and movements often suggest
animal or plant forms. Their rhythmic
patterns—unpredictable and ever
changing—are as important to the
overall compositions as the shapes
themselves and require a certain
amount of time to appreciate. Calder's
incorporation of chance, playfulness,
and humor into abstract sculpture
influenced succeeding 20th-century
artists. EDG

PETER VOULKOS
born 1924

Plate, 1957

Stoneware, epoxy paints
16½ inches diameter
The Minneapolis Institute of Arts
The John R. Van Derlip Fund and Gift of
Tod and Ruth Braunstein, 81.33

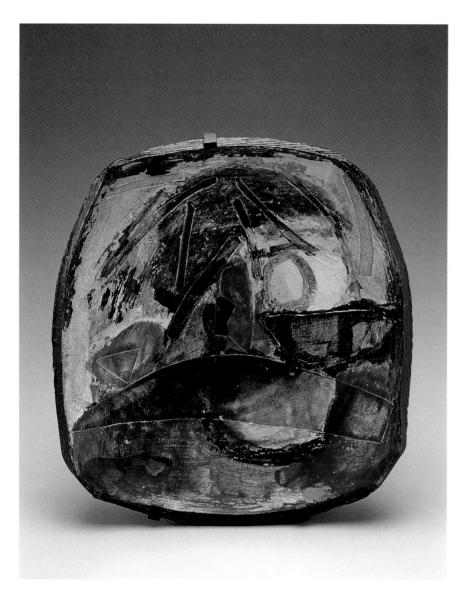

Although he chose to earn his living as a potter, Voulkos has considered painting to be his primary art and regards his ceramic works as paintings on clay. This plate is very close to the paintings on canvas that he produced at the same time, both in the colors used and in the rough sand texture. Voulkos first introduced the use of epoxy paint on ceramics to achieve brilliant effects of color. The rich, paint-encrusted glazes and playful inlaid designs, some of which were drawn from Japanese pottery, make this plate a unique and surprising piece of ceramic art.

In the early 1950s Voulkos lived in New York, where he was influenced by the painters Jackson Pollock, Mark Rothko, and Willem de Kooning, who were experimenting with a style that came to be known as Abstract Expressionism. In 1954 he moved to Los Angeles to head the new ceramic department of the Otis Art Institute, which soon became the Los Angeles County Art Institute. From 1954 to 1959, an especially exciting and productive period of his career, Voulkos worked and experimented alongside his students, making ceramics as controversial as the paintings of his contemporaries. As the leader in the craft movement, Voulkos challenged the traditions of ceramics; for the first time American ceramists broke away from established European and Asian designs and techniques to fulfill their own visions of ceramic art.

JAN and WBR

FRANCES HIGGINS
born 1912

Vase, about 1958–59

Crushed glass, glass sheets, enamels
9½ inches high
The Toledo Museum of Art
Purchased with funds from the Libbey
Endowment, Gift of Edward Drummond
Libbey, 1991.88

In 1962 Harvey Littleton with Dominick Labino led two workshops on the grounds of the Toledo Museum of Art that showed artists how to blow glass in their own studios. Prior to that, only a few pioneering Americans worked with glass outside a factory setting. Two of the best known are Frances and Michael Higgins who, already in 1949, were heat-shaping sheet glass. By 1950 they were marketing a range of wares made of fused sheets of glass with hand-applied enamel decorations.

In the 1950s the Higginses tried to expand their repertoire to include deep bowls. This vase is one of two experimental vessels that Frances created by dropping crumbs of glass into a mold and then heating it in a kiln. She attached enameled glass strips for decoration. The crushed glass failed to fuse completely, however, resulting in a vase form where partially melted crystals are intermixed with empty spaces.
DST

RICHARD DIEBENKORN
1922–1993

Black Table, 1960

Oil on canvas
55½ x 47 inches
The Carnegie Museum of Art
Gift of Mr. and Mrs. Charles Denby,
70.54.2

Black Table is among the represen-tational paintings that Richard Diebenkorn made between 1957 and about 1963, a period when the artist returned to issues that had been the subject of his earliest work. From the late 1940s until 1957, Diebenkorn had developed a body of work derived from landscape and related to the gestural abstraction that occupied most of his peers.

Diebenkorn's friend and mentor David Park had abandoned abstraction in 1949 in favor of a powerful figura-tive style that took the gestural free-doms of Abstract Expressionism and joined them to the representa-tional subjects of the German Expressionists. After Diebenkorn returned to San Francisco in the early 1950s, Park's exhortations to join him in working from the human figure became irresistible. Diebenkorn's use of space and naturalistic color distin-guishes his work from that of other Bay Area artists. In *Black Table* Diebenkorn unites two of his favorite motifs—still life and landscape—using a knife to guide the eye from one to the other. RA

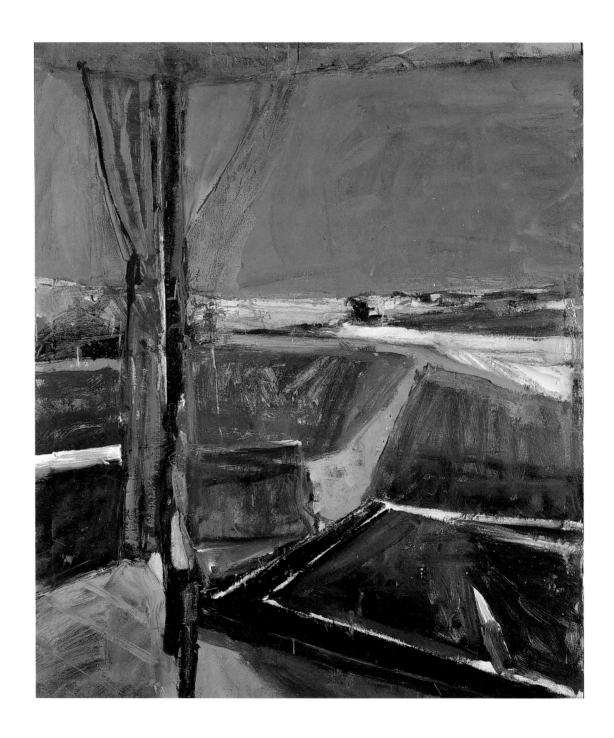

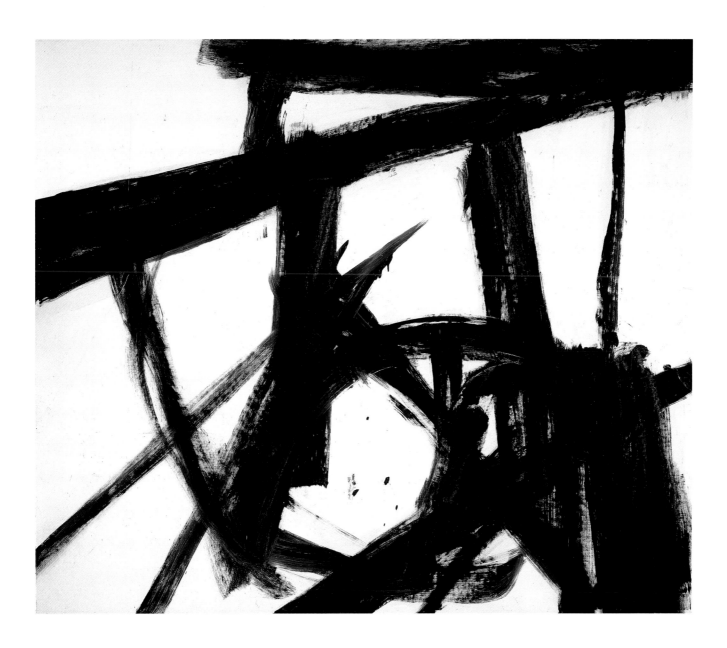

FRANZ KLINE
1910–1962

Turin, 1960

Oil on canvas
80 x 95⅜ inches
The Nelson-Atkins Museum of Art
Gift of Mrs. Alfred B. Clark through the
Friends of Art, 61–23

People often remarked on the similarity between Franz Kline's black and white strokes and Chinese calligraphy. The comparison annoyed the artist. He said repeatedly that his work had nothing in common with Chinese calligraphy because he was not writing. He also said that the black and white strokes, such as those in *Turin*, should be read as having the same weight. In other words, he did not intend that one be read as positive and the other as negative space.

Franz Kline was one of the Abstract Expressionists who revolutionized painting from the mid-1940s to the 1950s. Their work was large in scale, gestural, and about the direct experience of painting. By 1950 Kline had abandoned color, using only black and white paint with a dramatic bravura brushstroke. Working on large sheets of canvas attached to the wall, Kline allowed the composition to evolve during the process of painting. Only later would he determine the edges of the painting by cutting it out of the larger canvas and then stretching it. In 1960 Kline went to Italy to see ten of his works exhibited in the Venice Biennale. He titled several of his paintings, such as *Turin*, after Italian cities. DES

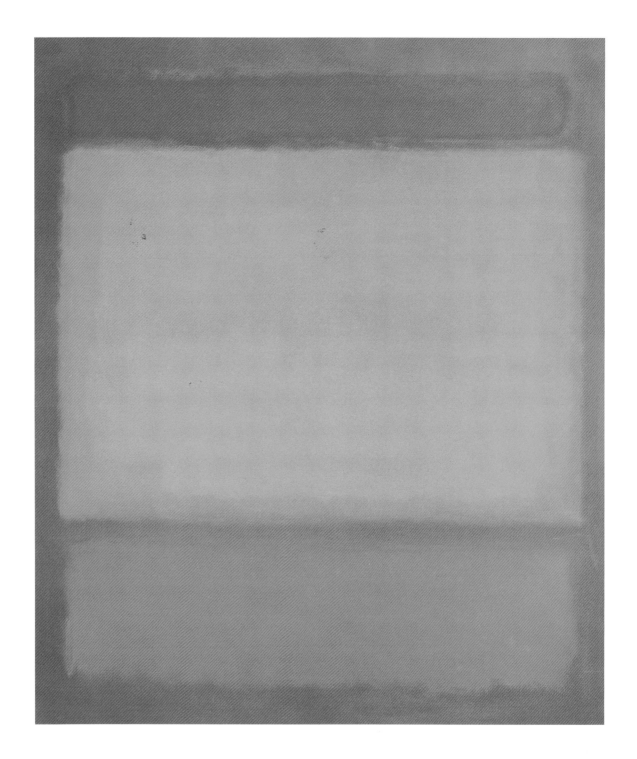

MARK ROTHKO
1903–1970

Red, Orange, Orange on
Red, 1962

Oil on canvas
92 x 80½ inches
The Saint Louis Art Museum
Purchase: Funds given by the Shoenberg
Foundation, Inc., 129:1966

Mark Rothko was a major figure of the Abstract Expressionist movement, and this painting is typical of his style from the 1950s until his suicide in 1970. The large field of subtly shifting color presents a contemplative or meditative experience for the viewer, who is encouraged to respond emotionally to the painting. It is this interactive element that gives many of Rothko's works, including this one, a mystical, transcendent quality.

Rothko combined an intense red, a red-orange, and gradations of these hues, balancing their emotional intensity with the stability of the rectangular shapes. He achieved spatial ambiguity by applying many thin washes to the canvas, so that light seems to emanate through the translucent scrims of color. Throughout his career Rothko experimented by varying the proportions of his rectangles and the intensity and saturation of his colors. DAR

ROBERT RAUSCHENBERG
born 1924

Tracer, 1963

Oil and silkscreen on canvas
84 x 60 inches
The Nelson-Atkins Museum of Art
Purchase: Nelson Gallery Foundation,
F84–70

Together with Jasper Johns, Robert Rauschenberg is often referred to as the cofounder of Pop Art, the school that rejected the subjectivity of Abstract Expressionism in favor of impersonal techniques and references to popular contemporary culture.

In 1963 Rauschenberg temporarily abandoned making "combines"— works in which he combined paint and unexpected materials like furniture, bedding, and stuffed animals—and began using a technique that enabled him to apply silkscreened images to canvas. *Tracer* is one of 79 silkscreens he produced between 1963 and 1964.

The screened images came from everyday sources such as newspapers, magazines, and personal photographs.

In *Tracer* Rauschenberg alludes to America's involvement in Vietnam by incorporating images of army helicopters and a bald eagle. A detail of the 17th-century painting *Venus at Her Toilet* by Peter Paul Rubens and a pair of songbirds are symbols of beauty and love. The inclusion of such disparate images is indicative of the extremes of our society during the turbulent 1960s.
DES

179

DAVID SMITH
1906–1965

Cubi XIV, 1963

Stainless steel
122½ inches high
The Saint Louis Art Museum
Purchase: Friends Fund, 32:1979

The *Cubi* series of stainless-steel sculpture was the crowning achievement of David Smith's final years. Smith's earlier work had been based on found objects selected for their forms and associations—pieces of scrap metal, abandoned tools, and machine parts—that the artist welded together. The volumetric shapes of the *Cubi* sculptures, by contrast, were made to specification by the artist or by his assistants. The improvisation that had dominated the production of Smith's earlier sculpture was now supplemented with preparatory drawings, paintings, and cardboard models.

Although the geometric shapes of the *Cubi*s make them appear the most abstract of Smith's sculptures, they nevertheless share the figurative concerns that engaged the artist throughout his career. *Cubi XIV* reflects Smith's long-standing interest in sculptural still life: the two rectangular blocks at the sculpture's summit can be seen as elements sitting atop a square table, which in turn rests on a high plinth.

All the stainless-steel surfaces of the *Cubi* series were burnished with a disk grinder. The abstract patterns thus created catch and reflect light, acting to transform the bulky steel blocks into shimmering surfaces. JS

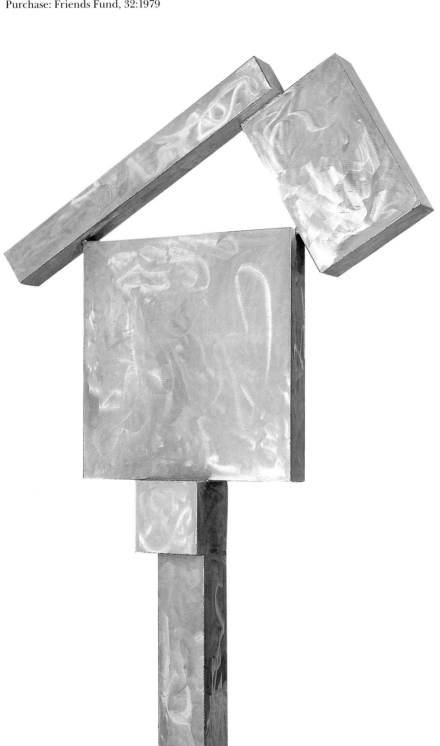

ANDY WARHOL
1928–1987

Double Elvis, 1963

Synthetic polymer paint and silkscreen
on canvas
82 x 49½ inches
The Andy Warhol Museum, Pittsburgh
Founding Collection
Contribution The Andy Warhol
Foundation for the Visual Arts, Inc.
The Andy Warhol Museum is one of the
museums of the Carnegie Institute.

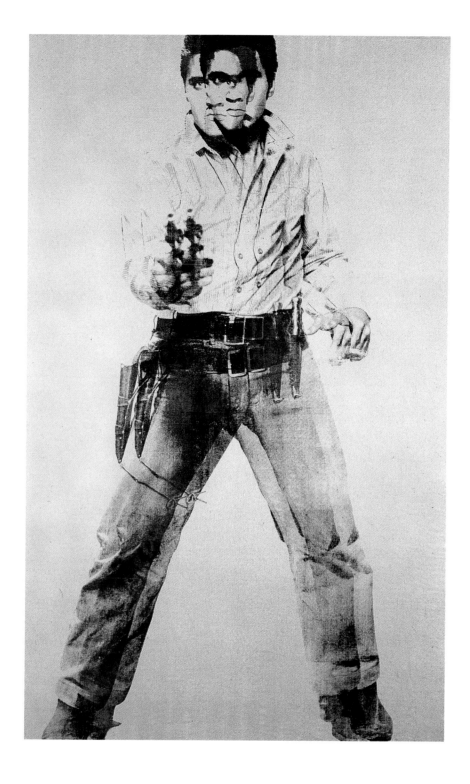

Andy Warhol's famous statement, "The reason I'm painting this way is because I want to be a machine," succinctly characterizes a fundamental shift in American art of the 1960s. His silkscreened canvases demonstrate a demystification of creativity. Deliberately repetitious, they celebrated the visual overload that accompanies and continuously renews a consumer society.

This image of Elvis is from a still from the movie *Flaming Star*, 1960. With the appearance and instantaneous acceptance of Pop art around 1962, the introspection that had propelled much of the art of the previous decade was no longer valued. In fact, it was considered irrelevant. The stark, iconic paintings of Roy Lichtenstein and Warhol illustrated the movement's appropriation of existing imagery. The new subject matter, unapologetically figurative,

came from the mass media, principally from advertising. Warhol had supported himself as a fashion illustrator throughout the 1950s, and his favorite symbols in the early 1960s were dollar bills, Campbell's Soup cans, disaster scenes, Marilyn Monroe, and Elvis Presley. RA

HARVEY LITTLETON
born 1922

Implosion/Explosion,
1964

Blown glass
7½ inches high
The Toledo Museum of Art
Gift of Maurine B. Littleton and Carol
Shay, 1992.36

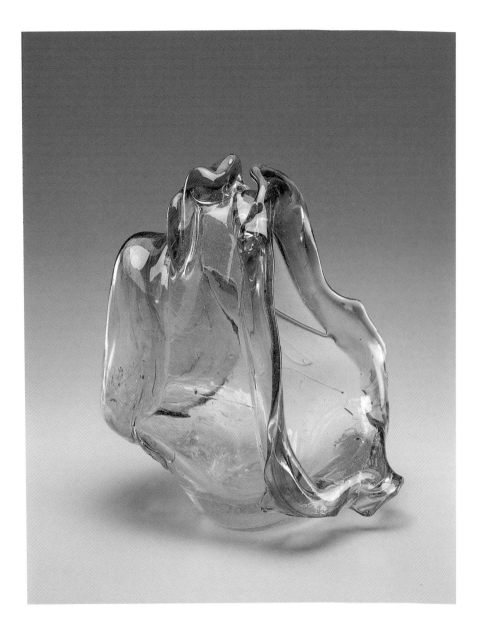

Harvey Littleton is considered the founder of the contemporary studio glass movement. In 1962 he conducted with Dominick Labino two celebrated workshops on the grounds of The Toledo Museum of Art, giving artists the opportunity to explore blown glass in their own studios.

As he worked to develop his own vocabulary in glass in the early 1960s, Littleton alternated between traditionally shaped vessels and more expressionistic sculptural forms like *Implosion/Explosion*. By smashing the blown-glass bubble with a metal file and then reheating it, Littleton was able to force the walls of *Implosion/Explosion* to fold outward while appearing to cave in. Throughout this series of controlled accidents, Littleton was able to bring to glass the highly expressive approach that Peter Voulkos had introduced with ceramics in the late 1950s. DST

SHEILA HICKS
born 1934

The Evolving Tapestry:
Blue, 1967

Linen and silk
27 pieces of varying sizes
The Saint Louis Art Museum
Gift of Vivian and Edward Merrin,
80:1992.1–27

Beginning in the early 1960s, experimentation in the fiber arts challenged traditional textile materials, concepts, and techniques. The outcome was works that were aesthetically equivalent to sculpture and painting. Fiber arts became increasingly free of the loom, and a variety of effects broke down the familiar distinctions between fine arts and craft. Textiles gained wider acceptance as a vehicle of artistic expression.

This work by Sheila Hicks is unusual in that it is made out of separate modular bundles of fiber that are stacked and piled like blankets into an "evolving" configuration that can always be rearranged. It is a freestanding sculpture that does not need a wall for its display. The notion of accumulation is characteristic of the 1960s, when Minimalist artists were making sculptures by piling things up or situating them in accumulative arrangements.
CM

ELLSWORTH KELLY
born 1923

Spectrum II, 1966–67

Oil on canvas
80 x 273 inches
The Saint Louis Art Museum
Purchase: Funds given by the Shoenberg
Foundation, Inc., 4:1967

Ellsworth Kelly's *Spectrum II* is a dazzling example of the artist's skill in creating flat, color-saturated paintings that seem to vibrate with a light-filled intensity. Kelly does not use frames or containing edges to stabilize or define his compositions but relies instead on the interrelationship of form, color, and scale.